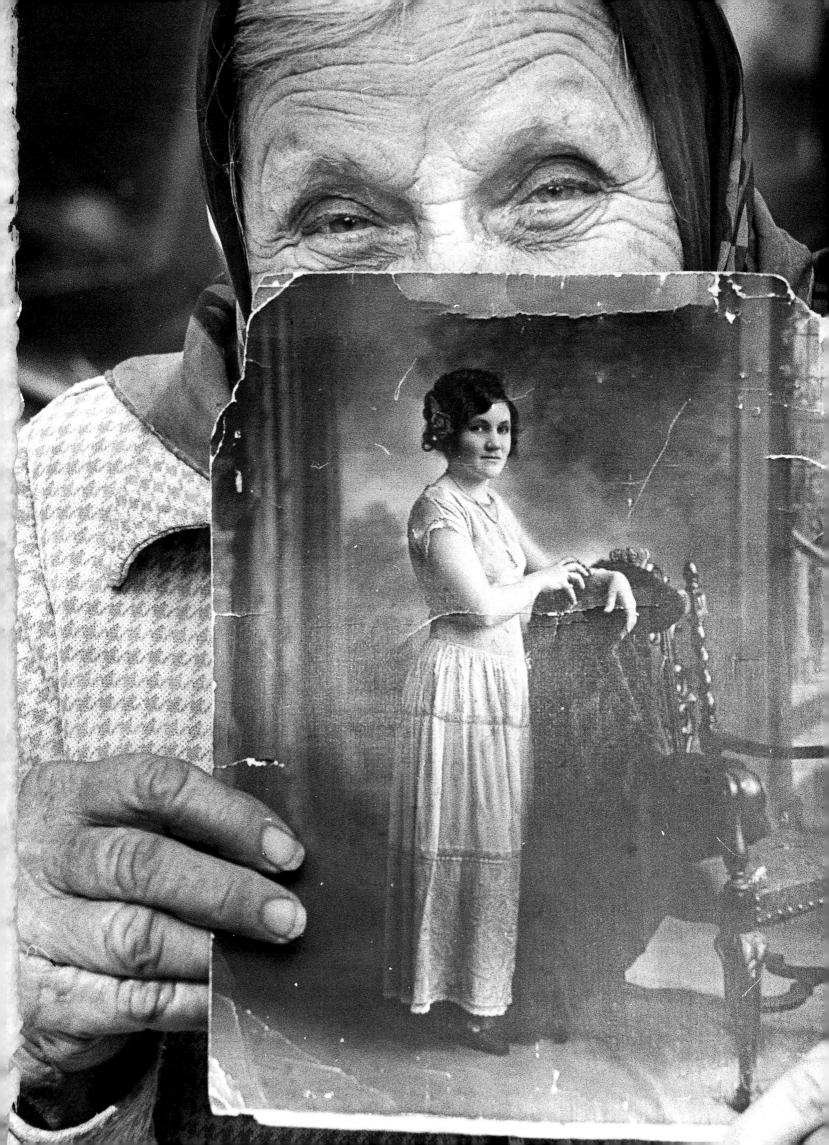

Overleaf:
Timothy Bullard
Gertrude Baccus, 18 and 84, 1984.
(Courtesy of the photographer)

american photography: a century of images

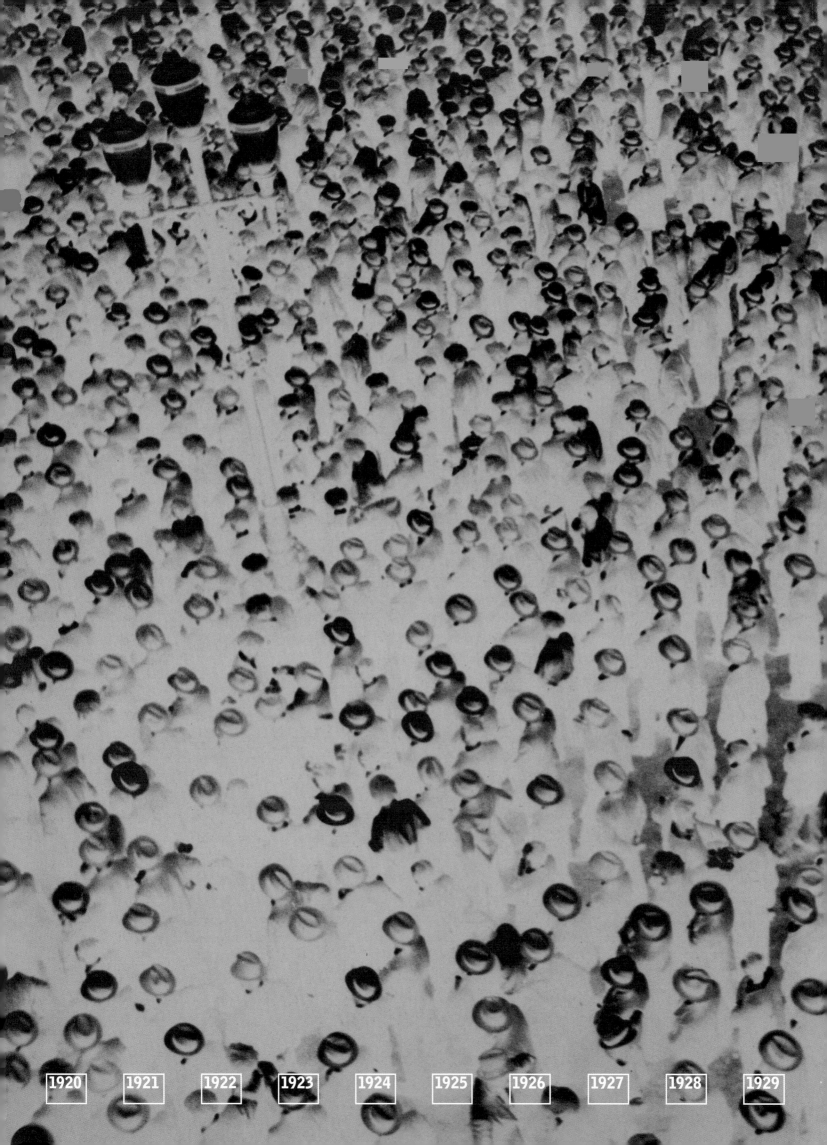

1920 1921 1922 1923 1924 1925 1926 1927 1928 1929

CHRONICLE BOOKS
SAN FRANCISCO

american
photography:
a century
of images

by Vicki Goldberg and Robert Silberman

1930 1931 1932 1933 1934 1935 1936 1937 1938 1939

Every effort has been made to trace and correctly credit the source
and ownership of all copyrighted material included in this volume.
Any errors or omissions are inadvertent and will be corrected in
subsequent editions, provided notification is given to the publisher.

Library of Congress Cataloging-in-Publication Data:
Goldberg, Vicki.
 American photography : a century of images / by Vicki Goldberg and
Robert Silberman.
 p. cm.
 Includes bibliographical references and index.
 ISBN 0-8118-2622-8
 1. Photography—United States—History—20th century.
 I. Silberman, Robert Bruce, 1950– . II. Title.
 TR23.G65 1999 99–31713
 770'.973—dc21 CIP

Printed and bound in the United Kingdom by Butler & Tanner, Ltd.

Produced and edited by Garrett White and Karen Hansgen, Los Angeles, CA
Book and jacket design by Simon Johnston @ praxis:

Acknowledgments appear on page 231.

Distributed in Canada by Raincoast Books
8680 Cambie Street
Vancouver, British Columbia V6P 6M9

10 9 8 7 6 5 4 3 2 1

Chronicle Books
85 Second Street
San Francisco, California 94105

www.chroniclebooks.com

contents

1950 1951 1952 1953 1954 1955 1956 1957 1958 1959

introduction

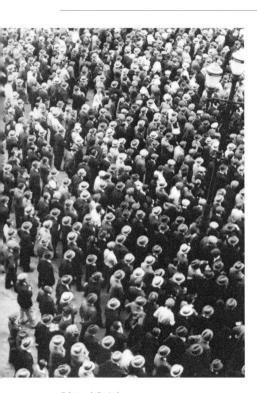

Edward Quigley
Crowd Scene, 1931.
(Courtesy of Barry Friedman, Ltd., NY)

THE MOST DEMOCRATIC OF ARTS IMMEDIATELY found a home in the most democratic of countries, not only providing the average citizen (whoever that is) with his or her own likeness but soon proving its value in elections and in the exploration of the West. Photography seems, in retrospect, like a natural for the American eye, which has always paid particular attention to the plain, hard facts; witness our early painters, like John Singleton Copley and the Peales. The medium could accommodate our transcendental yearnings too, and photographs of the eloquent and surprising landscape played a critical role in establishing national identity. Anyway, we took to photography: Almost as soon as international prizes were established, American daguerreotypes won top honors. American technology had the edge here; our mechanical techniques for cleaning and polishing were better than what Europe had.

The history of photography, still far from complete today, has focused on Europe and Britain, where the medium was invented, and on America, which quickly became an international power. Scholarship could change the emphasis; for now, we are stuck with the knowledge we have, and from inside this country, America looks important.

At the end of the nineteenth and beginning of the twentieth centuries, the Kodak and the Brownie put the ability to make pictures into everyone's hands, first in America and moments later across the world; it was as if we had embodied our democratic desires. And in this century, photography turned out to be one of this country's most important cultural products. Around the turn of the last century, Jacob Riis, an immigrant American, and Lewis Hine, born here, led the way in both the practice and style of social reform photography. The social reform movement took root in many countries, but it was typically American to believe that just knowing about injustice would move people to act, and it was ingenious to enlist the camera in the cause. The Farm Security Administration's photographic project, which echoed Hine, was by far the most comprehensive of any nation's effort to record the Depression. FSA photographers were highly accomplished, and their images influenced films that were seen around the world.

American modernism lagged far behind Europe in painting, but in the middle of the second decade, Paul Strand, taking a cue from avant-garde painting overseas, created a distinctly American modernist photographic style. Less involved in experimentation than Europe was, Strand and others like him in this country directly confronted the geometry of modern forms, the modern city, the lost and alienated modern citizen. New York was already the flagship city of the

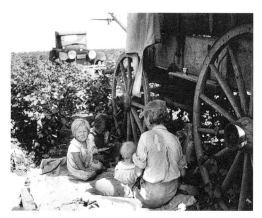

Ken O'Brien
The Cotton Patch, Texas, 1937.
(Courtesy of the photographer)

century, as Paris had been of the last, and Strand (and Alfred Stieglitz, Berenice Abbott, and later many others) reveled in its stark, sleek, powerful, energetic, empty, even inhospitable façade.

Between the two world wars, when traffic in literature, magazines, and entertainment became more and more international and rapid, American photographers were represented in major European exhibitions, and the export of America's increasingly visual culture became big business. Technology again played a role—*Life* magazine's production was better than that of the European magazines that had invented the form, and Technicolor and Kodachrome gave us the first edge in color technology. The size and resources of this country, which was the foremost economic power after World War II, and its evident (and some would say dubious) talent for pop culture fostered the wholesale export of manufactured and cultural products. Vast amounts of American photographic imagery in magazines, advertisements, film, and television have swept the world, sometimes to the distress of local talent elsewhere.

In the 1930s and 1940s and again in the 1950s, emigrés brought an immense reservoir of talent to the United States that added both an experienced 35mm photojournalistic practice—Alfred Eisenstaedt, Martin Munkacsi—and a sophisticated European taste and worldview—Andre Kertesz, Lisette Model—to a more provincial, raw, and plain-spoken American style. Even in fashion, European art directors recognized and galvanized the talents of extremely gifted photographers who led America to the forefront of fashion photography. Robert Frank brought with him from Switzerland a European existentialism and skepticism, and perhaps a certain cynicism about this country, then found visual correlatives for them in the car culture, the racism, the emptiness of the land.

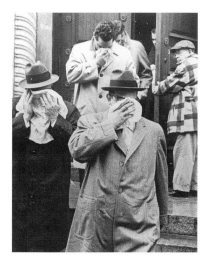

Clifton B. Jones
De Marco Witnesses, 1959.
(Boston Public Library)

If many memorable war images were made by Americans, that is not because American photographers were better but because Americans were involved in every major war and had the resources to provide extensive coverage, as well as having communications satellites in place at an early date.

By the mid-1950s and 1960s, what André Malraux called "the museum without walls," that museum in many a living room where pictures from the Louvre, the Uffizi, and the Hermitage sit side by side between book covers, was a worldwide establishment in which not merely the same art but the same news images ran through the memories of people everywhere: Japan, Nigeria, Chile, Belgium. It was already almost painfully clear that the media were dominating life, and American media were dominant.

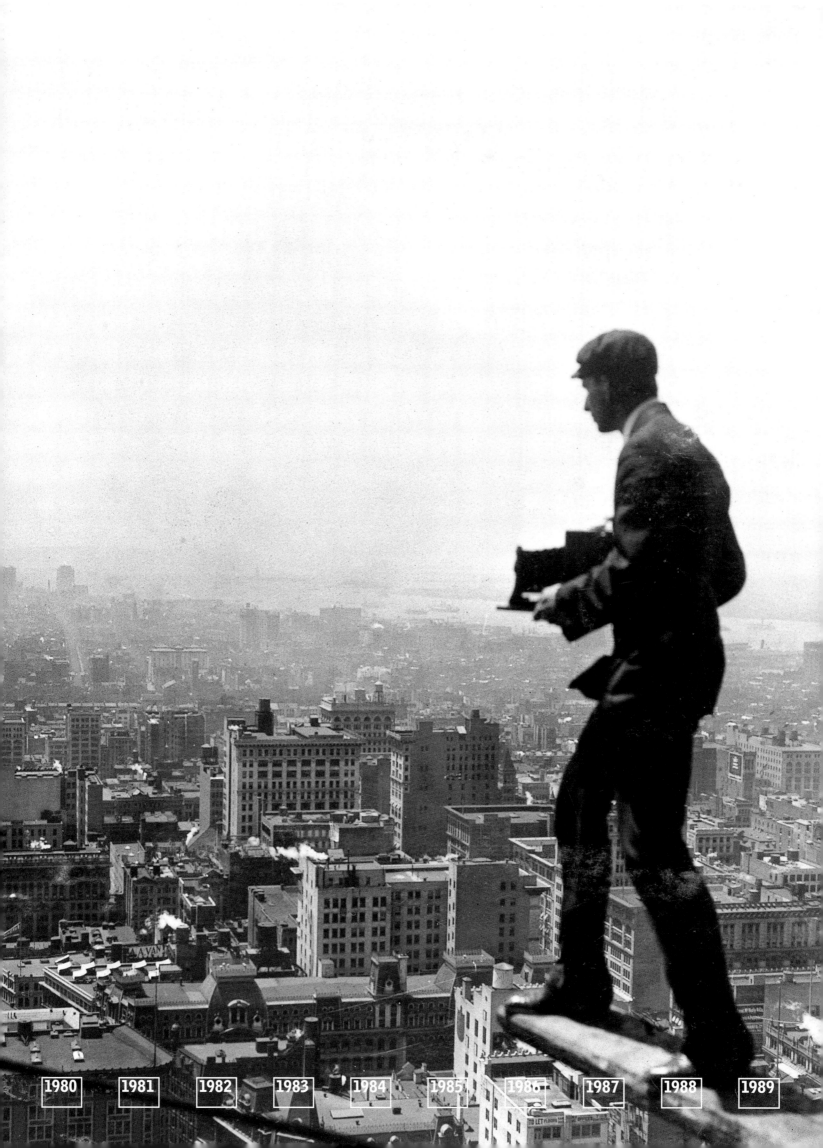

Photography *is* the modern world. Thomas Lawson

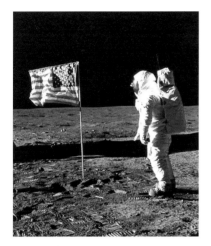

Above: NASA
Apollo 11 Eva View, 1968.
(Courtesy of NASA)

Opposite: Horace D. Ashton
*Underwood & Underwood photographer
making views from Metropolitan Tower,
New York*, 1911. (Courtesy of the Hallmark
Photographic Collection)

Even our worst faults were put before the world's eyes by our photographers because of the extent of our media industry and the openness of our press. We were damned around the world for civil rights abuses by the witnesses we ourselves had called, and then by our press that published their damning images.

The United States has become increasingly diverse in recent years, and the influence of our civil rights and feminist and gay activist movements has encouraged minorities to seek representation and self-expression—again, a democratic polity has permitted if not encouraged a varied ethnic representation and self-representation. America's prior record on this score was appalling, but this is a country with a fervent belief in self-improvement.

And technology still contributes to wide recognition of American photographs, as images of the earth seen from the sky by an American astronaut, of an American robot on Mars, and of spectacular discoveries in deep space made by NASA cameras and telescopes change everyone's vision of the universe.

Now, with the century drawing to a close and the status of photography changing under the relentless advance of new technologies, the time is right for a long look back at the medium that created the image of these hundred years and wove the strands of communal memory. Sometimes, when age and language and culture divide us, the images—of Betty Grable, a man on the moon, a monk burning to death in Vietnam—are all we share. Other times, photography furnishes the rituals and identities required of just about everyone: baby pictures, wedding announcements, passports. And most often they simply are the environment, in newspapers, magazines, and books, on billboards and phone booths and in store windows, in motion on big and small screens.

Family photographs remain our most intimate and at times our only connection to the histories that shaped our lives. After a tornado savaged Oklahoma City in May of 1999, thousands of torn and mud-stained photographs turned up in gutters and odd corners. A church offered to gather them in, and people who had lost everything came to reclaim the remnants of their past. Many said the greatest thing that they had left was life, then added that these photographs came next.

This book looks at one photograph for every year of the past century, and then at more. With photographs of just about every description, *American Photography: A Century of Images* is less a history than a proposition. "Photography *is* the modern world," the critic Thomas Lawson said. These pages present images of that world as American photographers saw it, with the hope that they set you to thinking about whether Lawson was right.

1990 1991 1992 1993 1994 1995 1996 1997 1998 1999

1.

the developing image
1900–1934

I.

the developing image
1900–1934

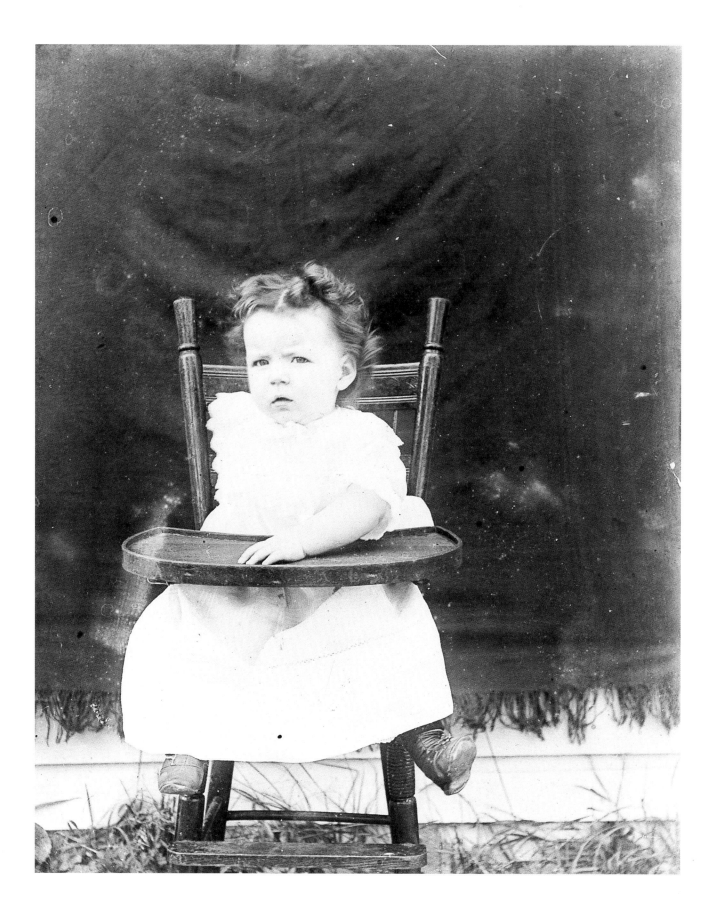

1900 Photographer unknown
Baby Picture.

the snapshot revolution

Family snapshots amplified the voice of nostalgia that swears the good old days really were better.

IT BEGAN IN 1888, WHEN GEORGE EASTMAN brought out the roll-film Kodak, sparking the revolution that made just about everyone a photographer and a picture maker. The camera was a stroke of commercial genius; with it, Eastman created the amateur market. The Kodak was sold already loaded with film, and once the roll was finished the camera was sent back to the factory, which processed the film, printed it, and loaded the camera once more. No one had to learn the difficult and messy complexities of printing. Everyone with a little money could do what few could do before.

In 1900, the Brownie, costing only a dollar, put this revolution in the hands of adolescents and lower-class families. Named for a creature in popular children's book illustrations, the Brownie promised to make children and women into photographers. It did. It also turned them into eternal subjects of the lens. Nimble cameras and easy photographs gave everyone in the family a starring role in repeat performances on a private stage. Photography, which had made faces durable, now registered growth, change, even decline: the new baby, her first birthday, her triumphant toddle, and great-grandma's fragile smile.[1]

Snapshots filled albums and attics with family pictures, almost always of happy families; the home camera scarcely knows another kind. For years most pictures were taken outside when the sun shone, so a certain bright, good feeling was virtually built into the task. Moreover, people did not snap pictures of their wives crying, their husbands drunk, their children in gangs; of accidents, violence, illness, insanity, divorce. (Nor often of death, for funeral and postmortem pictures, which persisted in some communities well into the twentieth century, were usually the province of professionals.) The simplification of photography was seized as an opportunity to construct ideal family myths and reinforce them by keeping the evidence in view. Family snapshots amplified the voice of nostalgia that swears the good old days really were better.

Amateurs began fashioning tales of happy families when the family was already under pressure. During the industrial revolution, work moved out of the home, improved transportation sent people across oceans or out West, and the home and family that were not necessarily as stable and permanent as they seemed came to be looked on as the last bulwarks against the frightening rapidity of social change. At the beginning of this century, social pressure increased with a flood of immigrants and a growing number of women in the workforce. Snapshooters ignored the signs, and photographs kept mum. Family albums featured darling boys whose grinning pictures in short pants betrayed not a hint that they might come to no good. Later some would be men who died in wars but still lingered vividly on the page, and some would be daddies whom divorce wrote

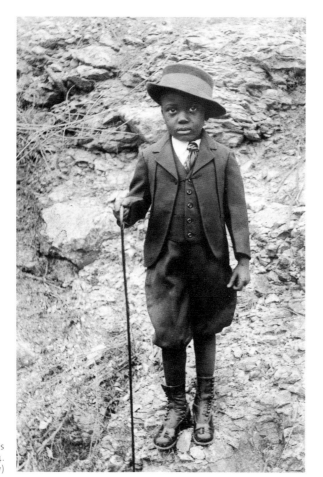

Edwin Collins
Boy with Hat and Cane, 1904.
(Houston Public Library)

out of the picture history or left in only at birthdays and Christmas. Families generally remained together at least for the length of an album.

Mythic they may have been, but snapshots also allowed people to take charge of their own images. If families depicted themselves unrealistically, that was how they wished to see themselves. Professional studios also specialized in ideal portraits, but homemade pictures were ongoing narratives and spelled out lives rather than particular moments. The power to create one's own image, however limited by inexpensive equipment and extravagant fantasies, must have been especially important to marginal groups like immigrants, African-Americans, and people on the edge of poverty, all of whom were most commonly represented by outsiders with cameras in their hands and stereotypes in their heads.

Even children could picture the world as they wished to see it instead of the way adults insisted it was. Well into this century, some educators guessed the camera might be an easy path to self-expression and self-confidence for the young. In the 1970s, a photographer named Wendy Ewald taught photography to Appalachian children; a surprising number made haunting and original images. Ewald and others continue to teach this simple and powerful magic to children who cannot afford it on their own.

From the beginning, snapshots were a quick and credible way to communicate to relatives back in the old country or across this ever-mobile nation: "Here we are in front of our home and I'm wearing my fur coat; see how well we're doing? Maybe you should come too." (Houses and possessions included in photographs are identifying marks for families, not just as signs of status but also as testimony to shared experience.) Recently video and the Internet have taken

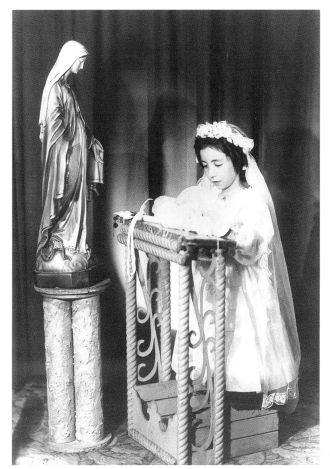

Photographer unknown
First Communion, Texas, 1904.
(Houston Public Library)

Birthdays, parties, holidays, an afternoon at the beach, a new car, a prize of any kind, a first prom dress, all seemed to necessitate photographs.

over some of the snapshot's function of communication, though the excitement of having a video camera doesn't seem to last long; eventually someone picks up a still camera again. Whatever kind of photography records the family, it fills in for porous human memory and in fact may substitute for it. Childhood memories frequently are not so much recalled as compounded of family tales, which may be apocryphal, and snapshots, which can always be reinterpreted.

The snapshot camera generated new behaviors, principally the photography session, where Dad or Mom lined everyone up and ordered them all to watch the birdie. Smiling for the camera became an obligation no matter how you felt at the moment, and people noted which one of their expressions looked best in snapshots and used it every time, one of the few new modes of self-definition through facial expression since the mass production of the mirror.

The Brownie and other inexpensive cameras changed the nature of family events, which now required photographic commemoration and added camera behavior to the tacit rules of event behavior. Birthdays, parties, holidays, an afternoon at the beach, a new car, a prize of any kind, a first prom dress, all seemed to necessitate photographs. Some landmarks, like first communion or weddings, were sufficiently solemn or special to call for a professional, which didn't rule out whole families snapping away.

Travel filled up with camera moments until vacations began to look like tours of photo sites. The experience of travel was subtly being transferred to pictures, which in a sense became the purpose of the trip as well as its commemoration. Travelers who ordinarily would not speak to strangers, much less go out of the way to meet them, cheerfully asked others to photograph them in front of

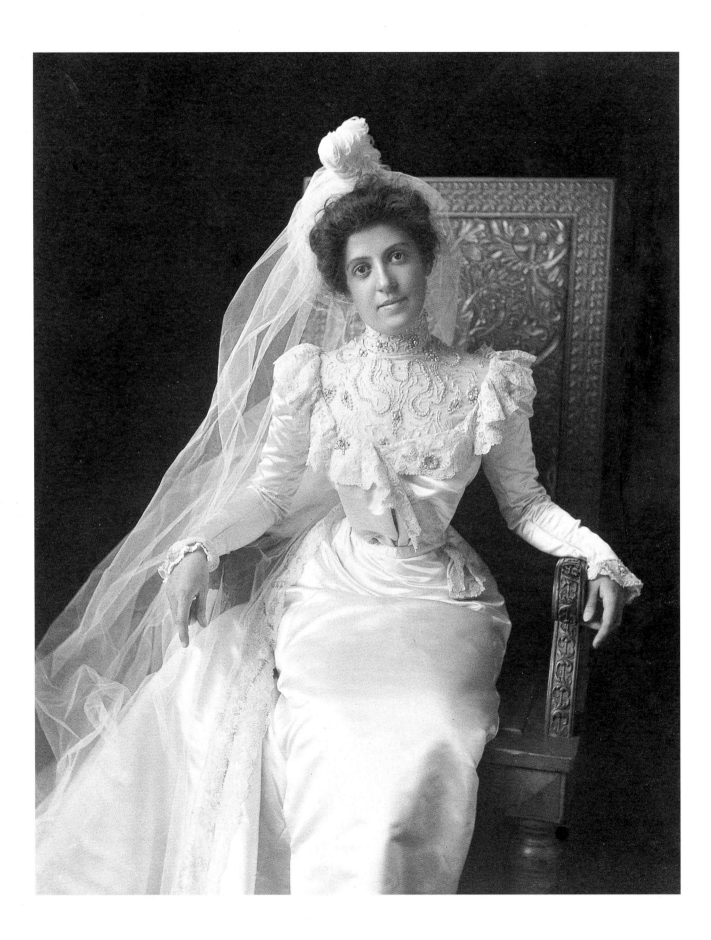

 1901 Photographer unknown
Wedding picture.
(George Eastman House)

Snapshooters generally tried to imitate the conventional styles of painted and photographed portraits, with full-length, frontally posed figures in the center of the frame.

the Eiffel Tower and photographed strangers on request. Today, one of the last vestiges of urban politeness is the detour that pedestrians make around tourists photographing their friends.

Well-born young women and some young men had long been tutored in drawing, but no matter how polite their educations, not all of them succeeded in making good copies of what they saw. Overnight, the snapshot camera turned even the fumble-fingered into a picture maker with a talent for likenesses. It is hard to think of another technology that has so generously and democratically bestowed such skill with so little training. Not that people became artists, for they did not, but the open secret was that few cared. Record and recognition were precious enough, well taken was better, artistic was like winning the lottery. So crucial is subject matter to photography that even inferior family pictures have the power to stop the heart, especially as time and life go by.

In fact, the snapshot forged a new aesthetic. The momentary became a commonplace, extraneous details that the eye usually discarded were now fixed for contemplation. And in the privacy of the home, both the designated photographer and the subjects of the pictures were permitted to be imperfect. The children might be sent to a studio for really good portraits, but these would then be pasted into the album next to the ones that showed them squinting into the sun, creating a mix of high and low, professional and vernacular that the public was comfortable with long before the art world was.

For a long while, snapshooters generally tried to imitate the conventional styles of painted and photographed portraits, with full-length, frontally posed figures in the center of the frame. Houses and monuments were similarly centered and groups arranged pyramidally as during the Renaissance. A respectful distance from the subject was maintained for years, with (sun)light at the photographer's back, since that's what the experts recommended. Distracting elements were shooed out of the picture.

But shadows and litter and dogs strayed in; people turned out unaccountably small and awkward, and shade played unanticipated dramas across their faces. Photography's unbounded greed for fact absorbed more of the environment than the photographer might have hoped for, and amateurs could not consistently override the camera's reluctance to flatter the world and its inhabitants. Many years would pass before the aesthetic that every American home found both acceptable and pleasing would be co-opted by artists, but during all those years a vast volunteer army of picture makers prided themselves on new identities as amateur photographers and a new responsibility: creating and conserving private history.

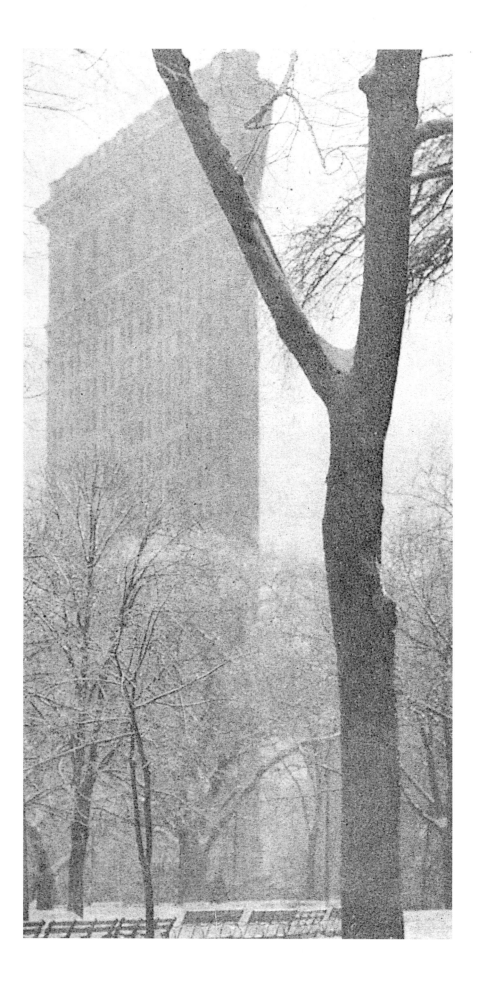

Alfred Stieglitz
The Flatiron Building, New York.

photography as fine art

FROM THE BEGINNING OF PHOTOGRAPHY, some saw the new medium as a path to art. Others, whether amateurs or professionals, had no such goal in mind. They wanted only to make a handsome portrait or record the new city hall in its pristine glory. If the photographs came out relatively clear, that was all that was expected. For most in the latter half of the nineteenth century, art never really entered the picture. Even those who considered photography an art generally thought it a lesser one.

Around the turn of the century, however, a group known as the Pictorialists sought recognition of photography as the equal of painting and sculpture among the traditional fine arts. Similar groups had already been active in Europe. In America, the movement was led by the indefatigable photographer, exhibition organizer, publisher, and gallery owner Alfred Stieglitz. Strong-willed and single-minded in pursuit of his vision for Pictorialist photography, Stieglitz organized a small, hand-picked group of photographers known as the Photo-Secession. In the first decade of the century, they played a key role in establishing photography as a fine art. Photography, Stieglitz wrote, should be regarded "not as the hand-maiden of art, but as a distinctive medium of individual expression."[1] If Stieglitz had his way—and eventually he did—photography would no longer be considered suitable only for commercial purposes or family snapshots. Photographs would no longer be exhibited at World's Fairs in the "industrial arts" sections, along with the products of other mechanical inventions, but would be accepted alongside painting and sculpture in the citadels of fine art: museums.

The efforts of Stieglitz and others led to photographs that were clearly meant to be seen as Art with a capital A. The Pictorialists frequently imitated the "isms" associated with nineteenth-century art—Impressionism, Post-Impressionism, Symbolism. Their preferred subjects were portraits, landscapes, and figure studies. There are Pictorialist photographs that look like Renaissance paintings, in which the photograph captures a carefully staged tableau. Even when the subject was contemporary, the pursuit of art meant depicting a world of refinement and elegance, qualities carried over into the foremost Pictorialist journal, Stieglitz's *Camera Work*, which featured elaborate printing and images hand-mounted on exquisite colored-paper backgrounds.

Since sharp focus suggested the use of photography as a scientific or at least mundane recording device, soft focus became the sign of poetic artistry and the pursuit of beauty. The photographers used techniques and materials to create surface effects that mimic brushwork. One of the most telling images of the period is a self-portrait made just after the turn of the century by Edward Steichen. Steichen is portrayed as a painter, palette and brush in hand. He was

Photography, Stieglitz wrote, should be regarded "not as the handmaiden of art, but as a distinctive medium of individual expression."

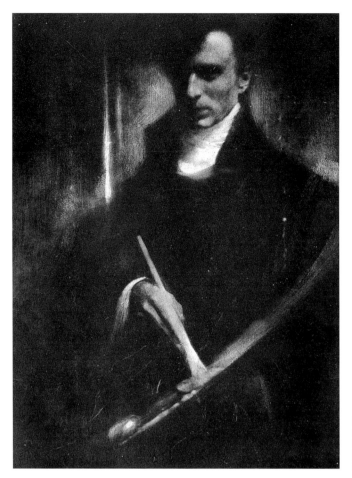

Edward Steichen
Self-Portrait with Brush and Palette, Paris, 1902.
(Los Angeles County Museum of Art)

forever swearing off painting and informing Stieglitz that he was dedicated to photography; here he embraces both. Sadakichi Hartmann, a contemporary critic, skewered Steichen with a parody of Hamlet's famous soliloquy: "To paint or to photograph—that is the question."[2]

Pictorialism suggests an imitation of traditional, essentially academic painting. Yet within this relatively narrow approach, technique reached a high level. Tonal subtlety was considered a sign of true photographic art, endowing Pictorialist images with a lovely range of carefully modulated grays. The Pictorialists placed a premium on technical virtuosity as a means of separating themselves from the casual amateur, and although a perusal of *Camera Work* reveals many old-fashioned images, their range remains considerable. Stieglitz and his collaborators were willing to try anything, from snapshotlike images of a racetrack to dreamy moonlit landscapes and still lifes of luscious roses. Stieglitz in particular seemed always to be trying to pull off some bravura feat, like making a picture in the midst of a snowstorm. Above all, Pictorialism makes clear the excitement engendered among photographers who sensed the limitless possibilities open to those willing to master photography as a medium of self-expression. And exclusive as it was, the Photo-Secession included many accomplished women, such as Gertrude Käsebier and Anne Brigman. Their work often suggests a feminist outlook, whether in images of mothers and daughters or in daring nude self-portraits.

A dramatic turning point in the early history of photography as a self-proclaimed fine art in America came with the final two issues of *Camera Work* in 1916 and 1917, dedicated to the work of a young photographer, Paul Strand.

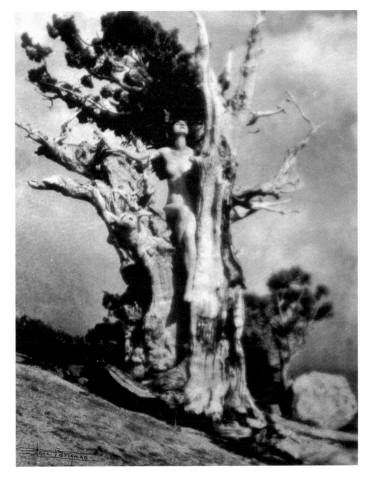

Anne W. Brigman
Invictus, ca. 1907–11.
(George Eastman House)

Although others were moving in a similar direction, Strand forcefully cleared away the fog and heavy atmosphere borrowed from Whistler and Olde England and presented a new approach. Stieglitz rightly described Strand's work as having a spirit of "brutal directness." He went on to say that the photos were "devoid of all flim-flam; devoid of trickery and of any 'ism' . . . These photographs are the direct expression of today."[3] For a brief period, Strand's work emphasized the formal experiments of newer movements in art, specifically Cubism and abstraction. He consciously attempted to see if what the European moderns were doing in painting and sculpture could be transferred to photography. He experimented with close-up still lifes and shots of a porch railing that emphasized abstract formal patterns, and composed longer shots that compressed or fragmented space in the manner of the Cubists. When he went out onto the streets of Manhattan, Strand approached the city in a hard, unflinching fashion, as evidenced in his portraits of individual men and women. These subjects were a long way from the middle-class women and children at leisure who had appeared in Pictorialist images playing ring toss or picking fruit in an orchard. They were gritty, even grotesque—unshaven, overweight, wrinkled—but Strand undoubtedly saw a kind of beauty in such subjects if addressed truthfully.

Later Strand photographed the inside of his own movie camera—he supported himself partly through newsreel work—as if to say that machine forms were at least as beautiful as roses. Soon photographers discovered that a skyscraper or factory could be as beautiful as a cathedral. The modern age created modern forms, and the camera could capture them with a clarity and directness that painting could not match.

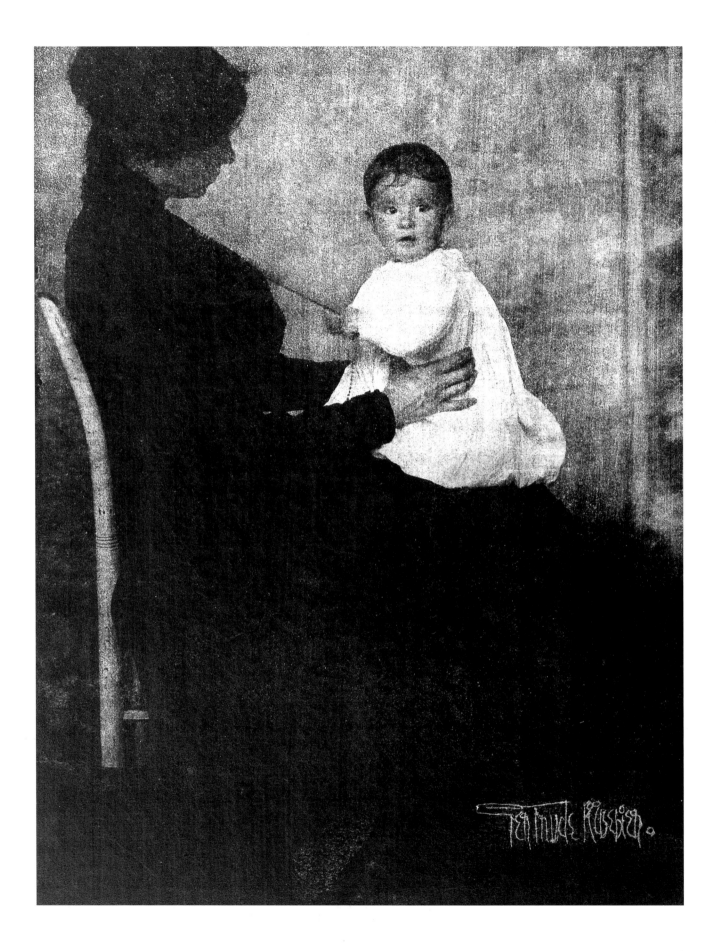

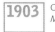 Gertrude Käsebier
Mrs. Ward and Baby.

Strand claimed that photography was "the first and only important contribution thus far, of science to the arts."

In an assertive, polemical 1917 essay, Strand claimed that photography was "the first and only important contribution thus far, of science to the arts."[4] Photography, he said, possessed "an absolute unqualified objectivity."[5] We may think we know better now; for Strand, such assumed objectivity made photography the preeminent art form for the modern age if used correctly, which did not include copying Old Masters, academic painting, or even Impressionism. Strand and the photography he represented proved enormously important for later photographers and those of his generation, who underwent a kind of aesthetic conversion. One after another they abandoned their soft-focus lenses and destroyed their early Pictorialist work in pursuit of sharp focus and subjects that had little to do with the moody twilight world of late-nineteenth-century art.

By 1923, Steichen was proclaiming the soft-focus lens "the most pernicious influence in the pictorial world."[6] He went on to say, "I don't care about making photography an art. I want to make good photographs. I'd like to know who first got it into his head that dreaminess and mist is art." Whoever it was, Strand helped to change such notions. Of course, a soft, painterly look continued to be favored by some photographers well into the 1950s. Even today, the techniques of Pictorialism form part of the vocabulary of many experienced photographers. But after the heyday of Pictorialism, the dominant aesthetic for photographers aspiring to artistic status was a sharp-focused and unmanipulated "straight" photography, among whose best-known advocates were Edward Weston and Ansel Adams. Steichen, Stieglitz, and other photographers affiliated with the Pictorialist movement soon shifted to the new way of seeing. Stieglitz himself came to regard Pictorialist photography as old-fashioned, and in 1933 gave his enormous collection of images to New York's Metropolitan Museum of Art, which had earlier been less than enthusiastic about the acquisition but now accepted it gladly.

 Photographer unknown
Augustine Lozno, Ventura County, California.
(Shades of L.A. Archives/Los Angeles Public Library)

The Circulation of THE MILWAUKEE JOURNAL was 40,880

THE MILWAUKEE JOURNAL. EXTRA

Proved by the Association of American Advertisers and the Milwaukee Merchants' Investigation to Have a Larger City and Total Circulation Than Any Other Wisconsin Daily Newspaper.

TWENTY-THIRD YEAR.　　　MILWAUKEE, WIS., MONDAY, MAY 29, 1905.　　　MARKET EDITION.

RUSS SHIPS ALL SUNK, CAPTURED OR IN FLIGHT

FIVE IRONCLADS ARE SUNK

TWO BATTLESHIPS AND THREE ARMORED CRUISERS BLOWN TO PIECES IN THE STRAITS OF COREA.

RUSSIAN FLEET IS SHATTERED

TWO BATTLESHIPS AND TWO COAST DEFENSE SHIPS CAPTURED AND WILL BE ADDED TO THE MIKADO'S NAVY.

RUNNING FIGHT ON WITH THE SURVIVING SHIPS

TOKIO, May 29.—It is officially announced here that Rojestvensky's fleet has been practically annihilated. In the battle fought Saturday in the straits of Corea, the Russian battleships Borodino and Alexander III, the armored cruisers Admiral Nakahimoff, Dmitri Donskoi and Vladimir Monomach; the coast defense ironclad Admiral Oushakoff, the protected cruisers Sviatlana and Jemtchug, the repair ship Kamtchatka and the cruiser Irtessin were sunk.

The battleship Orel and Nicolai I and the coast defense ironclads Admiral Seniavin and Gen. Admiral Apraxine were captured.

Eight captains of Russian war vessels were drowned Saturday in the battle in the straits of Corea.

WASHINGTON.—An official telegram from Tokio states that Admiral Togo reports to his government that the total losses sustained by the Russian fleet Saturday and Sunday were:

Two battleships, one coast defense armor-clad, five cruisers, two special service ships and three destroyers—all sunk.

In addition, there were captured two battleships, two coast defense armor-clads, one special service ship, one destroyer and over 2,000 prisoners.

Admiral Togo adds that the Japanese squadron was undamaged.

WASHINGTON, May 29.—A cablegram received from American Minister Griscom, at Tokio, dated this morning, says that Admiral Togo is claiming a great victory. It says that Admiral Togo reports that the result of the fighting of the fleets Saturday afternoon and evening were one battleship of the Borodino class sunk, and four other large vessels sunk, and two or three more vessels captured. All the large vessels of the Japanese fleet escaped injury.

The Japanese losses so far are stated to be one cruiser and ten torpedo boats.

Rear Admiral Nebogatoff, with 3,000 other Russians, is among the prisoners captured by the Japanese.

Vice Admiral Rojestvensky appears to have escaped.

The battle began Saturday morning and the Japanese are still in pursuit of the Russians.

WASHINGTON, May 29.—Admiral Togo has won a victory of colossal magnitude.

Mr. Takahira, the Japanese minister here, has received a cable message from his government relative to the naval engagement of Saturday and Sunday, which, he said, while lacking in detail, conveyed the information that the Japanese victory had been "absolute and overwhelming."

The damage Togo has sustained is not known. The Japanese have not permitted any information concerning their losses to leak out, nor have they communicated it to any of the diplomatic representatives of foreign powers in Tokio.

What the losses sustained by the personnel total cannot be ascertained. It is believed, however, that the Russians have lost at least 2,600 killed, wounded and drowned. One of their cruisers, the Admiral Nakahimoff, it is believed, was blown up and the 600 souls aboard were either killed or drowned.

The daring of the Japanese is shown by the fact that one of the Russian warships was boarded and captured, though it afterward sank.

Altogether the battle must have been one of the most thrilling of any age.

There does not appear to have been any hesitancy on the part of the Japanese. They rushed at their foe with the same fanatical bravery their troops have shown in Manchuria, and the Russians, who they had opposed in brave desperation, from all accounts do not appear to have been overwhelmed.

(Concluded on Tenth Page.)

JAPANESE VICTORY FORCES UP STOCKS

New York Market Buoyant Because of Effect on Jap. Government Issues.

NO DEMAND IS CREATED

NEW YORK, May 29.—Stocks had a buoyant opening today in sympathetic response to the London market. The...

RUSSIAN SHIPS SUNK OR CAPTURED

BATTLESHIPS SUNK.

BORODINO—13,500 tons four 12-inch guns and twelve 6-inch guns; 740 officers and men. Commanded by Capt. Serebyennikoff.
ALEXANDER III, sister ship to the Borodino—Same armament and complement of officers and men.
ADMIRAL OUSHAKOFF—Old coast defense ironclad; 4,648 tons; four 9-inch guns and four 6-inch guns; 318 officers and men.

ARMORED CRUISERS SUNK.

DMITRI DONSKOI—Armored, 8,200 tons displacement, carried six 6-inch guns, ten 4.7-inch guns. Crew consisted of 510 men.
ADMIRAL NAKHIMOFF—Armored, 8,524 tons displacement, carried eight 8-inch guns, ten 6-inch guns; 318 officers and men.
VLADIMIR MONOMAKH—Armored, 5,593 tons displacement, carried five 6-inch guns, twelve 6-inch guns. Crew consisted of 550 men.

BATTLESHIPS CAPTURED.

OREL—Sister ship to Borodino and Alexander III.
NICOLAI I—9,672 tons. Two 12-inch guns, four 9-inch guns and eight 6-inch guns; 600 officers and men.
GENERAL ADMIRAL APRAXINE—Coast defense ironclad; new; 4,126 tons; three 10-inch guns and four 6-inch guns; 318 officers and men.
ADMIRAL SENIAVIN—Coast defense ironclad; 4,792 tons. Four 9-inch guns and four 6-inch guns; 318 officers and men.

OTHER CASUALTIES.

In addition, the protected cruisers SVIATLAND and JEMTCHUG, the repair ship KAMTCHATKA and the auxiliary cruiser IRTESSIN were sunk.
It is reported that Admiral Rojestvensky's flagship, the KNIAZ SOURAROFF, was badly damaged.

The most serious loss to the Japanese fleet which has been reported is the sinking of a protected cruiser and ten torpedo boats. Admiral Togo, however, reports that his fleet was not damaged. It probably remains virtually intact and serviceable.

JUST WHAT JAPAN HAS DONE

A study of the day's dispatches from the far east shows how thoroughly Admiral Togo has crushed the Russian armada.

Only one first-class battleship, the Kniaz Souvaroff, which is Admiral Rojestvensky's flagship, has thus far escaped destruction or capture. Two of her sister ships, the Borodino and Alexander III, have been sunk. Another sister ship, the Orel, will soon be flying the flag of the Rising Sun.

The only three armored cruisers in the squadron lie at the bottom of the seas. One coast defense ironclad, the Admiral Oushakoff, keeps them company, while the two other coast defense ironclads in the squadron are prizes of war.

Three old battleships, the Oslabia, the Sissoi Veliki and the Navarin, have escaped thus far. Several other warships, protected cruisers and other craft, have been sunk or captured.

It is hardly possible that any of the coast's surviving ships will escape. Togo's great fleet, itself substantially uninjured, is in full chase after the Russian warships that remain afloat. The Japanese ships are fleeter and in better condition and it is hard to see how any of the remnants of the Russian fleet can escape.

Even if the ships that are not known to be sunk or captured should escape and form a juncture with the two armored cruisers, the Gromboi and Rossia, which have been making their rendezvous at Vladivostok, the Russians are so weakened, their strength on the sea so shattered, that they could not possibly face Admiral Togo's victorious fleet with any prospect even of inflicting serious damage upon it.

It is simply a question now of whether the remaining Russian ships will be destroyed in detail or collectively.

PLEADS GUILTY TO MANSLAUGHTER AND IS GIVEN TEN YEARS IN PRISON

ARTHUR H. MILLIGAN SPRINGS SURPRISE WHEN ARRAIGNED IN COURT, CHARGED WITH COMPLICITY IN DEATH OF HIS SWEETHEART.

HE SHOOTS GIRL; SHE BEGS RELEASE

Chorus Girl Pleads for the Release of Lover Who Shot Her.

WRITES FROM HOSPITAL

PHILADELPHIA, May 29.—Bessie Helen Davis, the chorus girl who was shot by Edward Snodee, a member of the same theatrical company, appeared at the Central police station to plead for her assailant's liberty.

Several days ago the chorus girl wrote a letter from the hospital to Capt. of Detectives Donaghy, begging him to release her in securing Snodee' freedom. She said she intended to withdraw all charges against her sweetheart, because, she said, "He did not mean to hurt me."

Many See Wonderland.

The crowd that attended the opening of Wonderland Saturday afternoon and evening is estimated at 7,800, while at the Sunday opening, in spite of the threatening weather, it is said to have reached 18,000 in round figures.

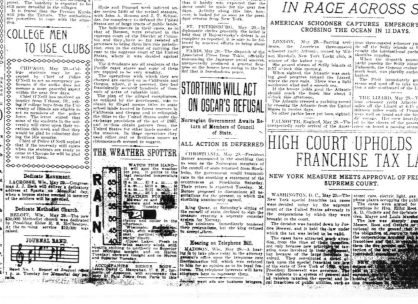

A. H. MILLIGAN.

Florence Grove. In accordance with a rule laid that the girl made four desperate attempts to take her life by drinking poison on the morning of Jan. 22 and on the morning of Jan. 23. After her death, Milligan, who had procured the poison, fled from Milwaukee, and was later arrested at Racine.

With the consent of the district attorney, Arthur H. Milligan pleaded guilty to manslaughter in the first degree in municipal court Monday morning, and was sentenced to ten years at Waupun. The extreme penalty allowed under the statute.

Milligan, a confessed embezzler and forger, has been in the county jail since Jan. 23, waiting trial on the charge of murder in the first degree.

On Jan. 16 he came to Milwaukee from Chicago, Ill., accompanied by Miss

"Milligan, stand up," said Judge Brazee to the defendant, after statement.
(Concluded on Third Page.)

ROTHSCHILD LAID AWAY

Relatives of Deceased Banker Give $10,000 to the Poor.

PARIS, May 29.—The funeral of Baron Alphonse de Rothschild, head of the French branch of the banking house bearing the name of Rothschild and governor of the Bank of France, was held at the house in Rue Laffitte, where he was born.

The government was represented at the services by Premier Rouvier, Foreign Minister Delcasse and other ministers. There were no flowers and no decorations. The grand rabbi conducted the services and the interment was in the Pere Lachaise cemetery. The family distributed $10,000 among the poor in accordance with the wishes of the deceased.

STREETS FILLED WITH BUTCHERED

Armenians in Transcaucasia Are Being Slaughtered by the Tartar Population.

ONE HUNDRED ARE DEAD

NAKHICHEVAN, Transcaucasia, May 29.—This government has been informed in a state of anarchy for days.

A massacre of Armenians by the Tartar population is proceeding here and in the surrounding villages.

The streets are filled with dead and wounded.

Chief of the alleged complicity, pillage and loot has the houses of Christians.

The number of victims is not established, but exceeds 100 dead, including a priest. The butchery is reported to be still more dreadful in the villages.

It is feared that the Persian Kurds will join the Tartars in their work. The authorities are powerless to cope with the situation.

COLLEGE MEN TO USE CLUBS

CHICAGO, May 29.—College students may be accepted by Chief of Police O'Neill to act as special policemen if the strike does not assume a more peaceful aspect within the next few days.

Chief O'Neill has received an inquiry from Urbana, Ill., asking if college boys from the University of Illinois are willing to act as policemen if the strike becomes serious. The letter stated that some of the students in the university will enter upon their vacations this week and that they would be glad to volunteer during the idle months.

Chief of Police O'Neill replied that if the necessity still exists when the students are ready to come to Chicago he will be glad to accept them.

MUST COME EAST TO STAND TRIAL

Westerners Compelled by Supreme Court to Appear in District of Columbia.

LAND FRAUD IS CHARGED

WASHINGTON, May 29.—In the cases of Frederick A. Hyde and Henry P. Dimond, charged with complicity in western land frauds, the supreme court of the United States has affirmed the decision of the circuit court for the northern district of California.

That decision directed the removal of the two men to the District of Columbia for trial and denied the petition for a writ of habeas corpus.

Justice Brown delivered the opinion.

Hyde and Dimond were indicted under section 5440 of the revised statutes, with John A. Benson and J. T. Schneider, the conspiracy to defraud the United States out of large tracts of public lands.

The indictments in their cases, as charged are carried on in California and Oregon, where it is contended that the fraudulently secured hundreds of thousands of acres of valuable land.

The plan of the alleged conspirators, as outlined by the government, was to obtain by illegal means titles to state school lands located in forest reserves in California and Oregon and to relinquish the titles to the United States under the exchange provisions of the act of 1897, and to then obtain patents from the United States for other lands outside of the reserves. In these operations they used either coal or fictitious names as circumstances seemed to suggest.

THE WEATHER SPOTTER

DIPLOMATS LOOK FOR EARLY PEACE

Washington Officials Await Developments Which Will Follow Effect of Battle.

RUSSIA IS NOW SUBDUED

WASHINGTON, May 29.—At the close of the official day the news of Japan's naval victory had turned the thoughts of the officials toward peace, and prominent diplomats are holding their counsel pending the absence and awaiting developments and instructions from their governments.

Thus far it has been impossible to ascertain if any direct steps in the direction of peace have yet been taken.

A European ambassador remarked that it hardly was expected that the move could be made for the next few days. Activity along this line, however, is looked for as soon as the president returns from New York.

PARIS, May 29.—The dispatch of the Associated Press from Tokio, officially announcing the Japanese naval success, unexpectedly produced a general firmness on the bourse here owing to the belief that it foreshadows peace.

SENDS $60,000 TO AN ACTRESS

LONDON, May 29.—Counsel for the plaintiff in the case of Alfred Fossick, a lawyer of Maidenhead, Berkshire, charged with misappropriating $60,000 just to a sichpound in court alleging that Fossick told him he lent the money to Mrs. James Brown Potter, the American, without security. The defendant was remanded.

NOT TO ACT TOGETHER.—Paper manufacturers of Appleton have decided not to act together in raising down their mills to curtail the product. Most of the mills are oversticked with paper.

BRITISH SHIP WAS SUNK

Russians Did Not Destroy American Merchantman, as Reported.

WASHINGTON, May 29.—Minister Griscom has cabled the state department from Tokio that the ship supposed to be American, which was sunk off the coast of Formosa May 20 by the Russian fleet, was a British vessel, according to a report made to him by the Japanese government.

ATLANTIC IS FIRST IN RACE ACROSS SEA

AMERICAN SCHOONER CAPTURES EMPEROR'S CUP, CROSSING THE OCEAN IN 12 DAYS.

LONDON, May 29.—Barring accidents, the American three-masted schooner yacht Atlantic, owned by Wilson Marshall's New York Yacht club, is winner of the kaiser cup.

She passed ahead of Scilly Islands at 5:57 o'clock this morning.

When sighted, the Atlantic was making good progress toward the Lizard, where the crew ends. There was a fight northwest wind and a smooth sea.

If the breeze holds good the Atlantic should reach the finish line about 3 o'clock this afternoon.

The Atlantic created a yachting record from Tokio that the ship supposed by crossing the Atlantic from the United States in twelve days.

No other yacht has yet been sighted.

FALMOUTH, England, May 29.—The unexpectedly early arrival of the American...

STORTHING WILL ACT ON OSCAR'S REFUSAL

Norwegian Government Awaits Return of Members of Council of State.

ALL ACTION IS DEFERRED

CHRISTIANIA, May 29.—President Berner announced in the storthing that as soon as the Norwegian members of the council of state returned from Stockholm, the government would communicate to the storthing a statement of the occurrences at Stockholm Saturday. Their return is expected Tuesday. The minister proposed to discontinue all negotiations for the present, to which the storthing unanimously agreed.

King Oscar, at Saturday's sitting of the council of state, declined to sign the measure creating a separate consular system for Norway.

HIGH COURT UPHOLDS FRANCHISE TAX LAW

NEW YORK MEASURE MEETS APPROVAL OF FEDERAL SUPREME COURT.

WASHINGTON, D. C., May 29.—The New York special franchise tax cases were decided today by the supreme court of the United States adversely to the corporations by which they were brought to the court.

The decision was handed down by Justice Brewer, and it held the law under which the tax was levied to be valid.

The cases have attracted much attention, from the time of their inception, not only because new principles of taxation were involved in their provisions, but because of the large interests involved.

The law was sharply assailed by Messrs. Root and Guthrie as unconstitutional on the ground that the obligation to pay...

A PREDICTION COMES TRUE

NEW YORK, May 29.—"The Russian and Japanese fleets will meet in a few days. Japan will win. The slaughter of men in that battle will be so great as to startle the civilized world. The only redeeming feature of the fight will be the fact that there will be no more wars for years.

"The Nororss will be too great. Japan's defeat, however, would not mean England's defeat, as many suppose. Japan was forced into this war, and has something more than the grabbing of territory to fight for."

Vice Admiral Lord Charles Beresford of the British navy made this statement here May 10, just before his departure for Liverpool on the Oceanic. The admiral, who had spent several days on the battleship Missouri off Pensacola with Rear Admiral Evans, said he did not think the Missouri has an equal in the world.

"The reason I think Japan will win in the coming fight," continued the admiral, "is that she is the greater gunner of the two. There is nothing in numerical strength."

Silk Thieves in Janesville.

JANESVILLE, Wis., May 29.—Two men answering the description of Jack Hess and Bloomington Breed, famous silk thieves, were in this city the day after the Beloit silk robbery. It is thought they escaped to Peoria, Ill., by river.

1906 Edward Curtis
Upshaw—Apsaroke—in Headdress.
(Smithsonian Institution)

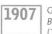 George H. Seeley
Blotches of Sunlight and Spots of Ink.
(The Royal Photographic Society, Bath)

foreign peoples, foreign places

One of photography's great gifts has always been to make possible many kinds of vicarious experience. Photographs enabled people to travel imaginatively to foreign places and encounter foreign peoples without ever leaving home. In a country as large and diverse as the United States, photography also offered a way to see people from other regions whose backgrounds may have been "foreign" or "other" than the viewer's.

Throughout the twentieth century, the best-known window onto the rest of the world for millions across the country has been *National Geographic* magazine. Since its inception as the official magazine of the National Geographic Society, the magazine has taken "geography" to mean far more than maps. In the words of one of its founders, the magazine's domain was nothing less than "the world and all that is in it."[1] With that broad charge, the magazine has consistently published images to thrill the armchair traveler, giving every would-be Indiana Jones a convincing sense of having seen Peary and his companions at the North Pole in 1909 or witnessed the 1911 (re)discovery of the Inca ruins of Machu Picchu, a site high in the Peruvian Andes unknown to the outside world for centuries.

National Geographic began using photographs in the 1890s. By 1908, after the publishers discovered how dramatically photographs boosted sales, photographic images filled more than half of the magazine. Along with wildlife and landscape photographs and conventional pictures of markets and native architecture, *National Geographic* also published images of bare-breasted

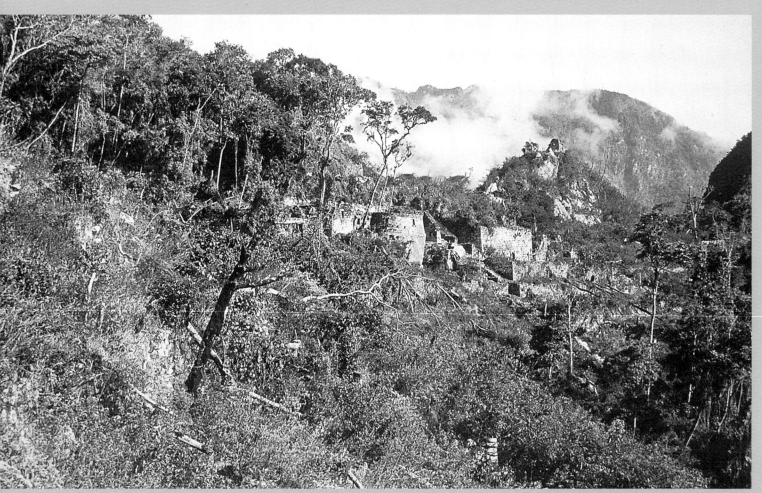

Hiram Bingham
Machu Picchu after ten days of clearing, 1911.
(Yale Peabody Museum/NGS Image Collection)

National Geographic magazine:
"The world and all that is in it."

women that notoriously sparked a prurient fascination in generations of curious young boys—not to mention older men. The rationale was apparently that prudery should not prevent accuracy in the presentation of other cultures. Such a sober explanation does little to diminish the possibility that the magazine at times provided casually erotic images under the guise of anthropology and education. Such photographs suggested that outside the United States or Western Europe or the sphere of influence of white Christian culture and modern civilization was a world of exotic cultures, "primitive" lands suitable for exploration and adventure and defined by their otherness. The religions were unusual, the food and clothing and forms of housing were unfamiliar, the wildlife and even the domesticated animals were frequently out of

the ordinary, and, above all, the people looked different. Under the guise of genial curiosity, a kind of pictorial imperialism was often at work, with the impulse to catalogue other cultures built on a shaky foundation of pseudo-science.

With the passage of time, the presuppositions and unfortunate beliefs about other peoples underlying early captions in *National Geographic* no longer appear as lighthearted or innocent as they might once have seemed. "Bali has no blondes," proclaims the caption for a 1928 group portrait of bare-breasted Balinese girls.

Ethnographers and journalists working abroad weren't the only photographers who made images of foreign peoples as "documents." Others did so right at home. At Ellis Island, Augustus Sherman photographed

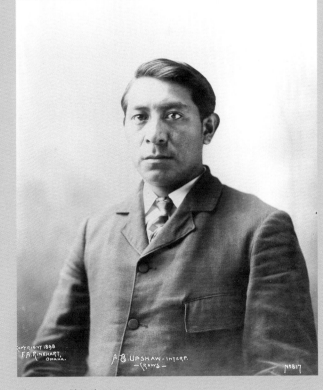

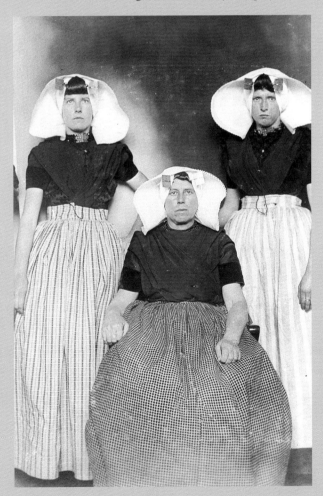

Above: F. A. Rhinehart
A. B. Upshaw, Interpreter, 1898.
(Smithsonian Institution)

Right: Augustus Sherman
Untitled (three Dutch women at Ellis Island), ca. 1910.
(Courtesy of the Ellis Island Immigration Museum)

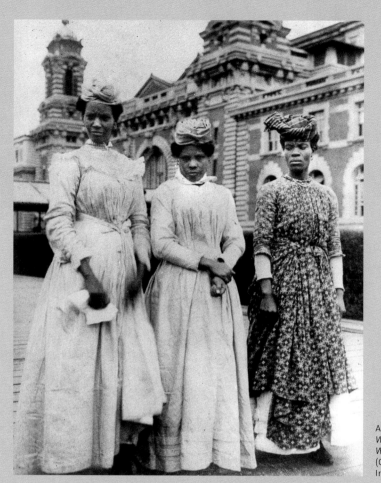

Augustus Sherman
*Women from Guadeloupe, French
West Indies, at Ellis Island*, 1911.
(Courtesy of the Ellis Island
Immigration Museum)

children from other countries in the initial stages of being transformed into young Americans. He showed foreigners on the edge of citizenship in their native finery, with a directness that gives them stature and a kind of respect. We do not know what purpose the photographs

Racial stereotyping did not of course originate with photography, but photography has proven to be an unusually powerful instrument for reinforcing and propagating racial (and racist) imagery.

served or were intended to serve, for they were not published. But they suggest the way in which photography as a cataloguing and institutional record-making device can underscore race and ethnicity and nationality and fortify an accepted sense of order in the world based on visual characteristics—in this case, costume, physiognomic features, and skin color.

The portrayal of ethnic minorities in the United States has with few exceptions always been problematic, an exercise in stereotypes even when undertaken with the best intentions. In San Francisco shortly after the turn of the century, Arnold Genthe made a series of photographs of Chinatown.[2] An outsider, he could take pictures only with a "Detective" hand camera, blending into the background as best he could and catching his

subjects unawares. ("Stolen" pictures recur in the history of the medium. Paul Strand's early photographs of New York City streets were shot with a camera that had a fake lens mounted on one side, enabling him to look one way and shoot another.)

There have always been photographers in the various ethnic and racial communities who ran photo studios, as James Van Der Zee did in Harlem, and took photographs for newspapers targeted at their own communities or documented family, friends, and neighbors as a hobby. These people took pictures of the ordinary and extraordinary that went on around them every day. Van Der Zee often showed his clientele as prosperous and attractive. Outsiders looked for traditions or specific events that struck them as different—or worse. In the South and elsewhere, racist postcards depicting African-Americans in demeaning, stereotyped poses were often sold commercially.

Racial stereotyping did not of course originate with photography, but photography has proven to be an unusually powerful instrument for reinforcing and propagating racial (and racist) imagery. This is perhaps most evident in photographs of Native Americans. The imagery of Edward Curtis, who between 1890 and 1927 took some 50,000 photographs of Native Americans across the continent, continues to inform popular notions of Native peoples. Early in the century, Native Americans seldom

Photographer unknown
Seven little Indian children in four stages of civilization, ca. 1900. (The Photography Collection, Carpenter Center for the Visual Arts at Harvard University)

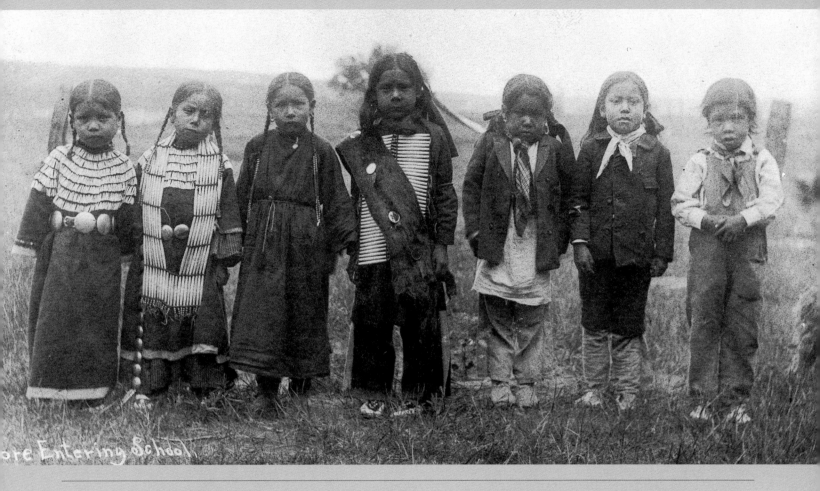

ore Entering School

took their own pictures, and their contemporary descendants, seeking models, have often incorporated Curtis's photographs into their art and cultural imagery.

Some of Curtis's work can be described as relatively straightforward portraiture, but his best-known images suggest a Pictorialist costume drama that depicts the white man's imaginative vision of the Native world. Like the filmmaker and sometime photographer Robert Flaherty, director of *Nanook of the North*, Curtis was well intentioned and knew that he was not photographing contemporary reality. But his images of what he called "The Vanishing Race" employ a kind of theatrical re-creation that keeps alive a nostalgic, mythical image of a pan-tribal Native culture.[3] Certain of the photographs offer a more authentic vision of Native life, but Curtis was not beyond ignoring the differences between Native

There have been many photographers of Native American life, but until recently the overwhelming majority have been non-Indians.

groups, or the distance between past and present. He kept Indian clothing on hand and sometimes dressed up his subjects with total disregard for the actual clothing worn by their tribe. There have been many photographers

of Native American life, but until recently the overwhelming majority have been non-Indians.

Today, *National Geographic* and other publications are more careful about their uses of photography, but the medium continues to play a significant role in shaping attitudes toward foreignness at home and abroad. Images of new immigrants, minority populations, religious subcultures, or political fringe groups are still inevitably caught up in the question of whether or not a particular presentation is fair—neither reinforcing negative stereotypes nor overly idealizing the "other."

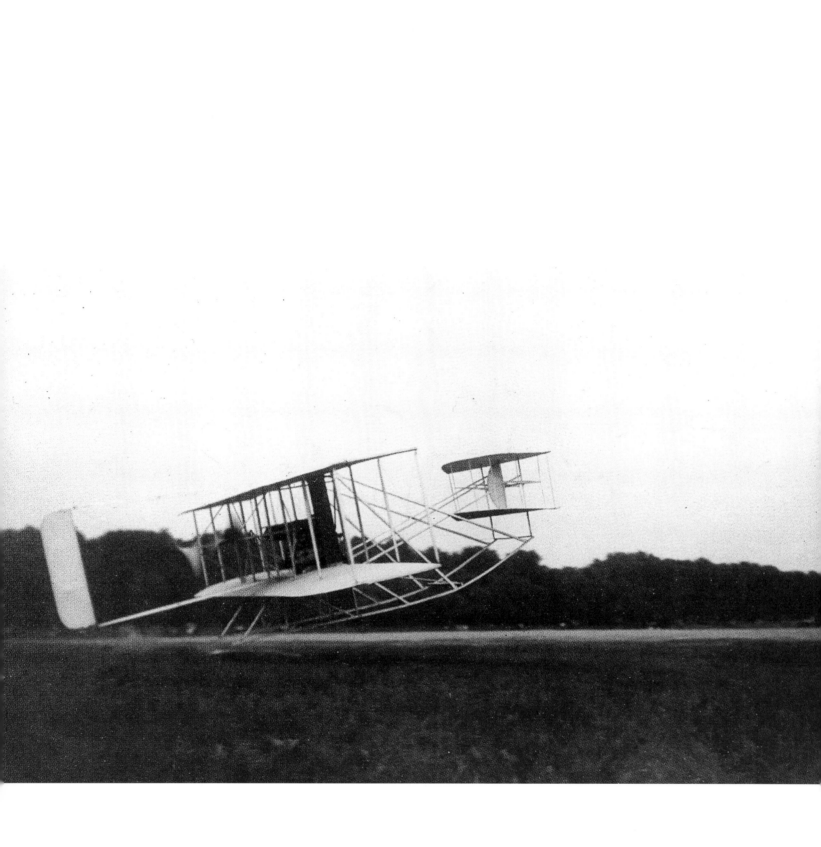

 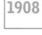

Augustus Sherman
Children's playground, Ellis Island roof garden.
(Courtesy of the Ellis Island Immigration Museum)

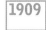

1909

1910 Photographer unknown
Halley's Comet, May 29, 1910.
(Courtesy of Yerkes Observatory)

extending vision:
science and photography

THE CAMERA WAS HARNESSED TO SCIENCE even before photography was officially invented in 1839: Around 1837, the photographic pioneer William Henry Fox Talbot, who would not reveal his process to the world for two more years, took microphotographs with the aid of a solar microscope.[1]

Daguerre himself supposedly made an imperfect picture of the moon;[2] American daguerreotypes of it in the 1840s were more successful. Medical photography without microscopes or other special attachments began as early as 1852, and during the American Civil War an extensive photographic record was made of post-operative wounded soldiers.

Such photographs, which far surpassed engravings for accuracy and after several decades began to replace them, stand at the beginning of the immense archive of photographic records compiled by the sciences in the nineteenth century (much as photographic archives were simultaneously compiled by branches of the humanities and by governments).[3] Photography was easier, quicker, more reliable, more exact, and less subject to human error and interpretative distortion than other means of graphic reproduction. As the nineteenth century progressed, the medium slowly but surely changed science, contributing not only accurate data but also new information and unanticipated discoveries.

Photographs of the great comet of 1882 showed the stars in the background so clearly that the first catalogue of stellar positions based on photographic measurements was begun in 1885.

Photographs of the great comet of 1882 showed the stars in the background so clearly that the first catalogue of stellar positions based on photographic measurements was begun in 1885. Shock waves were photographed in 1888, the first asteroid was found photographically in 1891, and the first photograph of Halley's comet was taken in 1910. (The comet had last been observed in 1835, too early for photographs.)

The first photographs of the interior of the human body were taken of the stomach in 1890,[4] and the X ray, discovered late in 1895, became known around the world almost instantly because the recently invented halftone made it possible to reproduce X-ray photographs in newspapers.[5] Photography radically changed our sense of our own bodies and their boundaries, revealing what was hidden inside, revealing the skeleton before we died.

It changed our idea of the universe too. In the first year of the new century, the American astronomer James Edward Keeler discovered the spiral character of several nebulae from photographic evidence.[6] In 1919, scientists photographed the solar eclipse in order to test Einstein's theory of general relativity, published in 1915. The images demonstrated that gravity did indeed deflect light in the neighborhood of the sun by almost exactly the amount that Einstein had predicted, confirming his theory and making a major contribution to physics.[7]

In 1919, scientists photographed the solar eclipse in order to test Einstein's theory of general relativity, published in 1915.

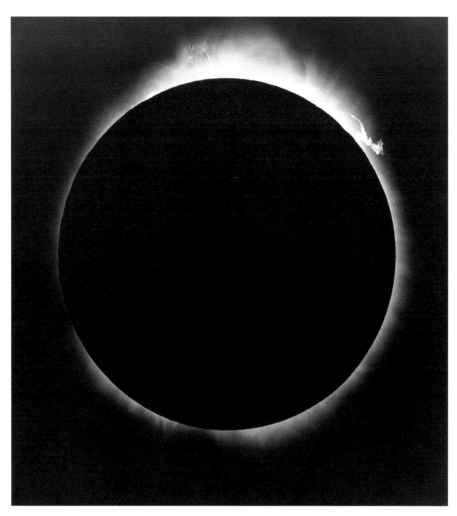

Lewis P. Tabor
Solar Eclipse, 1925.
(Courtesy of the Hallmark
Photographic Collection)

Photography generously handed out prizes. In this century it has played a major and often indispensable role in particle physics, astronomy, microbiology, crystallography, and some aspects of medicine, as well as making important contributions to many other branches of science like anthropology and entomology. Film is cheap and its uses many: Though millions and probably billions of snapshots routinely click out of cameras every year, technical and other non-amateur photographs, many of them scientific, outnumber amateur photographs both in quantity and in commercial significance.[8] In a single evening, shutters opening automatically in particle accelerators, astronomical observatories, and satellite surveyors can register photographs running into the thousands.

Techniques and instruments that "see" beyond human vision make photography immensely useful to science. The first X-ray diffraction pattern was produced in 1912, leading to a revolution in crystallography. The first electron micrographs of a biological specimen were taken in 1934, the first photographs of a fetus in vivo in 1965, the first photographs of a single atom, using a scanning transmission electron microscope, in 1970.[9] In 1952, an X-ray diffraction photograph of DNA taken by Rosalind Franklin in England but not properly interpreted by her gave James Watson and Francis Crick the final proof that their hypothesis was right: DNA was arranged in a double helix. Here a photograph converted a mental model from speculation to fact.

Mechanically operated cameras have made major breakthroughs that would not have been possible with human vision alone. In 1932, Carl David Anderson, using a camera set on a timer, discovered antimatter at the California Institute of Technology. Twenty-seven years old, he roiled and forever changed

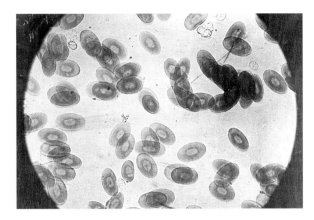

Leon Foucault
Blood cells of a frog, 1843.
(The Kodak Museum)

the world of physics. Anderson was studying the solar rays that haphazardly passed through a cloud chamber in their continual bombardment of earth. When rays pass through the supersaturated steam in such a chamber, vapor condenses on them, creating a trail that can be photographed. Anderson's photographs showed a particle that had the positive charge of a proton and the mass of a negatively charged electron.

Scientists doubted his report at first, but the photographic evidence was simply irrefutable, and Anderson won a Nobel prize for his discovery.

This was impossible. Physicists had firmly established the existence of the electron and the proton, which were accepted as the sole, fundamental building blocks of matter. Anderson undertook a series of mathematical calculations, trying unsuccessfully to bring his new and clearly mistaken evidence into line with the known paradigm of the world. He could not. At length, hesitantly and rather heroically, he declared that he had discovered an antiparticle, which he named the positron. Scientists doubted his report at first, but the photographic evidence was simply irrefutable, and Anderson won a Nobel Prize for his discovery. His revelation led to predictions of other antiparticles, one of which Anderson himself discovered.[10]

Scientists still have a healthy respect for the truthfulness of photographs, if properly taken and unmanipulated. Interpretation is the key. The photograph has an almost unmatched power as evidence, which it discloses only to those who can read the clues.

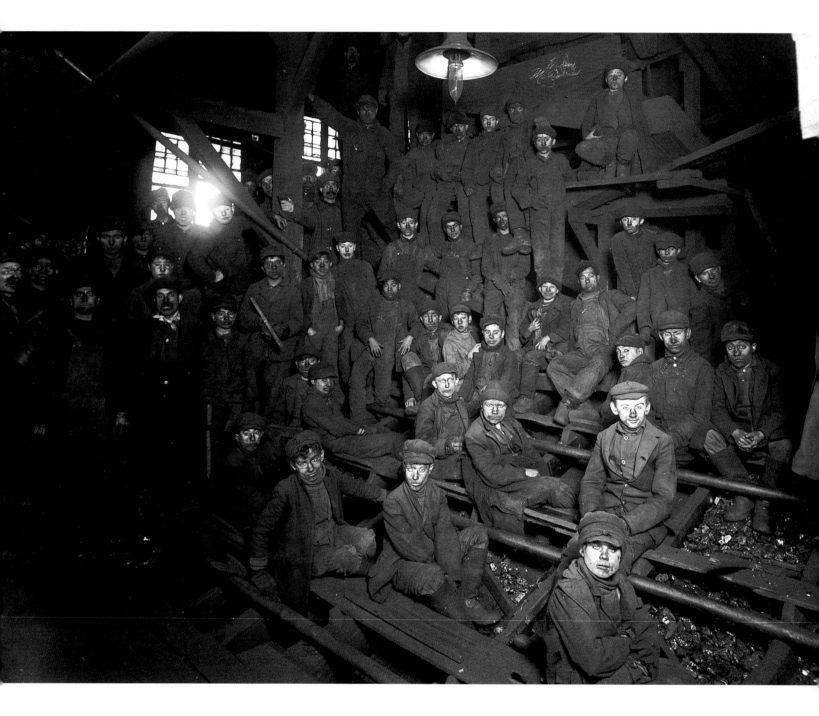

1911 Lewis Hine
Breaker Boys in a Coal Chute, South Pittsburgh, Pennsylvania.
(George Eastman House)

social reform:
the camera as weapon

MANY PHOTOGRAPHERS HAVE BEEN DEDICATED to showing the world a problem and convincing others to work toward a solution. Rarely does the photographic action lead to the desired social reaction. Social problems persist, and photographers still try to solve them with their images.

In the late nineteenth and early twentieth centuries, Jacob Riis, a Danish-born journalist, used photographs to support his arguments about the need to reform slum life. The title of his most famous work, *How the Other Half Lives*, remains a simple description of the goal of traditional social photography: to awaken the conscience of the middle and upper classes by providing a glimpse into the lives of the lower classes. The subjects of social photography are not usually the intended audience for the pictures, which generally aim to call the attention of the "haves" to the plight of the "have-nots."

Jacob Riis told an interviewer in 1888, "The beauty of looking into these places without actually being present there is that the excursionist is spared the vulgar sounds and odious scents and repulsive exhibitions attendant upon such a personal examination."[1] This revealing statement suggests that photographs of the slums can lead to what might be called pictorial slumming, with the viewer

Like Riis, [Hine] believed that the realism of photography was its greatest strength. Verbal reports could be challenged, but the raw evidentiary power of photography was, in Hine's view, unrivaled as a "lever for the social uplift."

engaging in a voyeuristic, vicarious relationship to social misfortune. A financial contribution or other support for a political program might be forthcoming as a result of seeing the horrors, but the photograph removes the viewer from the need to obtain any firsthand experience of the situation.

Riis was a print journalist who became a photographer (and at times hired other photographers) in the belief that photography carried more evidential weight than verbal description. *How the Other Half Lives* was profusely illustrated with photographs and engravings made from photos. Riis also reached his audience through lantern-slide lectures in which his photographic images, projected on a screen, could play to maximum effect. The photographs were relatively primitive—Riis used old-style chemical flashpower to illuminate the dark tenement interiors and alleys—but their roughness only heightened the sense of authenticity they conveyed and reinforced what amounted to photographic shock tactics.

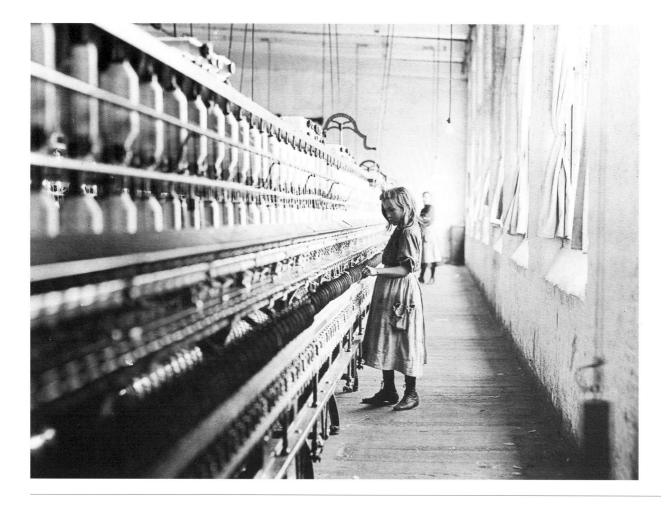

Lewis Hine
Carolina Cotton Mill, 1911.
(George Eastman House)

Lewis Hine, the next great figure in social reform photography, was originally a teacher and thought of his work as a kind of education. What he showed was powerful, but his methods were less sensational and moralistic than Riis's. His first major photographic project was a series of images, taken at Ellis Island, that showed immigrants as they entered the United States. It offered a sympathetic vision at a time when anti-immigration sentiment often ran high. Hine's best-known works are the thousands of photographs of child labor he made between 1908 and 1918. They show youngsters in the mills and mines, in sweatshops and pool halls, on city streets, almost everywhere but where they should have been—at home or in school. Even the photographs of their homes reveal the children doing piecework in cramped tenement rooms. A shot of a playground is no more reassuring: It shows the children amid junk in a vacant lot.

Even those who have never heard of Hine might recognize his images of children standing next to the spinning machines they operated in the mills, the young "newsies" out hawking papers late at night, the boys in the coal chutes. Hine worked for several social welfare organizations, such as the National Child Labor Committee, the National Consumers' League, and the Red Cross, and his pictures were widely disseminated. The great photographic representative of Progressive Era reformism, he participated in some of the major social welfare projects of his time, including the Pittsburgh Survey, for which he documented steelworkers, their families, and their living conditions. An ambitious foundation-supported study of what was then considered an exemplary industrial city, the survey ultimately helped to convince U.S. Steel to modify a few of its more extreme practices, such as the imposition of a seven-day work week. Hine also

We propose to make you and the whole country so sick
and tired of the whole business that when the time for action
comes, child-labor pictures will be records of the past. Lewis Hine

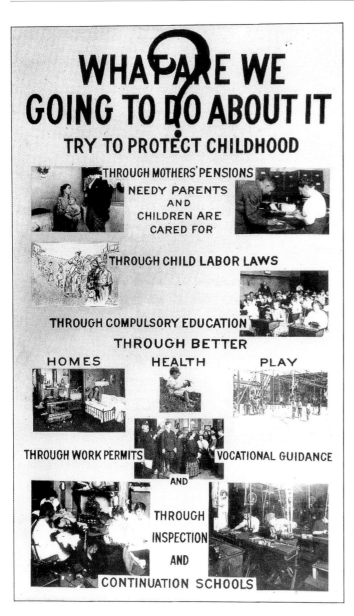

Lewis Hine
Poster for Social Reform, 1911.

worked for government agencies, including the
Tennessee Valley Authority.

Hine was determined to expand the uses of pho-
tography, along with its means of circulation. His work
appeared in pamphlets and posters, in institutional
reports and magazines, and in books and exhibitions,
though rarely in art exhibitions, and then mainly near
the end of his life. He was keenly aware of stylistic con-
cerns, such as the placement of figures in a composition
and the use of light and darkness to add visual drama.
He titled a 1908 photograph of a mother and her
child *Tenement Madonn*a, and referred to the Italian
Renaissance painter Raphael in discussing the work, but
according to a 1926 interview had a prejudice against
the phrase *art photographer*. A picture with beauty but
without significance meant little to him.[2]

Hine was not averse to using sly tactics to gain
access to factories and workplaces, but his photographs,
for all their ingenuity and skill, are anything but guile-
ful. Like Riis, he believed that the realism of photogra-
phy was its greatest strength. Verbal reports could be
challenged, but the raw evidentiary power of photogra-
phy was, in Hine's view, unrivaled as a "lever for the
social uplift." His straightforward style displayed a com-
pelling sense of truthfulness, an avoidance of melo-
drama, and an obvious respect for his subjects. As Alan
Trachtenberg has observed, Hine's children in particular
display "savvy." They are tough and spirited, and, like all
of his subjects, never portrayed as simple downtrodden
objects of pity.[3]

Hine's work eventually played an important role in the passage of child
labor laws, but he was not always interested in exposé. During World War I, his
involvement with the Red Cross took him to Europe, where he photographed
relief workers helping refugees. Hine thought of his work as educational, and
especially in his later photography hoped to bring employees and employers
together by showing the dignity of human labor. He believed that workers and
management could be led to do more than simply get along. A harsh critic of
many aspects of industrial capitalism, he nevertheless regarded work and

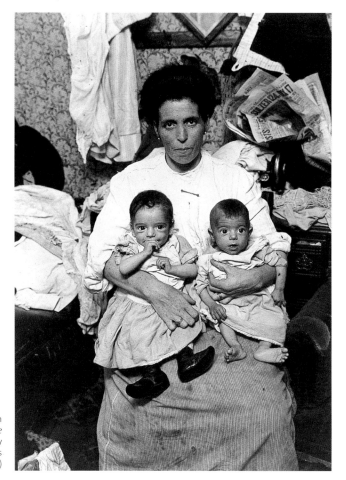

Photographer unknown
*Mother and twins when they began to take
fortified milk*, 1911. (The Photography
Collection, Carpenter Center for the Visual Arts
at Harvard University)

workers as noble. Among his last completed projects was a group of approximately one thousand pictures documenting men at work—Hine called them "sky boys"—on the towering steel skeleton of the Empire State Building.

From time to time, photographers have joined together under the banner of "concerned photography" or "photography as witness." Near the end of his life, Hine was affiliated with the Photo League, a New York group that promoted social documentary photography. As a center for photographic exhibitions,

As early as 1910, a writer observed, "The public soon wearies of pictures of destitute children or desolate tenement interiors."

classes, and discussions, the Photo League inspired a number of important photographers, including Walter Rosenblum and Jerome Liebling,[4] to pursue what has been called "civic photography," which displays a concern with the full range of social behavior, from work to politics and from recreation to education. Although an emphasis was placed on social understanding rather than direct calls for action, the subjects explored in Photo League group projects included the Bowery, tenement life, and Harlem, which suggests a fundamental continuity with the Riis-Hine tradition.

In recent decades, photography has shared its role as pictorial conscience with television and film documentaries. Nevertheless, major photographic projects have been produced—some in the realm of newspaper and magazine photojournalism, others generated independently—on the farm crisis, the rust

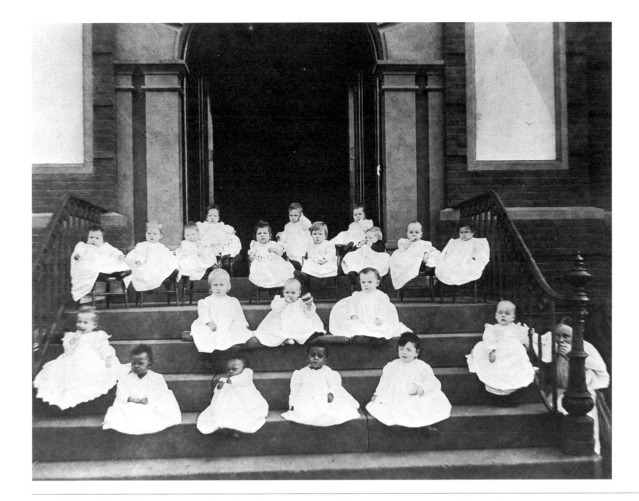

Photographer unknown
Orphans on steps, 1911.
(The Photography Collection,
Carpenter Center for the Visual
Arts at Harvard University)

belt, boat people, the homeless, victims of Agent Orange, street kids, and the
AIDS epidemic. Many photographers continue to work for the full spectrum of
social welfare agencies to help provide visual evidence of continuing social prob-
lems. Today, documentary photographers working in the tradition of Riis and
Hine are recording the situation along the border with Mexico and in new immi-
grant communities throughout the United States.

There is always a danger that the proliferation of photographs of horren-
dous situations will induce what has been called "compassion fatigue."[5] As early
as 1910, a writer observed, "The public soon wearies of pictures of destitute chil-
dren or desolate tenement interiors."[6] (In our own era of global media, the list
can seem endless.) Speaking to an audience of reformers a year earlier, Hine him-
self acknowledged that his listeners were probably weary of child-labor pictures.
He went on to say that he was too, then added: "But we propose to make you and
the whole country so sick and tired of the whole business that when the time for
action comes, child-labor pictures will be records of the past."[7]

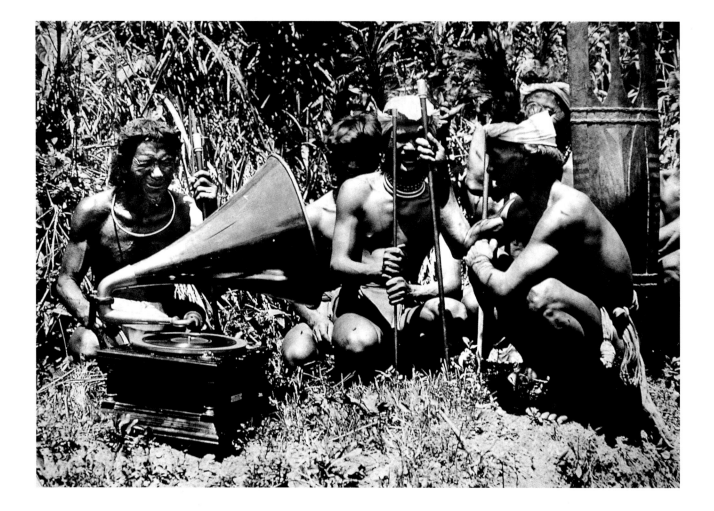

1912 Charles Martin
Kalinga Province Chiefs.
(Charles Martin/NGS Image Collection)

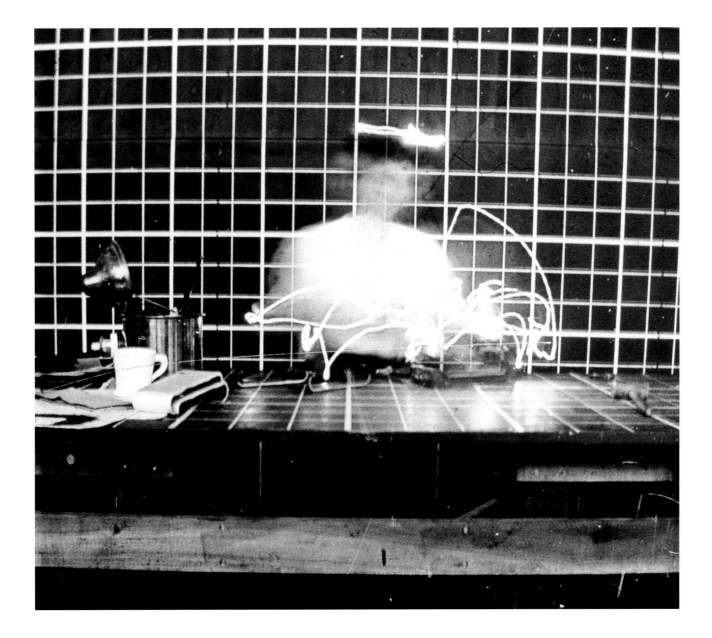

1913 Frank B. Gilbreth
Motion Study.
(Smithsonian Institution)

PRICE TEN CENTS

The New York Times
MID-WEEK
Pictorial War Extra
Printed by the New Rotogravure Process

Vol. 1, No. 4 NEW YORK, THURSDAY, OCTOBER 1, 1914 Price 10 Cents

Published every week by The New York Times Company, Times Square, New York. Subscription rate, $5.00 per year.
(Entered at the New York Post Office as second class matter.)

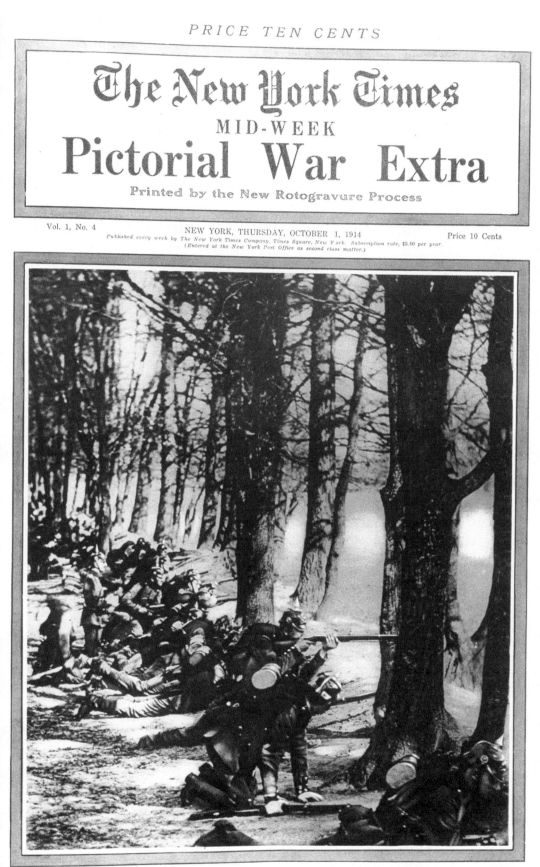

GERMAN SKIRMISHERS FIRING ON THE FRENCH
From the Cover Afforded by a Forest in the Vosges, Lorraine.
(Photo from Underwood & Underwood.)

1914 Front page, *New York Times
Mid-Week Pictorial.*

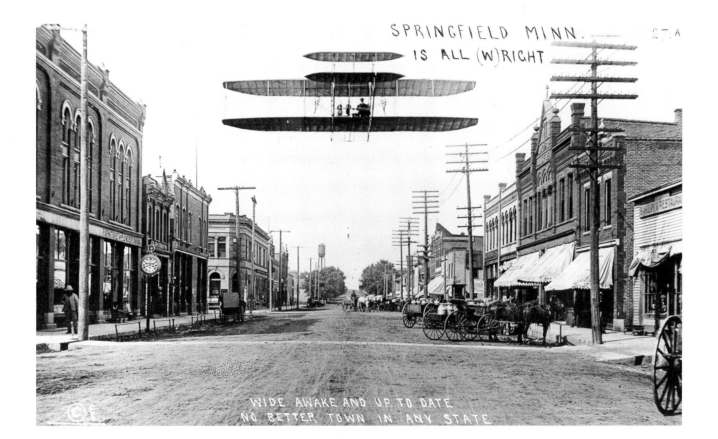

SPRINGFIELD MINN.
IS ALL (W)RIGHT

WIDE AWAKE AND UP TO DATE
NO BETTER TOWN IN ANY STATE

1915 Photographer unknown
Wright Brothers Postcard.

capturing time:
motion study and social control

THE TWENTIETH CENTURY HAS BEEN A CENTURY OF SPEED. From the telegraph to the telephone to transmission of data via fiber optics, from horses and trains to automobiles and planes, the pace of life has become faster and faster.

Photography has kept up, matching life's accelerating pace with an array of technical advances in shutters and lenses, film, and flash equipment that make it possible to arrest even the most rapid motion. Photography can freeze time by capturing a split-second event, or stretch out the moment, as when a long exposure turns automobile lights into bright ribbons running through the streets. The play between movement and the still

The photographic study of motion served more utilitarian purposes in the workplace. In the late nineteenth century, Frederick Winslow Taylor developed what came to be called "scientific management" by breaking down all work into individual tasks, which were then analyzed and timed with a stopwatch in the relentless pursuit of efficiency. Taylor was the very model of the corporate manager as unfeeling rationalist, a man with no sympathy for workers. His approach came at a time of increasing industrialization—the first assembly line appeared in 1914—and was adopted around the world.

Among Taylor's followers was Frank Gilbreth, an early management consultant who achieved notoriety as the

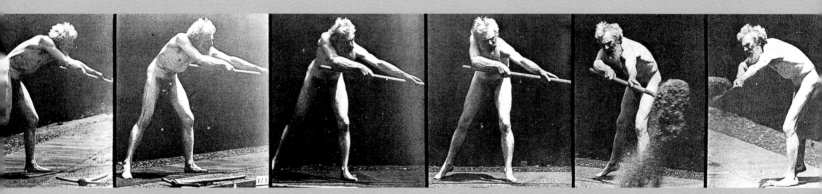

image offers infinite possibilities. In 1878, Eadweard Muybridge, an Englishman living in the United States, used photography to study motion and showed the world how the legs of a horse really moved. According to

paterfamilias in *Cheaper by the Dozen*, a best-selling memoir written by two of his children. The book, and the movie that followed, portrayed Gilbreth family life as a comic regime marked by attempts to enforce efficiency in all areas of daily life, including washing dishes and brushing teeth.

That charming portrait played down the actual work that Gilbreth (aided by his wife, Lillian, an industrial psychologist) had done to adapt Taylorism.[1] Gilbreth differed from Taylor in two basic ways: He complemented the clock with the camera, turning time study into motion study, and he was more sympathetic to workers. He could sound almost utopian when speaking about his desire to improve the conditions of employees, for he believed that motion study would prove beneficial to both management and labor. He thought that the country that mastered workplace efficiency through the streamlining of motion would attain "industrial supremacy of the world."

He thought that the country that mastered workplace efficiency through the streamlining of motion would attain "industrial supremacy of the world."

a tale that may well be apocryphal, his pictures won a bet for the millionaire Leland Stanford, who believed that a galloping horse lifted all four legs off the ground at once. In any event, such photographs taught painters like Thomas Eakins that "hobby-horse" depictions were false.

Gilbreth recorded all kinds of work-related activities, from typing to surgery, from bricklaying to oyster shucking. Using a clock, small blinking lights attached to the subject's moving hands, a grid to calculate distance, and stereo cameras, he traced the workers' motions and tried to ascertain for each task what he called the "One Best Way." His photographs, which he dubbed "chronocyclegraphs" (time-motion-writing) today have a kind of

Gilbreth himself applied his motion study techniques to aid the rehabilitation of wounded war veterans.

the standards he then imposed. Like the corporate bosses who controlled the assembly line in Charlie Chaplin's *Modern Times*, Taylor and his more ruthless followers thought only of increasing the pace of production, of turning workers into automatons. Gilbreth's idealism notwithstanding, photography as a form of surveillance and control in the workplace soon met with distrust and resistance.

Not all photographic motion study is Taylorism (or "Gilbrethism"), a matter of surveillance and social control. Gilbreth himself applied his motion study techniques to aid the rehabilitation of wounded war veterans.

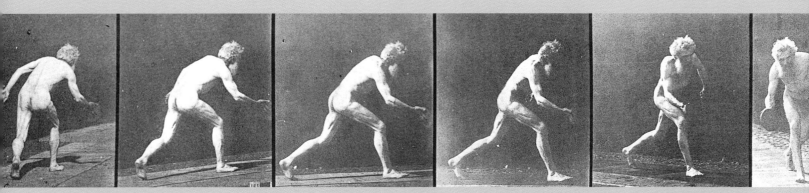

science-fiction oddity, as well as visual appeal. But they also had social, even political, implications. Here was photography employed as a recording device that could help to make work simpler, less physically demanding, and less time-consuming.[2] Gilbreth genuinely wanted work to become easier, and he helped to transform—and improve—certain work situations. In medicine, for example, he demonstrated the advantages of changing the layout of the operating room and the working patterns of nurses and surgeons. With Gilbreth as with Taylor, however, there was the possibility of enforced workplace control through standardization and an emphasis on speed. Gilbreth championed what we would now call ergonomic planning; Taylor was devoted only to the bottom line, with maximum production the end and rigid control of the worker the means. Taylor used the best performance as the basis for determining how much time a task required, and often fired those who could not meet

Gilbreth used motion pictures before developing the stereographic still-photography techniques that he found more useful. Today, the video camera has become the instrument of choice for analyzing motion, because it offers instant playback with slow-motion and freeze-frame capability, as well as digital time display.

Many of the most tedious jobs that Gilbreth studied have been replaced by robotic machines. And for some employees the computer, not the camera, tells all, measuring the number of phone calls per hour made by telemarketers or the speed of a worker ringing up customers at a grocery store checkout stand. In our time, motion study is probably used more often for analyzing golf swings than for charting the progress of assembly lines.

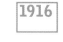

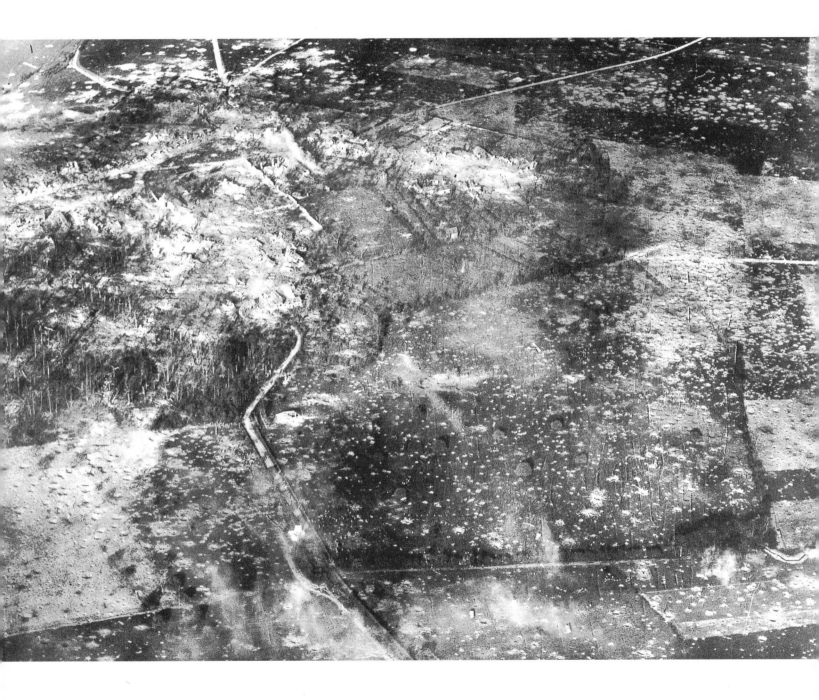

1917 Attributed to Edward Steichen
World War I aerial photograph.

photographing the news

Leslie Jones
Sacco and Vanzetti put on view after being executed, 1927. (Boston Public Library)

Opposite:
Underwood & Underwood
President Roosevelt running a steam shovel at the Panama Canal, 1906. (The Collection of the New York Historical Society)

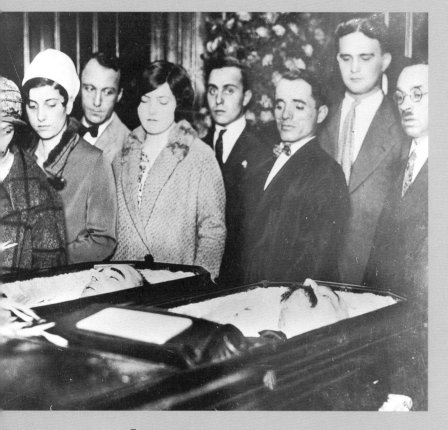

THERE WAS A PICTURE PRESS LONG BEFORE THE ADVENT OF photojournalism. In Elizabethan England, broadsides with a text accompanied by a woodblock image circulated almost immediately after public hangings. Given the public appetite for images, it might seem inevitable that the appearance of photography near the middle of the nineteenth century would transform publishing. But the picture press—the illustrated magazines and newspapers that became increasingly popular after the mid-nineteenth century—did not automatically become a photographic press. Photographic processes evolved rapidly as the new century approached, yet there was a technological roadblock: A method had not been found for reproducing photographs along with text in the large print runs required by mass-circulation publications.

In 1853, a photographer recorded a mill fire in Oswego, New York, producing what we would call a news photograph. But he made a daguerreotype, a unique image without a negative. Photographs were made of battlefields and of prisoners at Andersonville

Prison during the Civil War, and, just after the war, of the hanging of the conspirators in the plot to assassinate Abraham Lincoln. Yet none of these images could be mass-produced. Photographic prints were still made individually and tipped into the pages of books or used as the basis for lithographs or woodblock engravings.

In the 1880s, an invention called the halftone screen, which broke down photographic images into a field of minute dots, finally made possible the mass reproduction of images, with type, for newspapers and magazines.[1] But it was not until 1897 that the *New York Tribune* introduced the regular publication of photographs. Until then, editors and readers still preferred engravings, which reproduced better on the cheap, rough paper of the time.

By the end of the nineteenth century, rotary presses could turn out thousands of sheets an hour, but as late as 1898, images in *Scientific American* of a half-sunk USS *Maine* in the harbor of Havana—the flashpoint for the Spanish-American War—were still wood engravings based on photographs. However, the Spanish-American War received extensive press coverage, including a large contingent of photographers as well as sketch artists. Press mogul William Randolph Hearst supported America's involvement in the conflict for practical as well as political reasons: His papers could run forty editions a day to highlight the latest war news—and the most recent images. Even if the reproductions were not photographic, the tag "based on photographs" carried weight, suggesting a representation closer to the truth than a reporter's words or an artist's imaginative vision.

Since newspaper and magazine publishing is a business, change has often been driven by the reading audience as much as by technological developments. New technology reduced costs; the audience made its influence felt by favoring publications with more photographs. Some highbrow magazines resisted the shift in emphasis from text to image. In 1895, one magazine called for lovers of literature to resist "the Tyranny of the Pictorial."

Other publications, notably a few of the muckraking magazines such as *McClure*'s, embraced photography as the perfect instrument for exposing the truth about unpleasant situations. In general, the photograph had come to be regarded as evidence that could clinch any argument, as when Jimmy Hare, reinforcing a reporter's

In the 1880s, an invention called the halftone screen, which broke down photographic images into a field of minute dots, finally made possible the mass reproduction of images for newspapers and magazines.

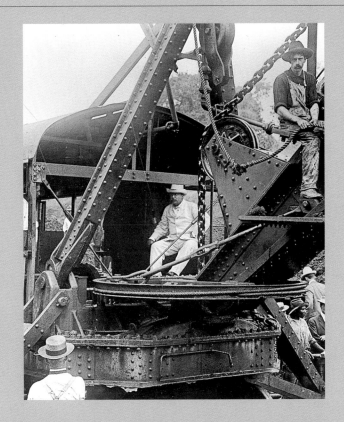

written account, captured the Wright brothers' plane in flight and proved that their accomplishment was real.

Estelle Jussim has called catastrophes "the photojournalist's dream picture opportunities."[2] When the great San Francisco earthquake struck in 1906, the portraitist Arnold Genthe recorded the aftermath in a series of photographs published in the *San Francisco Examiner*. That was photography at its most dramatic and immediate, that was news. Most journalistic photographs, of course, were more mundane, featuring staples such as sporting events and appearances by politicians.

Early news photographs were not limited to newspapers and magazines. Stereographic cards—3-D!—and lantern slides also placed news images before the public in living rooms, schools, and lecture halls. In every way possible, people were receiving more and more information through photography. After the Spanish-American War, newspapers supported globetrotting photojournalists who set off in pursuit of a "scoop." By 1914, most papers featured supplements based largely on photographs. A decisive change in this direction took place

during World War I, driven by public interest in seeing images of the war. Before the arrival of the wire services, it was not easy to send photographs, but they could still be disseminated more quickly than the weekly newsreel.

The year 1919 brought the debut of the first truly photographic newspaper in America, the tabloid *New York Illustrated Daily News*. Other tabloids—the term refers to the format of this new breed of half-size papers—soon appeared that also featured murder and mayhem, crime, sex, and disasters, along with questionable reporting and a few relatively less objectionable subjects such as sports and high-society (sound familiar?), all of which helped to spur the use of photographs. These publications engaged in fierce competition for readers and advertisers, and were in some ways the descendants of the old topical broadsides. They took a special interest in sensational crime stories, but photography was not always permitted in the courtroom. This led to ingenious, if dubious, solutions. In a famous 1925 case involving a society scandal, the courtroom was emptied and the key figure, a woman, partly stripped before the judge. "The hell with photographers," an editor at the *New York Evening Graphic* said. He combined photographs of the judge, a witness, lawyers, and family members, then hired a model to pose as the woman. This "composograph" boosted the circulation of the paper by 100,000, a figure that no doubt compensated for an attack by *Time* magazine that described the *Graphic*'s ploy as "the blackest day in the history of American journalism."

In 1928, the rival *Daily News* fought back. A reporter was sent to witness the death of Ruth Snyder, the first woman to be executed in New York in the twentieth century. With a hidden camera strapped to his leg, he snapped a grisly image that was soon splashed across the front page. As has become ever more obvious in our own day of ravenous paparazzi, if the payoff is high enough, somehow a photograph will be taken.

By the early 1930s, the picture press—which by then meant the photographic press—was a regular part of American journalism. All of the major newspapers had large photo staffs, and dozens of photographs were reproduced in every issue. The next step would be the development of picture magazines devoted to photography as the main vehicle for storytelling.

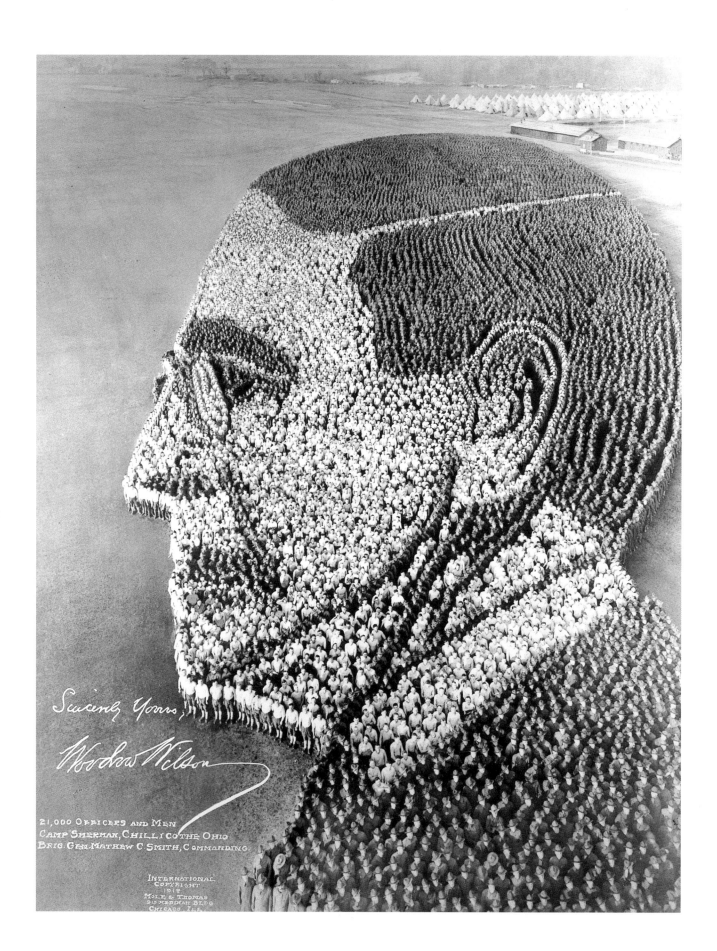

Arthur S. Mole & John D. Thomas
Woodrow Wilson (image formed by 21,000 men at Camp Sherman).
(The Chicago Historical Society)

1918

THE Illustrated Daily NEWS

No. 53. Copyright, 1919, by News Syndicate Co., Inc. New York, Tuesday, August 26, 1919. Trade-mark registered U. S. Patent Office. 2 Cents

FLIES FROM TORONTO TO NEW YORK IN 6 HOURS 21 MINUTES

SEE PAGE 3

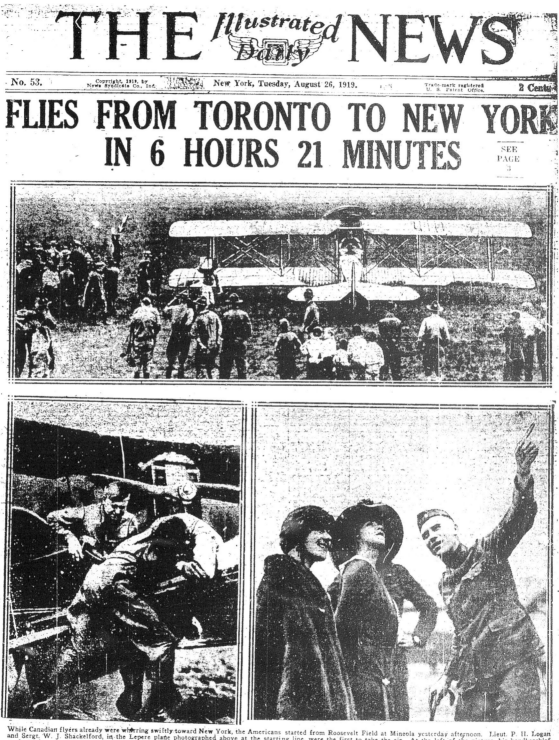

While Canadian flyers already were whirring swiftly toward New York, the Americans started from Roosevelt Field at Mineola yesterday afternoon. Lieut. P. H. Logan and Sergt. W. J. Shackelford, in the Lepere plane photographed above at the starting line, were the first to take the air. At the left of the picture, his handkerchief ready to drop as the signal, is Maj.-Gen. Charles T. Menoher, official starter of the race. An instant after the photographer clicked his camera shutter the plane was off. Below, at the left, are two soldiers holding down one of the wild mechanical birds after the propellers were roaring and the pilot was awaiting the drop of the handkerchief. The other photograph shows the Princess Della Paftra, of Egypt (left), and Mrs. Francis M. Wilson following the course of the Lepere plane with Lieut. Daniel Passh, U. S. A., whose own machine took the air a little later. (Exclusive photos by our own photographer)

TODAY

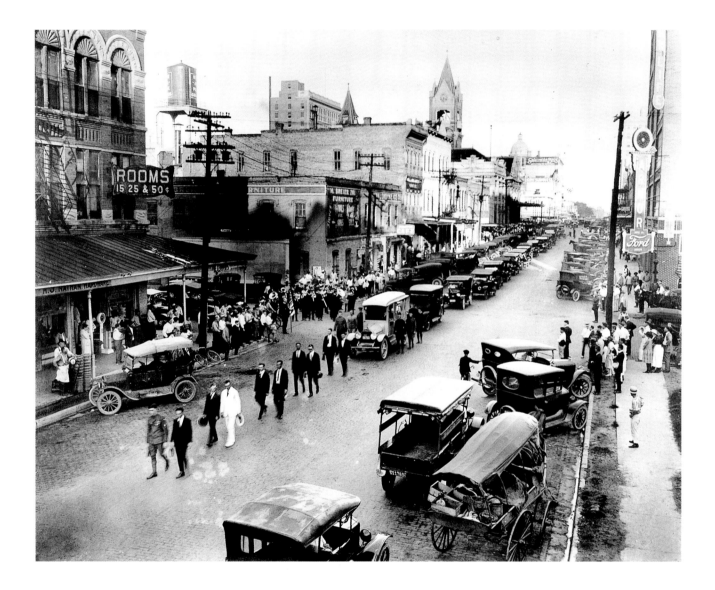

1920 Photographer unknown
Funeral at Louisiana Street and Preston Avenue,
Houston, Texas, 1920. (Houston Public Library)

Ernest Hemingway's passport.
(Ernest Hemingway Collection, John F. Kennedy Library, Boston, MA.
Courtesy of the National Portrait Gallery, Smithsonian Institution)

world war I:
the camera goes to war

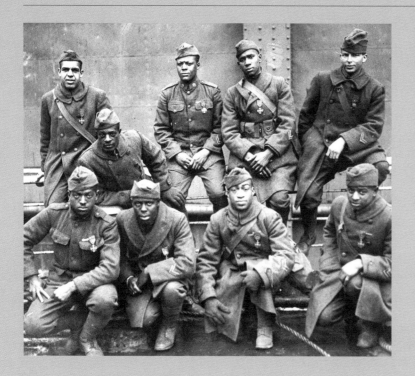

DURING WORLD WAR I, THE AMERICAN PUBLIC SAW VERY few action photographs, very few pictures of American wounded, and not a single picture of a dead American, though photographers were neither incapable of making such pictures nor overly fastidious. War photographers had taken action photographs in battle as early as the Boer War at the turn of the century, and equipment had improved since then. But during the Great War authorities distrusted the press, believed the public didn't want to see horror pictures, and were convinced that civilian

Planes brought death in ingenious ways, and the most far-reaching depended on the combination of camera and airplane.

morale depended on good news and a sanitized version of combat. Restrictions were so severe that before 1917 civilian photographers were not allowed at the Western front under threat of arrest or even death, and even after America entered the war in late 1917, pictures of

American dead and severely wounded were censored.[1] Censorship may be justified for military reasons, but such extreme controls signal loud and clear that officials recognized, and feared, photography's powerful influence on the public.

Even the photographers thought World War I was an unphotogenic war. Opposing camps huddled far apart in muddy trenches, separated from the enemy by land that had been laid waste by artillery. Action consisted of firing a weapon or running crouched across this no-man's-land, seldom with a good view of the enemy until the last few moments. Thousands died from gas attacks, which no correspondent dared pause to photograph. Action photographs, such as they were, leaned toward views of men clambering out of trenches or muzzy pictures of the smoke from shell bursts at a distance safe enough to ensure survival. They didn't have the drama of battle paintings in museums. They didn't look the way war was supposed to look.

And yet the war was news, big news. The public was intensely interested, the rotogravure press had already made Sunday photographic supplements popular, and magazines and the few newspapers that ran photographs in any numbers increased their coverage. In 1914, the *New York Times* established the *Mid-Week Pictorial*, a photographic supplement designed to carry news of the war (along with a few society and garden photographs), with pictures of troops on parade or in training, men in camp or in trenches, an occasional picture of a tank or an explosion, prisoners of war, refugees (who began to merit a bit of picture space in this war), ruins, and even, in the early years, such German propaganda as pictures of German soldiers feeding Belgian children.[2] The *Mid-Week Pictorial* occasionally ran portraits of men who had been killed in battle, transforming family pictures into news or war photography.

The Great War changed the very nature and perception of war, partly because of the camera. The war also changed the Western world's attitudes toward photography. World War I was a new kind of industrialized warfare, using newly developed weapons: tanks, improved

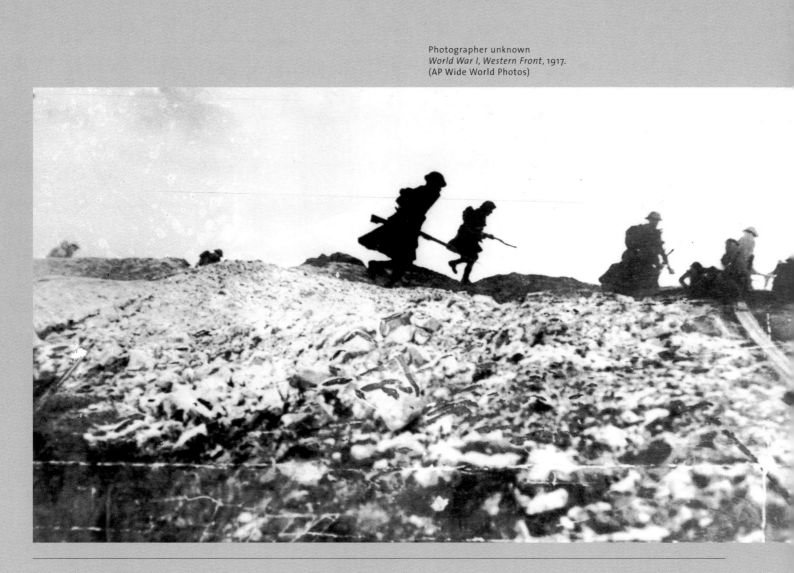

Photographer unknown
World War I, Western Front, 1917.
(AP Wide World Photos)

machine guns, poison gas, and airplanes. Planes brought death in ingenious ways, and the most far-reaching depended on the combination of camera and airplane. An observer in 1918 wrote: "A bullet may kill a man, perhaps two; a round from a machine gun may bring down an enemy plane. But the influences of the aerograph are wider, more deadly."[3] Aerial reconnaissance laid the

The war has demonstrated the superiority of the photograph and film as a means of information and persuasion.

foundation for the wars to come, in which photography and optical technologies like radar and surveillance satellites would play enormous roles and killing would depend as much on visual representations as on firepower.[4]

Late in the war, aerial photographs in the press added a new dimension to the eyewitness value of photographs, putting civilian viewers in the pilot's position as if they were direct observers of the war rather than mere recipients of a photographer's observations. Aerial photographs had an even more profound effect (as did aerial bombardment), subtly shaping a new experience of battle as mechanical, distant, rather abstract, and

removed from the traditional concentration on individual human beings and compassion for their ruptured lives.

Among other radical social changes in the wake of World War I was a distrust of the written word in the press, which had carried the main burden of reporting, and a wholesale acceptance of photography. The papers had repeatedly reported atrocities that were never shown or proven and had consistently described Allied losses, even carnage, as something resembling victory. Soldiers, who knew better, scoffed at the printed word. Photography presented itself as the more truthful, more neutral, more convincing reporter. German General Erich Ludendorff wrote in 1917, "The war has demonstrated the superiority of the photograph and film as a means of information and persuasion."[5] Censored war photographs that were released after the Armistice, and memoirs written during the 1920s, persuaded the public that the press had been deceitful and could not be relied on. Photography stepped into the breach, wearing the cloak of honesty.

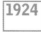 1924 Photographer unknown
President Coolidge Radio Transmission.
(Museum of the City of New York)

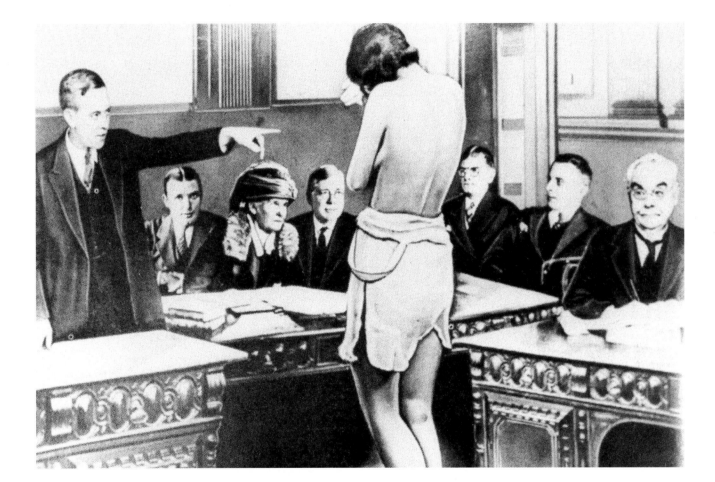

 Photographer unknown
Composograph of Alice Rhinelander, created by Harry Grogin
and the editors of the *New York Evening Graphic*.

Lovely to look at and touch, in spite of all the thousand tasks they do

In Spite of Housework— Your Hands can Keep their Fresh, Young Look

CAN a woman have beautiful hands— soft, smooth, gleamingly white—and yet use them to dust, sweep, wash dishes, polish silver—keep her house and all the things inside it bright and shining?

It is true that even a few days of unaccustomed housework will often make a woman despair of her hands.

She is amazed and sorrowful to see how quickly the white, soft skin becomes rough and chapped—the finger-tips stiff and sore, the cuticle inflamed— the whole feeling of her hands dry and uncomfortable.

But this is because she has not yet learned *to protect her hands while using them.* You can safeguard your hands against the drying, chapping effect of housework! Today thousands of women are keeping their hands smooth and white, in spite of hard use, by means of a new preparation especially made to heal and protect the skin, and give it a soft, lovely texture.

This new preparation is Jergens Lotion, a product containing benzoin and almond, two of the most healing skin restoratives known.

Gives instant relief to a dry or irritated skin

Benzoin has been used in medicine from time immemorial because of its wonderful effect in healing the skin and stimulating skin repair. Almond softens and whitens.

In Jergens Lotion, benzoin and almond are combined with other healing ingredients, forming a clouded, silvery liquid—deliciously fragrant—which gives instant relief to a dry or irritated skin. Roughness, inflammation, chapping, are healed by a few

Your hands can keep their fresh, soft, young look, in spite of housework. Today there is a new preparation especially made to protect much-used hands and to keep the skin smooth, white, silky-soft

applications of Jergens Lotion. *Every time you have had your hands in water,* use it—and all your difficulties about keeping your hands in good condition will disappear. Your hands will stay smooth, white, silky-soft —lovely to look at and touch.

Jergens Lotion is easy to use, for it leaves no stickiness. Your skin absorbs it instantly.

You can get Jergens Lotion for 50 cents at any drug store or toilet goods counter. Get two bottles at a time! Keep one on the bathroom shelf to use for your face—keep another above the kitchen sink, for convenience when you are using your hands for housework!

THIS fragrant, silvery liquid contains two of the most healing skin restoratives known. Use it every time you have had your hands in water—and see what a lovely, smooth texture it will give your skin.

Are your finger-tips rough and scratchy when you try to sew? This new preparation softens rough cuticle and keeps the skin smooth and white.

Don't sacrifice the loveliness of your hands, even though you do give them hard use. You can keep them soft and smooth by this simple new method of caring for them.

THE ANDREW JERGENS CO.,
453 Spring Grove Ave., Cincinnati, Ohio.

Please send me FREE a trial-size bottle of Jergens Lotion and the booklet "*Skin Care.*"

Name ..

Street ..

City .. State

If you live in Canada send to The Andrew Jergens Co., Ltd., 453 Sherbrooke Street, Perth, Ontario

Free Offer

Send this coupon today and get a trial-size bottle FREE!

advertising photography

Every day, Americans encounter advertisements at a rate that outstrips just about any other kind of information. In 1984, a study reported that the average consumer was exposed to 1,600 ads a day;[1] few would suggest the number has declined since then. Most ads are primarily visual, and photographic at that. Advertising, the business that oils the wheels of capitalism, is a territory colonized by the camera.

By the late nineteenth century, as more consumer goods became available and income was on the rise, advertising grew faster than the economy.[2] Advertisers were already convinced that illustrations sold goods. In 1898, a trade journal advised that pictures, not words, were "the quickest-acting medium for the transmission of one man's thought to another man's mind,"[3] and though most pictures were still engravings and lithographs, by the early twentieth century photographers were being advised that advertisers were eager for their wares.[4] The advertising community was courting photography, but it wouldn't make a major commitment to the medium until the 1920s.

Even when the photograph's potential for flattery, exaggeration, and bias was understood, it was not immediately visible; both common fantasies and utopian promises acquired a precious measure of credibility when couched in the trusted language of photography.

World War I was a turning point. If photography acquired a heightened importance during and after this war, so did advertising, which had successfully encouraged patriotism and helped sell war bonds. (Wars have been good to advertising. During World War II the government mounted the most extensive ad campaign in history.)[5] World War II brought more women into the workplace, more of them stayed there afterward, and more money was available to more people in the prosperous postwar decade. By the turn of the century, manufacturing had already outstripped the public's needs and turned to advertising to create excess desire. After World War I, Americans shed their last hesitations and gave in to the joys of possession.

They also gave in to the lure of pictures, which were deemed more compelling than ever. After mid-decade, photographs began to crowd out the traditional drawings in ads. In 1926, more than 80 percent of the covers of the trade journal *Advertising and Selling* were lithographs or engravings; by 1928, over 80 percent were photographs.[6] Advertisers and photographic associations

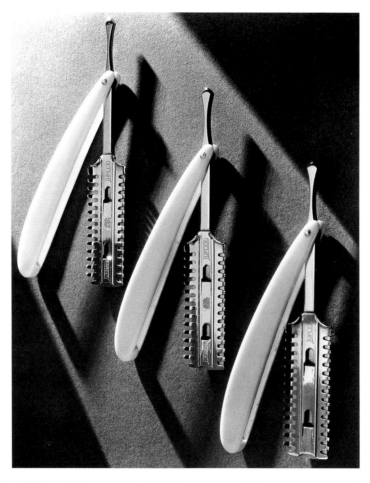

John F. Collins
Duplex Razors, 1934.
(George Eastman House)

trumpeted the virtues and efficacy of photographs. A 1932 survey of 4,000 reader reactions ranked photographs more effective than other illustrations, confirming what advertisers had been saying for some time.[7]

Photographs were thought to be more convincing because of their "realism" and "truthfulness." A drawing was obviously beholden to imagination and fantasy, but the photographic process appeared to be direct, unmediated, and guileless. Even when the photograph's potential for flattery, exaggeration, and bias was understood, it was not immediately visible. Both common fantasies and utopian promises acquired a precious measure of credibility when couched in the trusted language of photography. This was particularly useful in the 1920s, when advertising's very success and sometimes insupportable claims stirred up distrust and stoked the fires of an organized consumer movement.

It is unlikely that people, then or now, swallowed advertising claims whole, yet advertisement—and by extension, advertising photography—has contributed heavily to setting frames of social reference and spelling out the anxieties of twentieth-century life, then offering palliatives. In the 1920s (and more strenuously in the 1940s and 1950s), agencies employed psychologists to look into motivations and targeted women as the chief purchasers. Advertisements sold products meant to assuage common insecurities that ads themselves had heightened.

Advertising photography created an idealized version of middle-class life that was always white, attractive, happy, and capable of reaching the next rung on the ladder to health, beauty, luxury, and success. (In the late 1960s, some of the race and gender biases of advertising—an industry that traditionally had

An advertising photograph may be recognized as a performance, but it touches real wishes and anxieties and invites belief or wish fulfillment, at least subliminally.

been dominated by white men—were at last addressed, even as consensus about what constituted a proper middle-class life came under pressure.) Photographs of perfect features and figures and families or of glaring flaws speak to common desires and fears even for those who know that scenes have been staged and images retouched. An advertising photograph may be recognized as a performance, but it touches real wishes and anxieties and invites belief or wish fulfillment, at least subliminally.

Besides, a message that is repeated often enough earns a certain credit, as gossips know very well. A woman may not honestly believe that curing chapped hands will make the man in her life propose, but the lessons of personal hygiene and grooming and the danger of a single lapse, as well as the power of social conformity, are ingrained by repetition.

Almost from the beginning, a number of exceptionally talented photographers worked in advertising, which was not yet rigidly separated from art. Edward Steichen, who had been an avowed Pictorialist prior to the war, went to work for Condé Nast in 1923. He took portraits and fashion photographs for *Vanity Fair*, shot advertising pictures for various clients, and included such images in exhibitions with his other photographs.[8] In 1921, one writer, contending that business had supported architects in developing the skyscraper as a new American architecture, predicted that advertising would "engage the best artists to produce its advertising pictures and thus a second great national art expression based on usefulness will be developed."[9] Business claimed that the improved ad designs it was backing would raise the level of public art education,[10] much as the Bauhaus in Germany intended to raise public taste through revamped utilitarian design.

In fact, these businessmen had a point. Advertisers had borrowed from art as early as the late nineteenth century, but in the decade of the 1920s they began a dizzying assimilation of contemporary art that has greatly accelerated in recent years. For a few years in the 1920s and 1930s, advertisers embraced, sometimes daringly, the most modern of photographic styles, almost all stemming from the straight photography enunciated by Paul Strand around 1916. Photographers took cues from Cubism, Precisionism, Art Moderne, and geometric abstraction. A few professionals, such as Steichen, Paul Outerbridge, Ralph Steiner, Anton Bruehl, and Margaret Bourke-White, put these styles at the service of commerce and thus contributed to the spread of a modernist aesthetic far beyond the world of the museum.

Paul Outerbridge's 1922 *Ide Collar*, its open-ended, graceful curve hovering above the rectilinear grid of a checkerboard that tilts up at a perplexing angle,

Victor Kepler
"A Little Glass Tube," 1938.
(George Eastman House)

Advertisers had borrowed from art as early as the late nineteenth century, but in the decade of the 1920s they began a dizzying assimilation of contemporary art that has greatly accelerated in recent years.

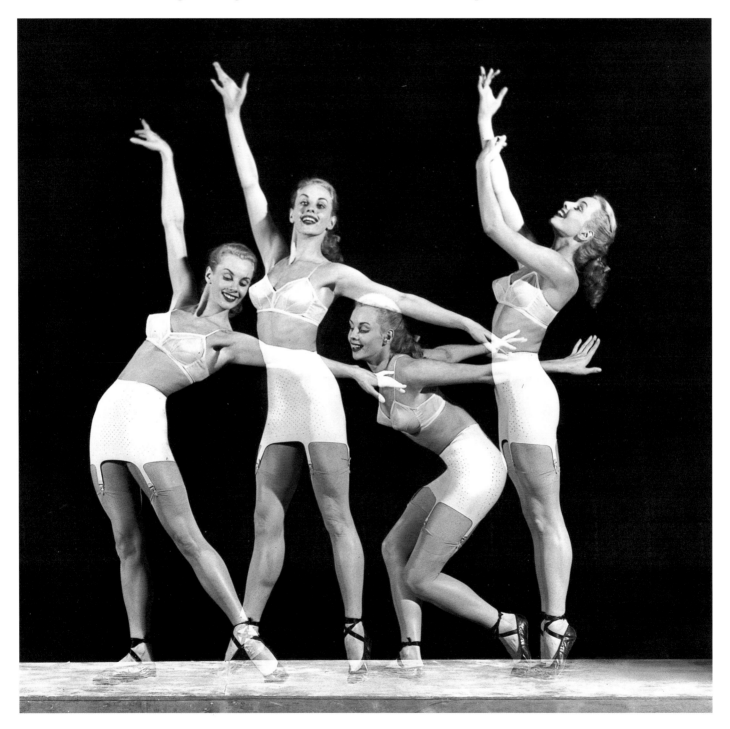

Ralph Bartholomew
Playtex, ca. 1950.
(Los Angeles County Museum of Art)

exemplifies the strong graphic character of this style and its ready translation to the printed page. The audience for ads like this one thought it chic to be modern, and there was a flattering element of connoisseurship to "consuming" an ad couched in the latest artistic idiom. The ad as well as what it advertised became an adjunct to self-esteem.

For all of photography's supposed realism and its subterranean ability to make fantasy credible, the most radical change that the medium made to advertising and to perception in the 1920s was its glorification of the object. The cinema could exalt actors by enlarging and isolating their faces, lighting them gorgeously and concentrating on them fiercely. Still photography went further, turning ordinary objects into icons. Isolated from their usual functions, some-times cropped to more distinctive shapes, carefully framed to emphasize their importance, and displayed against a backdrop or design that becomes the photo-graphic equivalent of the gold ground behind a saint, everyday objects and products achieve a mysterious presence. What Edward Weston did in the art world with peppers, Steiner did with typewriter keys, Outerbridge with a collar.

As the scholar Herbert Molderings has pointed out, advertising photogra-phy is "the pictorial expression of commodity fetishism"; it turns the commodity into a fetish that the consumer is prepared to dote on and need. Advertising photographers put massive amounts of energy, care, and talent into tabletop photographs of complex arrangements—ranks of cigarette lighters elaborately lit and reflected, place settings elegantly aglitter—much as the makers of TV commercials spend more time and money per second than program producers can. Molderings concluded that this new photographic concentration on the object, more than Cubism, Fauvism, or Expressionism, "modified and renewed the centuries-old genre of the still life of the twentieth century."[11]

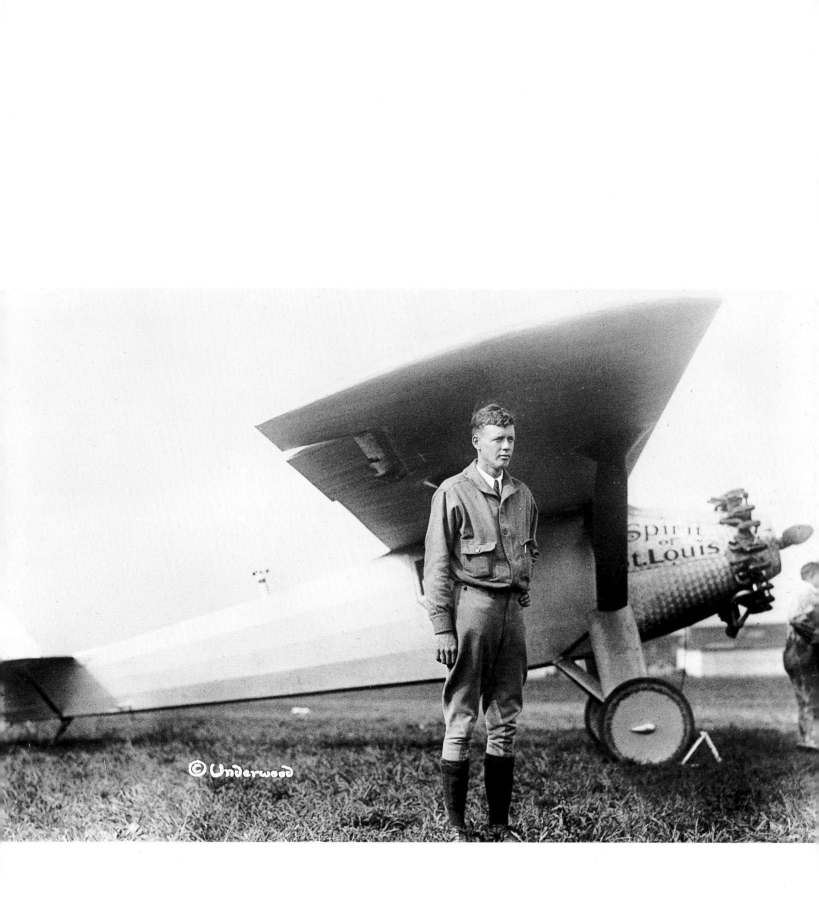

© Underwood

1927

DAILY NEWS EXTRA EDITION

Average net paid circulation of THE NEWS, Dec., 1927:
Sunday, 1,357,556
Daily, 1,193,297

NEW YORK'S PICTURE NEWSPAPER

Vol. 9. No. 173 36 Pages New York, Friday, January 13, 1928 2 Cents IN CITY LIMITS | 3 CENTS Elsewhere

DEAD!

Story on page 3

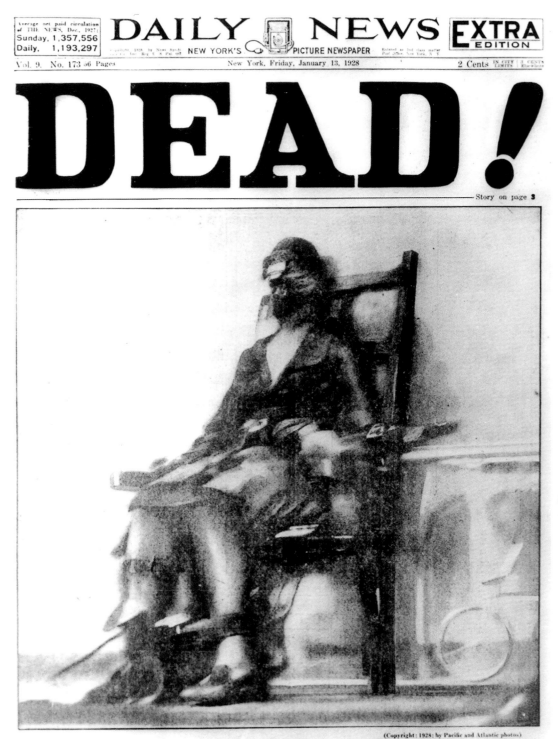

(Copyright: 1928; by Pacific and Atlantic photos)

RUTH SNYDER'S DEATH PICTURED!—This is perhaps the most remarkable exclusive picture in the history of criminology. It shows the actual scene in the Sing Sing death house as the lethal current surged through Ruth Snyder's body at 11:06 last night. Her helmeted head is stiffened in death, her face masked and an electrode strapped to her bare right leg. The autopsy table on which her body was removed is beside her. Judd Gray, mumbling a prayer, followed her down the narrow corridor at 11:11. "Father, forgive them, for they don't know what they are doing?" were Ruth's last words. The picture is the first Sing Sing execution picture and the first of a woman's electrocution.—*Story p. 3; other pics. p. 28 and back page.*

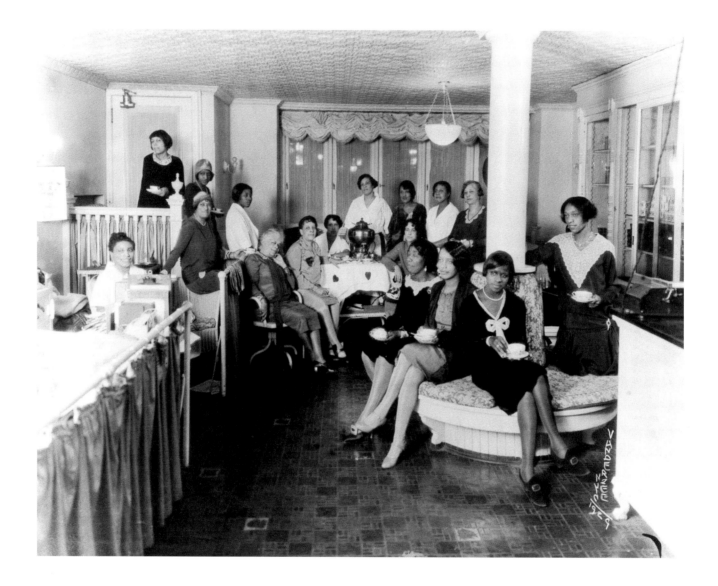

James Van Der Zee
Madame Walker's Tea Parlor.
(© Donna Mussenden Van Der Zee)

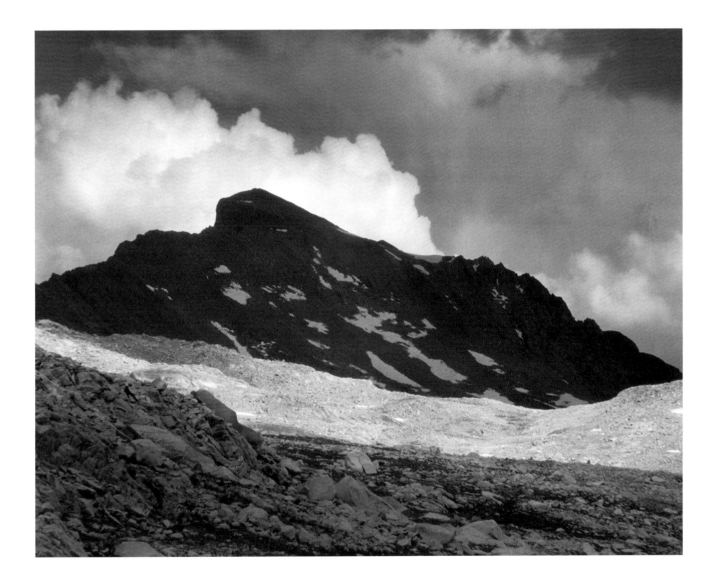

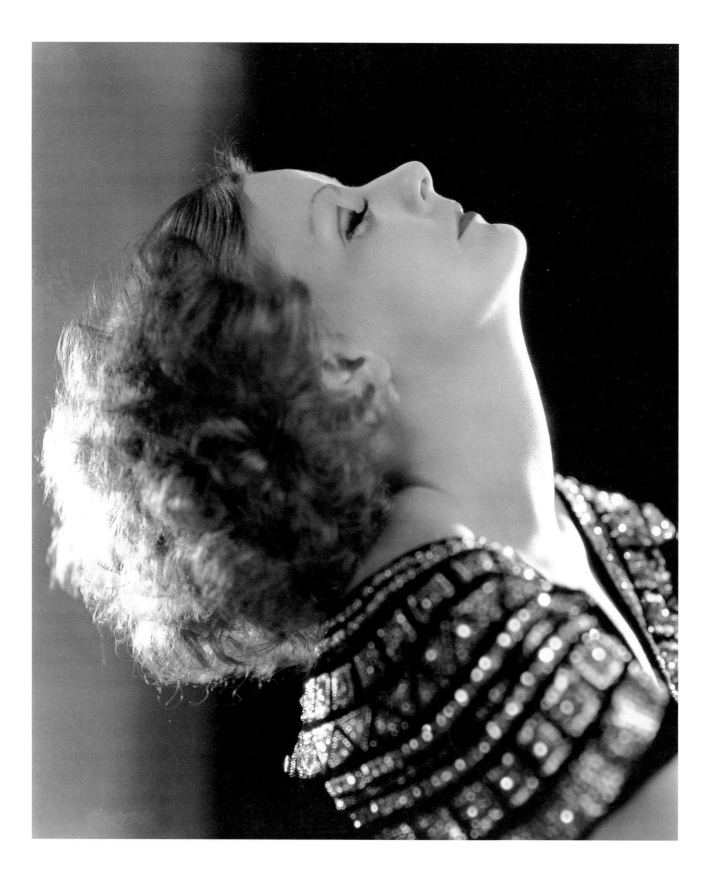

 1931 Clarence Sinclair Bull
Greta Garbo, publicity photograph for *Inspiration*.
(The Kobal Collection)

the cult of celebrity

Where once it was a sign of status simply to be able to have your portrait painted, the invention of engraving and of the printing press made it a matter of status to have your portrait desired by those who did not know you. Each new medium and means of distribution has added to the roster of the famous and the crowd of fame seekers. Photography put an exceedingly heavy emphasis on appearance and on being, and remaining, in view. It expanded the unknown and unseen audience of an image so enormously that it ushered in a new degree and kind of fame, helping to establish the cult of celebrity. Fame had depended on high birth or accomplishment; celebrity no longer did. As Daniel Boorstin put it, "The celebrity is a person who is known for his well-knownness."[1]

The industrial revolution and the rise of modern society undermined the significance of the individual even as democratic institutions emphasized individuality. As the yearning for a meaningful position in society intensified and its fulfillment became less likely, it was readily displaced onto the emblematic and

American politicians understood as early as Lincoln how useful photography could be in establishing their popularity with the electorate.

symbolic images of famous people, even if their fame was only a by-product of the information boom. Someone whose photograph is instantly recognizable is famous, whether mind and talent and deeds deserve that fame or not: Witness Al Capone and Monica Lewinsky.

American politicians understood as early as Lincoln how useful photography could be in establishing their popularity with the electorate. Teddy Roosevelt, though he complained bitterly about the intrusiveness of photographers on his presidency, played masterfully with the camera's potential both before and during his tenure in the White House. A photograph of him as a Rough Rider during the Spanish-American War of 1898 was so popular that a letter with no address but a drawn copy of this picture was delivered to his home.[2] Roosevelt had a formidable mind; one aspect of his brilliance was his knack for keeping the country supplied with images of him as a man of action—on safari, out West, on a steam shovel at the Panama Canal—who had overcome severe childhood illness.

Woodrow Wilson's public persona was more one-sidedly intellectual, but he too benefited from the tradition of providing leadership portraits meant to be treasured by patriotic citizens. Around the end of World War I, the Army arranged

Chicago Daily News, *Rogue's Gallery,
Al Capone mugshot*, 1931.
(The Chicago Historical Society)

a large group of soldiers, some in dark dress, some in light, to form a pattern that at a distance read as a profile of Wilson. A photographer was on hand to register this symbolic image of the democratic leader, commander in both war and peace, who, seen from the right vantage point, was revealed to be entirely composed of his loyal followers.

Other heroes were presented, and represented, to the public eye in photographs that extended their deeds and personalities through time. Babe Ruth was so popular and so easily recognized that his face beneath a straw hat stood

Someone whose photograph is instantly recognizable is famous, whether mind and talent and deeds deserve that fame or not: Witness Al Capone and Monica Lewinsky.

out in a photograph of him nearly drowned in a sea of young admirers. Japanese banzai attacks in World War II were preceded by cries of "Death to Babe Ruth!"[3] Eventually The Babe would be scrutinized from all angles by scores of photographers and became so familiar that Nat Fein's picture of him saying goodbye to his fans on his last day in Yankee Stadium is immediately recognizable, though it is only of his back.

Fame sold products. Actresses and opera stars lent their faces, usually anonymously, and hand-drawn rather than photographed, to product advertisements at the beginning of the century, and in the second decade famous actresses like Mary Pickford were paid to be identified in ads. By the end of World War I,

Eugene R. Richee
Clara Bow, publicity photograph for
It, 1926. (The Kobal Collection)

Above right: George Hurrell
John Barrymore, 1933.
(Courtesy of G. Ray Hawkins Gallery)

fame was already beginning to be thought of as a kind of personal validation, and many people wanted their pictures in the papers. Society women, their names prominently featured, frequently appeared in photographs endorsing everything from hand cream to fine china.

The most celebrated man of his time was Charles Lindbergh, who wasn't prepared for the fame of the media era. It nearly ate him alive. Lindbergh's feat of flying the Atlantic alone in 1927 was truly heroic, an achievement worthy of an earlier definition of fame. His made-to-order handsomeness made his image all the more valuable; photographs of him raced around the country in papers and magazines and on postcards that sometimes went by air mail. But when he tried to keep reporters and photographers away from his private life, that in itself became the story for news hounds who had to have some tidbit to relate. Lindbergh too became famous for being famous.

He was not without a desire for recognition. Before he took off, he had engaged a clipping service in hopes of seeing himself in the papers. The morning after he landed in Paris, the *New York Times* devoted its first five pages to his exploit except for a few ads on the fifth page; when he returned to New York a few weeks later, the *Times* gave him most of its first *sixteen* pages.[4]

Early in the century, businessmen and politicians dominated news reports of personalities, but by the 1920s entertainers were taking more space. This was partly due to the newest photographic medium, the cinema, and the still photographs that were intimately tied to it. Soon after 1910, as close-ups transformed actors and movie makers finally began to list their names in the credits, fan magazines sprang up. People could contemplate their favorites as long as

George Hurrell
Marlene Dietrich, ca. 1938.
(Courtesy of G. Ray Hawkins Gallery)

they wished, in private and at all hours. In time, studios discovered that they could launch actors inexpensively in still photographs alone. If the public responded vigorously to the still images, a movie career followed; if not, not.

In the late 1920s and 1930s, Hollywood studio photographers invented a mode of portraiture for portraying gods on earth. With tricky lighting and deft retouching, they turned out stars of marble and ambrosia, often more perfect than they were in the movies, where no one had quite so much time to spend on detail. This was artifice beyond a magician's dreams, a realm where looks and

Studio photographs of the stars offered fans the dream of limitless perfectibility, suggesting that the self was the new American frontier conquerable by force of will.

persona could be radically transformed overnight. George Hurrell took a picture of the young Joan Crawford in 1930 when she still had freckles; the freckles disappeared shortly thereafter with a wave of the retoucher's wand. Studio photographs of the stars offered fans the dream of limitless perfectibility, suggesting that the self was the new American frontier conquerable by force of will.

Fans wrote in, and the stars came back in the mail. The longing for closeness, and for a moment in the sun, was increasingly displaced onto photographs. Now teenagers plaster their rooms with pictures of their heroes or wear the stars' faces emblazoned on T-shirts. Grown-ups laughingly (and wishfully) pose with cut-outs of presidents to show off to their friends.

Nat Fein
Babe Ruth Bows Out, 1948.
(Courtesy of the photographer)

Publicity and fan photographs, imbued with beauty, sexual attraction, power, or merely the attraction of fame, create at once a fantasy of identification with glory, a momentary and pleasant delusion of intimacy, and subterranean rumblings of frustration. The photograph insists on its distance from the beholder, who can neither embrace nor equal the object of such longing.

The stars and their fame also offer a surrogate immortality in a secular age; nothing could do that better than photography, which seems to stop time and preserve the momentum of this fleeting life. When Rudolph Valentino, the secret lover in millions of women's dreams, died in 1925, a composite photograph showed him entering heaven. In the past, the beloved of the gods, like Ganymede, might enter heaven, and the holy figures of religion were expected to do the same. Human souls, like that of Count Orgaz in El Greco's painting of his burial, might go to heaven, and in relatively recent history, a few exceptional human heroes, like George Washington or Napoleon's generals, were depicted by artists entering heaven or Valhalla. But Valentino is probably the first person and certainly the first actor ever photographed during his ascension.

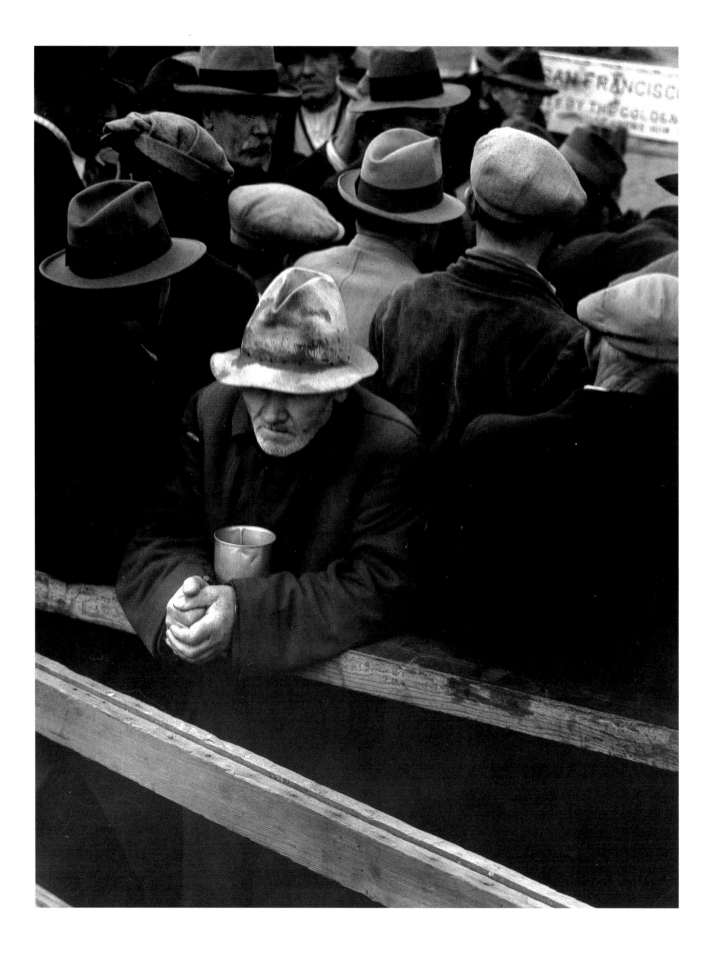

1933　Dr. Max Thorack
Homo Sapiens.
(© Chicago Museum of Science and Industry)

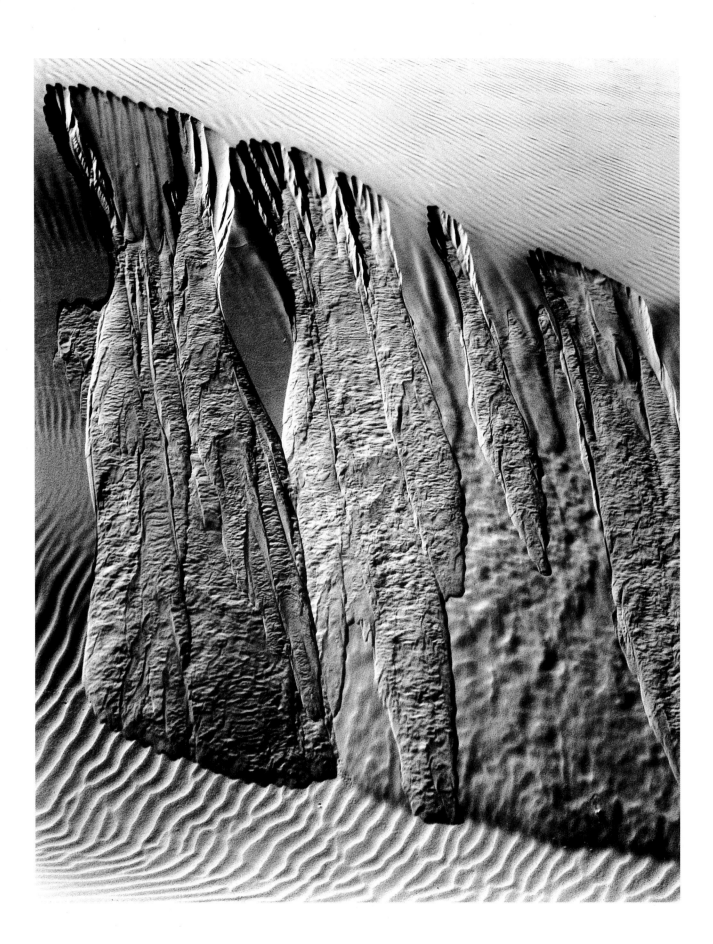

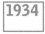 1934 Edward Weston
Dunes, Oceano.
(The Lane Collection, Museum of Fine Arts, Boston)

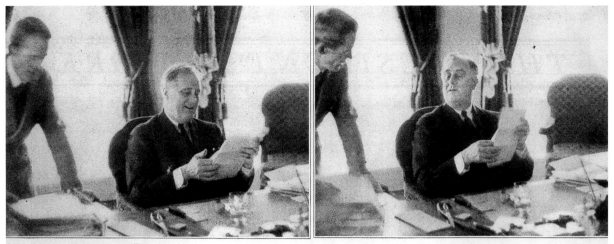

Hey, Hey! *Oh, Mac—*

Hah! *Eh?*

HE GRAPPLES WITH HIS DAILY DUTIES (Above)

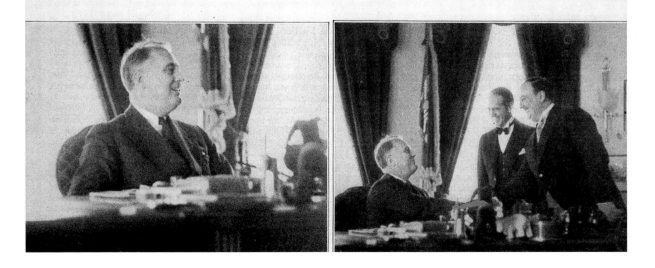

II.

the photographic age
1935–1959

II.

the photographic age
1935–1959

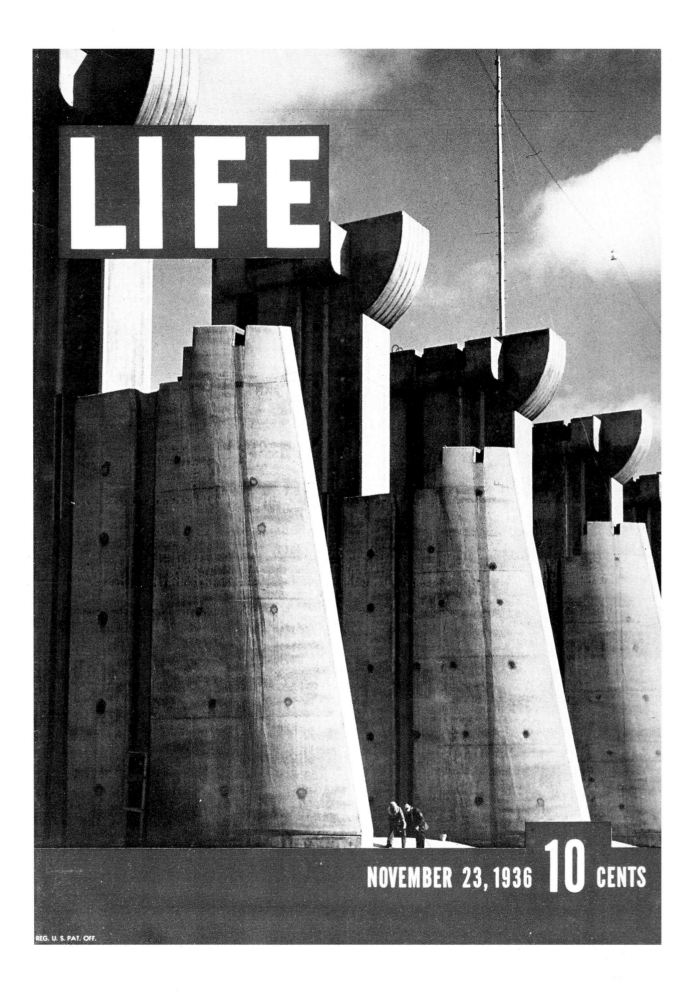

LIFE

NOVEMBER 23, 1936 **10** CENTS

 1936 Margaret Bourke-White
First *Life* Cover (Fort Peck Dam).
(Margaret Bourke-White/*Life* Magazine © Time Inc.)

LIFE and the rise of the picture magazines

By the 1930s, it was no secret to anyone that people responded strongly to photographs. The tabloids alone made this clear, though their spectrum was narrow, consisting largely of cheesecake and murder. People around the world trusted photographs and were becoming accustomed to them as bearers of more news and entertainment than before, yet photographs were not yet the integral part of life they have become. Hard as it may be to imagine today, the editors of America's first photo magazine in the mid-1930s felt obliged to write captions that would teach people how to read a photograph.

Germany invented the photo magazine in the late 1920s; the idea spread rapidly across Europe and Great Britain. America had a few good illustrated magazines, including Time Inc.'s splendidly printed *Fortune* (which began in 1930), but *Life*, which came out in November of 1936, was the first publication effectively modeled on the European precedent, and for a time the American entry was the most brilliant of its kind in the world.

The new photojournalism opened the doors of human interest wide and really did teach Americans something about America.

It reserved the center stage for photographs, which were expected to tell the story rather than merely illustrate it, though text and captions did heavier duty in *Life* than is generally acknowledged. The magazine was born of technical advances in printing plus the realization that a market existed for news, human interest, and a broad range of everyday information in photographic form. Fast-drying inks and thin, inexpensive, coated papers that could be used on rotary presses made it possible to turn out a large-circulation magazine on glossy paper with the best reproduction of any magazine of its kind. (Today that reproduction seems surprisingly disappointing; then its quality impressed even photographers.)

When the first issue appeared with Margaret Bourke-White's photograph of Fort Peck Dam on the cover and her lead story about New Deal, Montana, the town that had grown up to house the workers on the dam, the public took to the magazine as if they had been praying for it. The first printing of 200,000 sold out and the magazine went back to press. Again. And again. The presses finally stopped at 1.5 million copies.[1]

The time was more than ripe for a picture magazine. *Look*'s first issue came out a few months later, followed by a rash of short-lived imitators with names like *Click*, *Pic*, *See*, *Peek*, and *Focus*. *Life*'s circulation reached three million in 1940,

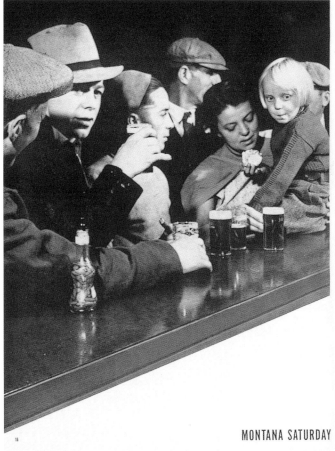
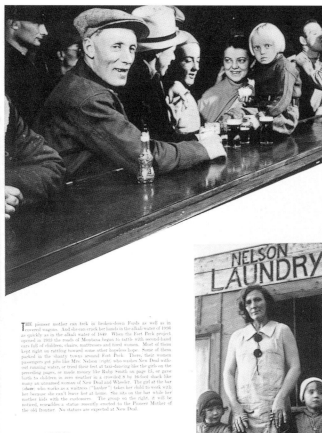

THE pioneer mother can trek in broken-down Fords as well as in covered wagons. And she can crack her hands in the alkali water of 1936 as quickly as in the alkali water of 1849. When the Fort Peck project opened in 1933 the roads of Montana began to rattle with second-hand cars full of children, chairs, mattresses and tired women. Most of them kept right on rattling toward some other hopeless hope. Some of them parked in the shanty towns around Fort Peck. There, their women passengers got jobs like Mrs. Nelson (*right*), who washes New Deal without running water, or tried their feet at taxi-dancing like the girls on the preceding pages, or made money like Ruby Smith on page 15, or gave birth to children in zero weather in a crowded 8 by 16-foot shack like many an unnamed woman of New Deal and Wheeler. The girl at the bar (*above*; who works as a waitress ("barber") takes her child to work with her because she can't leave her at home. She sits on the bar while her mother kids with the customers. The group on the right, it will be noticed, resembles a statue recently erected to the Pioneer Mother of the old frontier. No statues are expected at New Deal.

MONTANA SATURDAY NIGHTS: FINIS

Margaret Bourke-White
Interior spread, first issue of *Life*, 1936.
(Margaret Bourke-White/*Life* Magazine
© Time Inc.)

grew swiftly during World War II, and remained enormous in the years when there was no national newspaper and television was not quite yet the medium of choice; at its peak *Life* had eight million subscribers, and only began losing readers in 1969.

Bourke-White's grandiloquent photograph of the powerful repeating forms of Fort Peck Dam, built by the government, was visible evidence of New Deal efforts to get the country moving again. This image summed up a common faith in the glories of the machine age and the belief that technology would pull America out of the Depression. (The picture was, in fact, less than half the frame of her original photograph. The rest was unfinished construction. Magazine photography is not controlled by photographers. Here the editors excerpted the graphic elements that would come across loud and clear on the newsstands.)

Photographers with miniature cameras courted informality, a sense of unstudied casualness and intimacy, free access to previously unnoticed moments in daily life, unusual angles, a dramatic sense of on-the-spot immediacy, even danger.

Bourke-White's pictures of taxi dancers and of a baby on the bar in the lead story about the new Western frontier town were equally grand in their assurance and composition but a trifle ironic and just a tad saucy, inviting readers to be amused, intrigued, slightly superior, and perhaps a bit tickled to think the American spirit was still, by golly, full of vim and vigor. *Life* was a treasure house of revelations about America. The country's natural monuments had been shown

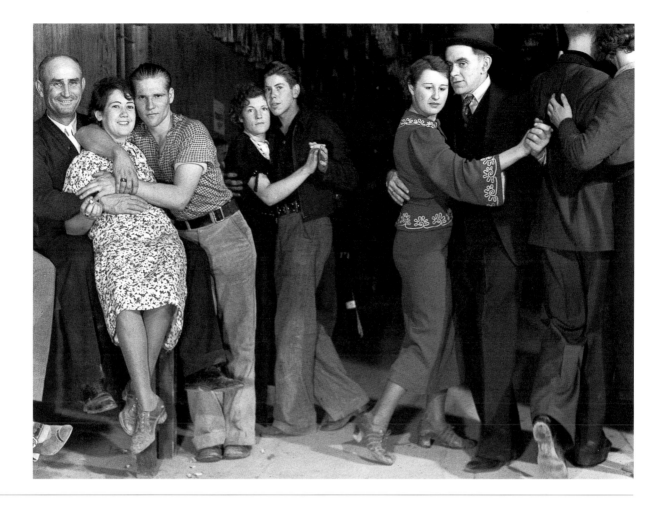

Margaret Bourke-White
Taxi Dancers, Fort Peck, from the first issue
of *Life*, 1936. (Margaret Bourke-White/*Life*
Magazine © Time Inc.)

countless times in photographs, but ordinary folks and everyday life had not. The new photojournalism opened the doors of human interest wide and really did teach Americans something about America, or at least, in a time when people did not travel quite so readily, about the way the nation and its citizens looked.

Life's strategy of picturing as wide a world as possible, including hardships and threats, was combined with an unspoken policy of buffing the image of America as "normal," industrious, resourceful, and family-centered. During World War II, the magazine was practically a propaganda arm for the government, much as the cinema was at the time, and after the war *Life*'s photographers and writers for the most part continued to view the American scene with affection and pride. The Depression and the threat of a European war having made news an urgent matter, the magazine from the beginning published some extremely hard-hitting photographs, including pictures of lynchings, murders, and sharecroppers barely subsisting on the ragged edge. But *Life* also generously dispensed optimism and expanded the standard journalistic menu of human interest and popular diversions. One commentator in 1938 remarked, with no more than the usual literary license, that the magazine consisted of "equal parts of the decapitated Chinaman, the flogged Negro, the surgically explored peritoneum, and the rapidly slipping chemise."[2]

In a way, *Life* invented photojournalism as it was known in America for the next forty years. Many of the top names in American photojournalism worked for the magazine at one time or another, from Bourke-White to Eve Arnold, Robert Capa, Cornell Capa, David Douglas Duncan, Alfred Eisenstaedt, Elliott Erwitt, Leonard McCombe, Ralph Morse, Carl Mydans, W. Eugene Smith, and others.

Before the photo magazine, photojournalists had been merely working stiffs, but *Life* turned a few photographers, like Bourke-White, Robert Capa, and [W. Eugene] Smith, into stars.

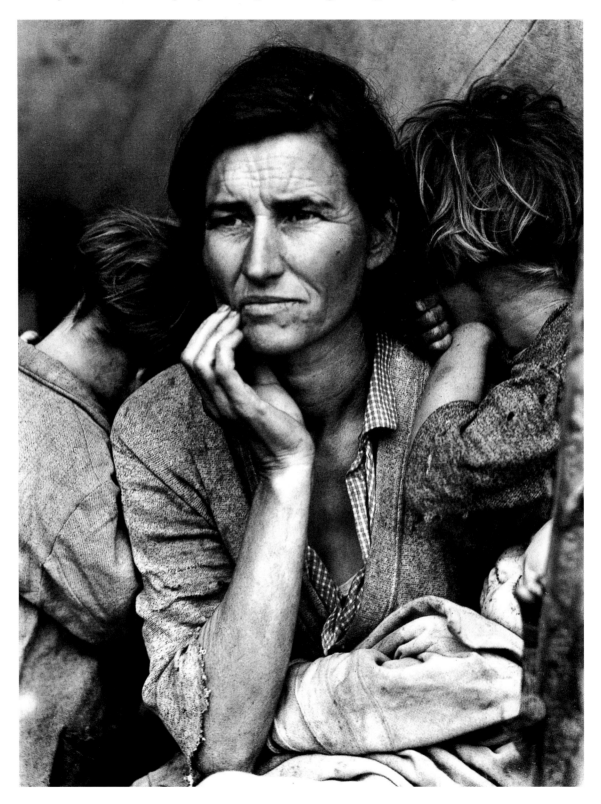

Opposite: Dorothea Lange
Migrant Mother, 1936.
(George Eastman House)

The photo essay, invented in Europe and adapted by *Life*, became the standard form. A collection of pictures and text put together by editors rather than photographers, the essay was meant to add up to more than the pictures alone but rarely did. Occasional essays, like W. Eugene Smith's "Country Doctor" and "Spanish Village," did propose a new and complex form.

From the beginning, most of the photographers (but not Bourke-White) used the miniature camera, which was still so new that newspapers disdained it. It became the instrument of choice for photojournalists. The Leica and other early 35mm cameras (and some of slightly larger format) were small, quiet, unobtrusive, easy to handle. A photographer could work fast, sometimes even unobserved, in available light, without a tripod or cumbersome lights. The revolution in street photography that had begun with the hand camera late in the last century now spread far and wide.

Photographers with miniature cameras courted informality, a sense of unstudied casualness and intimacy, free access to previously unnoticed moments in daily life, unusual angles, a dramatic sense of on-the-spot immediacy, even danger. Images of people appeared to be and sometimes were candid, with the subject caught at in-between times, no longer performing for the camera. Tom McAvoy showed how this was done in *Time* magazine in 1935 in a short series of pictures of President Roosevelt at his desk. This was the first time a president had permitted a photographer to snap him at will, as he worked, without posing—another instance, like FDR's fireside chats on the radio, of the president's keen understanding of the foremost media of his time.

With notable exceptions, photojournalism in *Life* was principally black and white until the 1960s, when color television proved heavy competition. Kodak put Kodachrome on the market in 1935 and other films followed, but black-and-white film was faster and required less light, and for years it took so long to make the color separations for the presses that topical stories ran the danger of being outdated. Black and white, the medium of Lewis Hine, Walker Evans, and the Farm Security Administration, remained the documentary color of honor for decades.

Before the photo magazine, photojournalists had been merely working stiffs, but *Life* turned a few photographers, like Bourke-White, Robert Capa, and Smith, into stars. The elevation of photographers to another plane was part of a program to make photographs themselves into stars, a program that had the exquisite backing of the cultural history of the time.

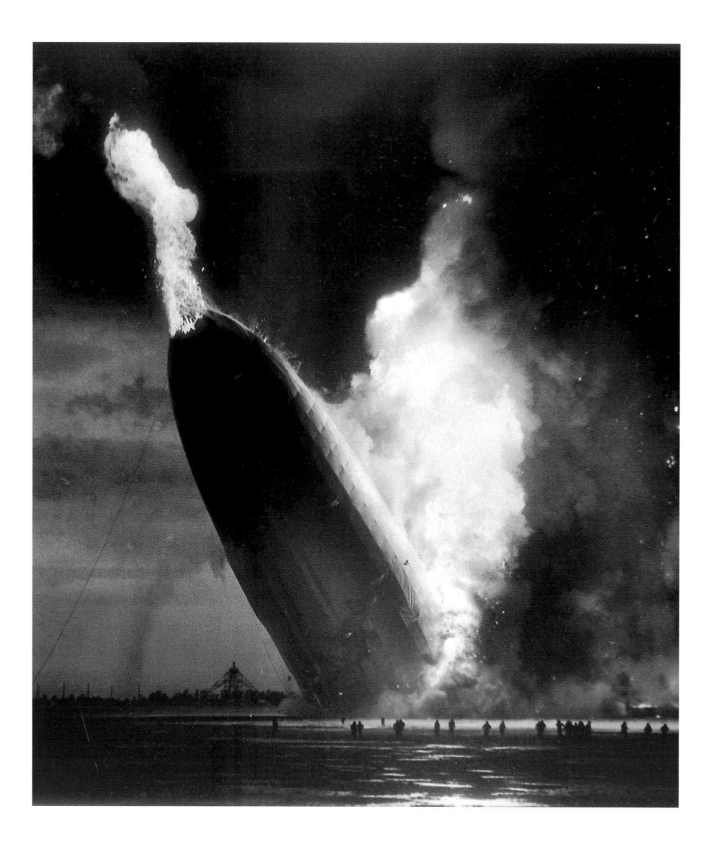

Murray Becker **1937**
Explosion of the Hindenburg.
(AP Wide World Photos)

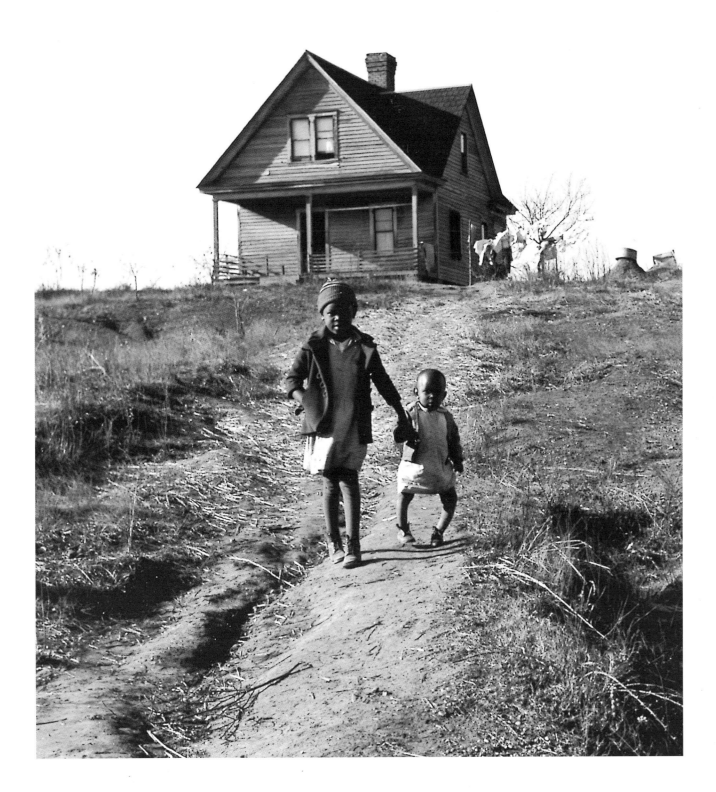

Marion Post Wolcott 1938
*Tenant farmer's children, one with rickets, on badly
eroded land near Wadsboro, North Carolina.*
(Linda Wolcott-Moore Fine Art Photography)

the wire services

When it came to news, speed always made a difference. The invention of the railroad shortened the time of delivery, and the telegraph shortened it further. By the end of the nineteenth century, when newspapers were printing some halftones, the yellow press went to elaborate lengths to get photographs into print faster by sending them on the fastest trains or ships. Then early in this century a breakthrough occurred, and in 1907 a photograph of a German prince was sent over a telegraph wire to America and printed on the cover of *Scientific American*.

Yet electrically transmitted photography remained a rarity well into the 1920s. It was usually blurry and always expensive, and there was generally a single telegraph line available with a lot of traffic lined up to get onto it.

The public was used to seeing pictures days after the written account—the first photographs of Lindbergh in Paris were published in the *New York Times* eleven days after he had landed.

Besides, photographs were not yet the crucial carriers of news and information. The public was used to seeing pictures days after the written account—the first photographs of Lindbergh in Paris were published in the *New York Times* eleven days after he had landed—and there was no pressure on newspaper editors to compress words and images into a single time frame.

By 1930 that was changing, as new media transformed the world. Radio had achieved national popularity, leaping across distances and raising expectations of access to information and entertainment. In 1923, a photograph had been sent by radio from Washington, D.C., to Philadelphia. The following year, Calvin Coolidge made the first live presidential radio speech, and his photograph took a cross-country journey by radio as well.[1]

In 1925, American Telephone and Telegraph (AT&T) set up a limited commercial wire-picture service between New York, Chicago, and San Francisco. Two years later, the Associated Press, which had dealt exclusively in word journalism, inaugurated a photo service, still using trains and planes.[2] Most editors were quite willing to put up with the delays. But then a new medium raised its head, alerting a few people to the prospect of a wholly altered world: Experiments with television in the mid-1920s proved that live transmission was possible. Clearly, TV would become practical one day, making newspapers unable to afford the wait for pictures.

The AP got the backing of a group of its member papers and on January 1, 1935, opened the AP Wirephoto, transmitting photographs over telephone wires to a twenty-four-member network in record time. The first picture on the wire was an aerial photograph of a plane crash, an apt reminder that bad news travels fast. Within months, three competing wirephoto services opened. Spreading the news in pictures to a wide audience in the shortest possible time had become not simply desirable but good business as well.

The climax of the trend toward rapid transmission of pictures and news came about by accident when the *Hindenburg* burst into flames as it landed in Lakehurst, New Jersey, on May 6, 1937. The zeppelin was on its first transatlantic voyage of the season, making its arrival sufficiently newsworthy to bring out a corps of reporters, twenty-two photographers, several newsreel photographers, and one radio announcer broadcasting directly to a Chicago station. The disaster happened just as the ship docked at its mooring tower, precisely in the viewfinders of all those poised to record it, a coincidence of place and time that made this the first major disaster ever so fully recorded as it happened. When the *Titanic* and the *Lusitania* had gone down in distant seas, words had been the only means of grasping the terror. The *Hindenburg* burst into flames virtually before the eyes of millions.

The new rapid-transit system for news went into action immediately. Tabloids were already printing numerous photographs; readers woke up on May 7 to full-page and half-page pictures of flame and crash and people running for their lives. The *New York Post* ran seven pages of photographs, the *Daily Mirror* nine. What's more, because of the wire service, papers across the country and in Europe printed many of the same pictures. People

The film was shocking, and images that close to direct experience were still so new that the audience often screamed out loud.

living at great distances were receiving the same news at the same time.

By noon on May 7, newsreels of the crash were showing in theaters in New York. (The first all-newsreel theater had opened in New York in 1929,[3] another indication of how avid people were for images of the news.) Later that day, film could be seen across the country, thanks to the relatively new system of air transport. The film was shocking, and images that close to direct experience were still so new that the audience often screamed out loud. The news went out by radio as well: The Chicago announcer's stunned and sobbing voice had been heard on his home network as the *Hindenburg* burned, and by

the next afternoon a national radio network picked up his broadcast and put it on the air.[4] Within twenty-four hours, people thousands of miles apart read and heard eyewitness accounts that were magnified by still and moving images taken on the spot.

Not long afterward, the cause of instant, on-the-spot transmission of news advanced via radio. During the Battle of Britain, Edward R. Murrow broadcast live from London, sometimes with bombs bursting in the background, as war sped by new means directly into distant homes. Only a few years later, words and images would be united on a small screen in the living room, and millions would tune in.

Photographer unknown
Plane crash in the Adirondacks, first image
sent out on the AP Wirephoto, 1935.
(AP Wide World Photos)

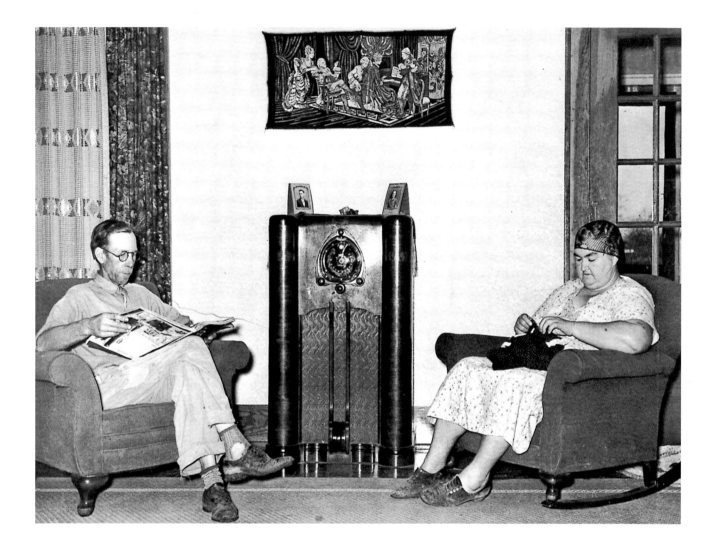

Russell Lee 1939
Hidalgo County, Texas.

the farm security administration (FSA): documenting the depression

They were to be shown displaying determination, strength, and dignity. The pictures could not portray despair, for that would suggest that their problems were beyond remedy.

PHOTOGRAPHS SHOW WHAT THE WORLD LOOKS LIKE NOW. They also show what the world looked like *then*. In both roles, photographs help to create a sense of shared, communal memory. When people think of America in the 1930s, odds are that the images that come to mind were created by photographers working for the Farm Security Administration (FSA), a government agency that sponsored the most famous and influential photographic project in U.S. history.

The project began in 1935 as the Historical Section for the Resettlement Administration, which in 1937 became the FSA. The director, Roy Stryker, was a social scientist who had studied economics with Rex Tugwell, a member of FDR's brain trust and the original head of the resettlement agency. Stryker wanted to use photographs to illustrate problems in the country and chart the agency's response, which took the form of making loans to farmers, building migrant camps, and initiating erosion and flood control. He was not a photographer himself but had the good sense to hire many exceptional ones, including Walker Evans, Dorothea Lange, Russell Lee, Carl Mydans, Arnold Rothstein, and Ben Shahn.

Stryker sent his photographers material on the areas to which they were headed and furnished them with lists of questions and related topics—the so-called shooting scripts. "How do people spend their evenings?" Stryker asked, then noted "listening to the radio" as a possible subject.[1] Though the photographers at times bristled at Stryker's attempts at control, they responded with some of the most famous images in American photographic history—including Lee's classic of a couple at home in the evening listening to the radio.

"We introduced America to Americans," Stryker said, and that's exactly what they did.[2] The FSA showed urban Americans their rural counterparts who had fallen on hard times and would have remained unseen had photographers not sought them out. FSA images were distributed for use in any and all outlets: exhibitions (including one at the Museum of Modern Art), internal government reports, publications ranging from *Life* and *Look* to *Junior Scholastic*, and several important books, including Walker Evans and James Agee's *Let Us Now Praise Famous Men*, Richard Wright and Edwin Rosskam's *12 Million Black Voices*, and Dorothea Lange and her husband Paul Taylor's *American Exodus*. One hundred seventy thousand prints and negatives are on file at the Library of Congress. Ordinary citizens can still buy copies at a minimal price.

From a certain perspective, FSA photographs can be construed as propaganda: They were, after all, government-sponsored images meant to create a favorable impression of government programs. For all the individualism of the photographers, there was often a shared outlook. The prototypical FSA image

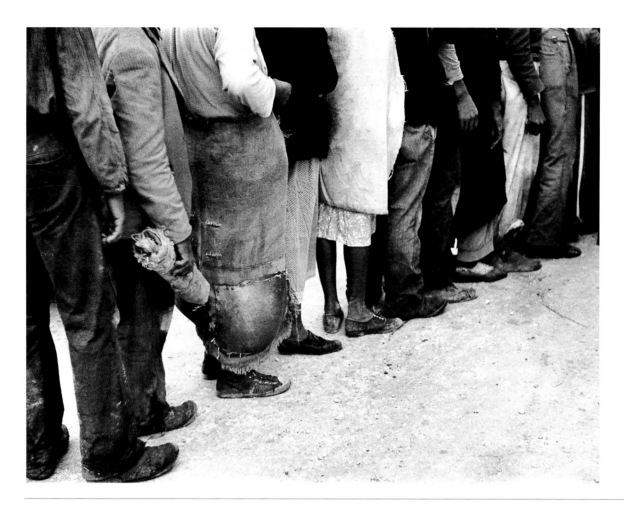

Marion Post Wolcott
Migrant Vegetable Pickers Waiting to be Paid,
1939. (Linda Wolcott-Moore Fine Art
Photography)

shows a man or woman with an exhausted, anxious expression echoed in the
gesture of a raised hand. Russell Lee told a woman in Minnesota in 1937, "We
want to show them that you're a human being, a nice human being, but you're
having troubles." Or as Stryker put it, commenting on a Lee photo, "Here is a fel-
low who is having a hard time but with a little help he's going to be all right."[3]
The proper balance was essential: Such people were down and in need of help,
but not out. They were to be shown displaying determination, strength, and dig-
nity. The pictures could not portray despair, for that would suggest that their
problems were beyond remedy.

The most famous FSA image of all, Lange's *Migrant Mother*, was also
Stryker's favorite: "She has all the suffering of mankind in her but all the perse-
verance too. A restraint and a strange courage. You can see anything you want to
in her. She is immortal."[4] Lange's picture conjured up strong feelings about
mothers and children. As John Ford said of the evocative power of that other
great maternal figure from the Depression era, Ma Joad in Steinbeck's *The Grapes
of Wrath*, "Everybody's got a mother." Many FSA photographs drew on an emo-
tional connection with women and children, but there were equally powerful
images of men, such as Lange's portrayal of displaced Texas tenant farmers who
supported an average of four persons each on $22.80 a month.

Action shots were rare, but at least one of the classic FSA images caught a
dramatic moment: Arnold Rothstein's shot of a farmer and his two small sons
moving toward a shed in the midst of a storm. All three seem to struggle against
the wind. Recently a scholar relying on other images in the FSA files suggested
that in an effort to create a more effective tableau the photographer may have

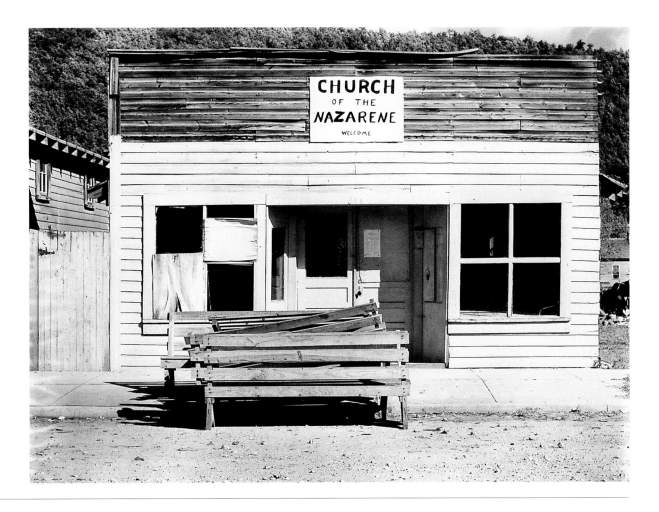

Walker Evans
Church of the Nazarene, Tennessee, 1936.
(George Eastman House)

asked the father to lean and the youngest son to fall back to make the wind seem stronger. Only those with a naive notion of photographic truth and no knowledge of how photographers often work will be shocked or surprised that Rothstein may have tried to make his picture more dramatic.[5]

Stryker encouraged a kind of systematic curiosity on the part of his photographers. They knew how to pay close attention to what they saw, and they documented more than people in need of help. Furrowed brows and gnarled hands may have been standard elements in FSA photographs, but so was the telling use of newspapers and signs as counterpoint. In Alabama, Rothstein photographed a young black woman next to a newspaper ad for the new wonder of cellophane; the ad features a white woman holding a "tempting variety" of baked goods. A number of FSA photographers noted an ironic juxtaposition of advertisements for the good life and the lives people actually led, as in Lange's image of walking migrants near a billboard with the caption, "Next Time Try the Train—Relax." The decor, the architecture, and the broader setting of the pictures were often as revealing as the expressions, gestures, and clothing of the individuals portrayed.

The landscape often formed a major element in FSA photographs. Stryker had asked for "quite a little effort in getting us good land pictures, showing the erosion, sub-marginal areas . . . the relationship of the land to the cultural decay."[6] The photographers responded with images of abandoned farms, eroded fields, and the bleak highway West that took scores of migrants to "sunny California."

The FSA subjects were, to borrow from Ma Joad's final speech in the film version of *The Grapes of Wrath*, "the people that live"—ordinary people, just folks. Occasionally an individual with power appears, such as a plantation overseer or a

The FSA subjects were, to borrow from Ma Joad's final speech in the film version of *The Grapes of Wrath,* "the people that live"—ordinary people, just folks.

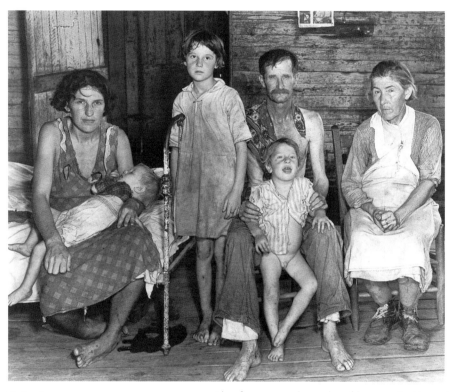

Walker Evans
Sharecropper Bud Fields and family at home,
Hale County, Alabama, 1936.
(George Eastman House)

deputy sheriff, only to be portrayed less sympathetically than the poor. For obvious reasons, the wealthy were almost never principal subjects. In one memo, Stryker insisted, "Absolutely no celebrities."[7]

The FSA photographers covered more than the Dust Bowl and rural areas. Deliberately echoing Grant Wood's *American Gothic,* Gordon Parks took his famous photograph of an African-American charwoman, Ella Watson, standing with her broom and mop in front of the American flag in a government office. Walker Evans worked largely in the South, but it was in Bethlehem, Pennsylvania, that he took his great image of a church graveyard with a tombstone cross in the foreground, workers' houses in the middle ground, and mills in the background. A woman once came to the FSA offices in Washington and asked for a copy of the photograph. She was the sister of a steel company executive and wanted to send it to him so she could say, "*Your* cemeteries, *your* streets, *your* buildings, *your* steel mills. But *our* souls, God damn you."[8] Not all FSA photographs were overtly or even covertly political, though the sympathy of the photographers for their subjects is unmistakable. Evans said that he was "critical" of American society—Lange observed that his work had a "bitter edge"[9]—but he insisted that he wished only to contribute to the historical record with "NO POLITICS whatever."[10]

Inevitably, however, the FSA was caught up in the politics surrounding the New Deal. When an exhibition appeared in New York City in 1938, the comment book was filled with opposing responses: "Teach the underprivileged to have fewer children and less misery," wrote one person. Another added, "Typical of the New Deal bunk," but yet another wrote, "Every comfortable person who objects to the present administration's efforts to help the poor in city or country should be made to look at these splendid pictures until they see daylight."[11]

As the war approached, Stryker stressed the need for more positive images, asking for photos of "people with a little spirit . . . who appear as if they really

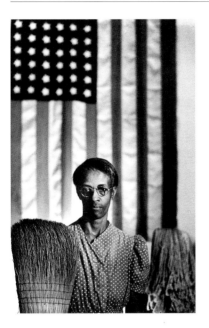

Gordon Parks
Ella Watson, 1942.
(© Gordon Parks. Courtesy of the photographer)

believed in the U.S." and of "the happy American worker."[12] He wrote Lee, "We particularly need more things on the cheery side." The FSA photographers had never relished the mandate to take photographs that accentuated the program's successes. Asked to photograph a resettlement camp supported by the FSA, John Vachon averred that he could come up with the "same old hash"—photos of mothers with laundry and children on slides. After years of productive effort, partisan politics and budgetary pressure finally took their toll. In 1943, after the program was shifted to the Office of War Information and the files were placed in the Library of Congress, Stryker resigned.

The FSA project is the single most important group effort in the history of American photography. It produced an unusually large number of memorable pictures, and remains the primary example of how photographs can be used to create a historical archive, as incomplete as such a visual archive may be as a record of a particular time and place. As a model of documentary practice, it remains the fundamental reference point for all later photography that addresses social issues.

There were contemporary criticisms of the FSA, often in the form of indirect attacks on the New Deal. In recent years, doubts have been raised about photography and its methods that had not occurred to an era with more trust in the medium. FSA photographers have been accused of taking advantage of their subjects, and of violating "objective" truth, as suggested in the case of Rothstein's image of the farmer and his sons. Evans, for his part, is known to have moved furniture and objects and carefully positioned his camera for the sake of orderly compositions, perhaps in the process depicting a different living environment. Some have also questioned the omission of certain photographs in favor of others that presented a situation in a particular light. Such criticism has its place. But the FSA existed in a different time, socially and photographically. The photographers may well have been aware of the imposition their cameras placed upon the good will of their subjects, many of whom were disadvantaged, but they surely believed that their cause was just, and it was their sincere wish to help these people out of their dire straits.

Beyond the strength—and fame—of individual photographs, it is the collective nature of the FSA project, its ambition, and its development of a model for making, presenting, and preserving images that continue to make the FSA a landmark in the history of photography.

MoMA, 1937: the history of photography comes to the museum

In 1937, the Museum of Modern Art (MoMA) in New York presented *Photography: 1839–1937*, the first major museum exhibition in America devoted to the history of photography. The museum was less than a decade old and had not yet attained its status as the preeminent museum of modern art. Yet the exhibition was a significant event, a formal acknowledgment of photography's importance in modern life and art.

Earlier in the century, Alfred Stieglitz had struggled to gain a foothold in the fine art world. In 1910, the Albright Art Gallery (later the Albright-Knox Art Museum) in Buffalo, New York, agreed to present an exhibition organized by Stieglitz. The exhibition presented more than six hundred photographs, most of them by individuals associated with Stieglitz. Despite Stieglitz's gargantuan efforts, however, other museums did not follow suit.

The MoMA exhibition was another story. *Photography: 1839–1937* attempted to place contemporary photography in a historical context and stake a broad claim for the importance of photography of all kinds. The young curator, Beaumont Newhall, had been hired to serve as a librarian but was also involved in photography. The museum's director, Alfred Barr, learned of this interest and gave Newhall the opportunity to organize a photography exhibition.[1]

Newhall's approach was unusually all-inclusive. It offered an introductory survey of many uses of photography as a medium rather than the history of photography as a fine art. Unlike Stieglitz, Newhall saw nothing wrong with mixing fine art and commercial, documentary, or scientific work. The catalogue to the exhibition was the first history of photography published in America.[2] It became

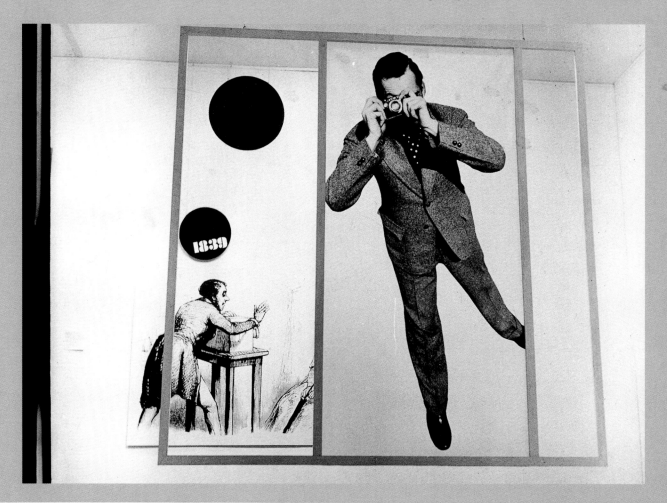

Edgerton's strobe experiments). To top things off, a film series accompanied the exhibition, so that even photography's importance in the movies was acknowledged.

As always with photography, the division of images into categories was problematic. The section on contemporary photography, dedicated to photography as art, contained portraits of artists and a shot of a nightclub dancer, straightforward sharp-focus images, and examples of avant-garde use of techniques such as double-exposure. What this diverse group of photographs had in common is not easy to say, but most of the images featured strong compositions and a dramatic use of light and shadow.

Some of the photographers included are now famous names: Paul Strand, Edward Weston (represented by six photographs of sand dunes, classic studies of natural form), Imogen Cunningham (three photographs, including two of her elegant close-ups of flowers), Walker Evans, and Ansel Adams. Others are virtual unknowns today.

In 1940, Newhall was appointed curator of the newly created Department of Photography. No such curator and no such department had ever existed in an art museum. (Photography, as a modern form, fits uneasily into art museums, which often follow nineteenth-century models of organization.) In Newhall's first exhibition as a regular curator, organized with the assistance of Ansel Adams, he took a more purely aesthetic approach to photography, addressing the medium in traditional art historical fashion by applying connoisseurship to pick the best prints by the best photographers, creating a canon of masters and masterpieces. His emphasis shifted to the photographer's individual personal expression as the essential factor in judging a photograph. As Christopher Phillips has noted, this approach represents "the ultimate guarantee against the charge that the photographic process was merely mechanical."[3]

The tension between an aesthetic approach to photography and a more cultural or functional perspective runs through the history of photographic exhibition, as is evident in the subsequent history of the MoMA program. Edward Steichen's directorship of the department began in 1947. He took yet another approach, epitomized by his organization of *The Family of Man* exhibition in 1955. Fine art photography would continue to be presented, but

a book, which Newhall later revised several times, and it remains in print today.

Since most people were unfamiliar with the history of photography, Newhall included in his survey an explanation of nineteenth-century technical processes such as daguerreotype and calotype. Their artistic qualities were

Szarkowski's taste has proven widely influential; many of the photographers he championed have become the classic photographic artists of the past fifty years.

not always explicitly emphasized, though there was a section on the "Esthetics of Primitive Photography." Other sections were devoted to "press photography," "color photography," "stereoscopic photography," and "scientific photography" (which included X rays and Harold

Harry Callahan
Eleanor and Barbara, Chicago, 1953.
(© Estate of Harry Callahan.
Courtesy of the George Eastman House)

Steichen's bias was toward photography as a vehicle for mass communication.

John Szarkowski took over as head of the department in 1962. He moved away from Steichen and staked his own claim for the presence of photography in a fine art museum, and in particular a museum of modern art, moving back toward a more aesthetic approach. His last major MoMA show as director of the department was *Photography Until Now* in 1989,[4] a survey for the 150th anniversary of photography that emphasized technological change, methods of distribution, and economics as aspects of photography, apparently in response to the repeated accusation that he had been concerned only with formal matters.

Szarkowski has been the most important curator, and possibly the most important individual, in American photography in the final four decades of the century. A fine photographer and an exceptional writer, Szarkowski interpreted photographs of all kinds—from news photos to scientific images—in terms of a photographic aesthetic based on what he regarded as the essential attributes of the medium.

Szarkowski's taste has proven widely influential; many of the photographers he championed have become the classic photographic artists of the past fifty years. Harry Callahan, Aaron Siskind, and Minor White were among the great favorites at MoMA during the

Szarkowski years. Siskind moved from social documentation to purist images that resembled contemporary abstract paintings. Callahan, working in a wide variety of styles, made a large number of images of his wife, Eleanor, that suggest a mythological view of the female nude, as well as others that present a less exalted, more everyday image. White, who became the first editor of *Aperture*, a major journal founded in 1952 and still published today, worked with a romantic, even mystical vision of nature and the body that recalled both Stieglitz and Weston.

The work of these three men demonstrates just how various are the modern fine art styles in photography. Through their own photographs and the work of their students—for they were important teachers in Master of Fine Arts and other advanced programs in photography—Callahan, Siskind, and White were dominant figures in the field of fine art photography.

There were, of course, many other significant fine art photographers, and many other kinds of photography. As Newhall demonstrated, photography is a protean instrument. How best to present the history of photography has been under continual reevaluation since Newhall's pioneering effort in 1937.

1940 Weegee
On the Spot.
(Weegee/ICP/Liaison Agency)

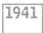 1941 Kelso Daly
*Pearl Harbor inhabitant watches
bombing by Japanese planes.*

world war II:
censorship and revelation

THE SPANISH CIVIL WAR, WHICH COINCIDED with the rise and proliferation of photo magazines, was the first war in history extensively documented in photographs seen by a broad audience in many countries. It was also the first war recorded in action with some frequency. In these as in other ways, that war was a practice session for the war that was to come.

In 1935, when Henry Luce was considering whether to found *Life* magazine, one of his advisers told him, "A war, any sort of war, is going to be a natural promotion for a picture magazine."[1] He was right. During the Second World War, *Life*'s circulation soared, and other picture magazines also benefited from public hunger for a view of war.

No war had ever been reported or photographed like World War II. Nor did anyone, by this time in history, underestimate the importance and power of photography. Wirephoto agencies, magazines, and newspapers that could afford it sent photographers overseas. Each service branch trained and fielded large numbers of photographers. Edward Steichen, who had briefly headed aerial reconnaissance photography in World War I, convinced the Navy to set up a photo unit not just for reconnaissance but to convey the human drama of the war. In 1948, a picture editor remarked that "World War II was a photographer's war."[2]

No war had ever been reported or photographed like World War II. Nor did anyone, by this time in history, underestimate the importance and power of photography.

A photograph by Kelso Daly of a man in pajamas on his terrace watching the attack on Pearl Harbor through binoculars speaks succinctly about this war. It was quite literally a distant war for Americans, who nonetheless watched it avidly. Looking over the shoulders of photographers, they saw battles on every front. The war came home in images: photographs, posters, paintings by artists at the front, newsreels, and documentary films made by the government for education and propaganda.

The public even saw some photographs made without direct human intervention. Cameras were activated by the trigger of a fighter pilot's guns, pictures were taken automatically through submarine periscopes, a color motion picture was made by cameras synchronized to a plane's wing guns.[3] These pictures were forerunners of images seen from the nose cones of smart bombs during the

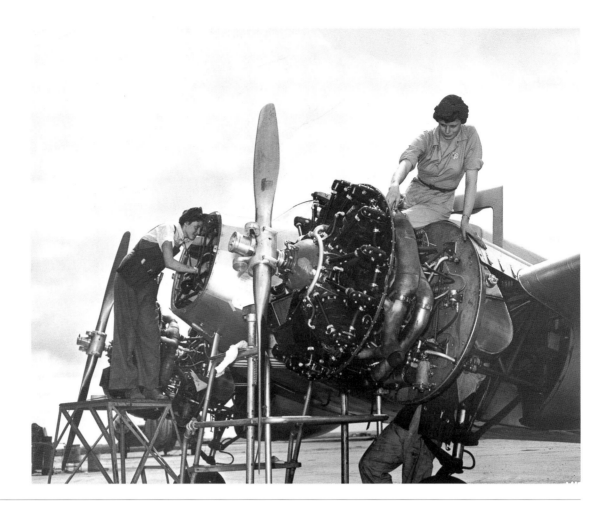

Photographer unknown
Women supporting the men by working as airplane mechanics, 1942.
(Boston Public Library)

Persian Gulf War. On top of all these eyewitness or camera-witness reports, Hollywood produced its own versions of combat, adding another layer of apparent closeness and actual distance.

Though soldiers on the ground doubtless thought the war too close, combat itself depended heavily on distant vision as well. In the battle of Midway, the opposing ships never came within sight of one another; the battle was fought between planes and ships. In *Shooting War: Photography and the American Experience of Combat*, Susan D. Moeller says that 80 to 90 percent of Allied information about the enemy was gleaned from aerial reconnaissance.[4] Even if this estimate is high, it signifies an enormous number of photographs taken from a great height and requiring a huge amount of sophisticated photo interpretation.

Images of dead Americans were not shown because the government and the military feared they would harm morale on the home front.

Radar, not an optical instrument but one that could be programmed for optical display, was developed at this time as another kind of distant vision. By 1940, British night-fighter planes were carrying on-board radar; by 1943, this could provide an image—a lighted silhouette—of the target below.[5] Pictures of one sort or another influenced the conduct of war as well as the understanding and perception of it. And yet, as in every war, censorship made certain that not too much was seen on the civilian front. The censors were not so draconian as

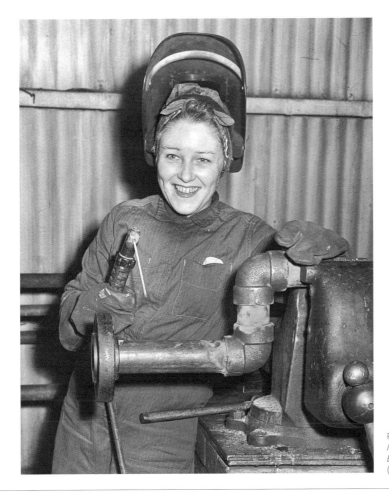

Photographer unknown
Mrs. Ethel Wakefield of Dorchester, welder at the
Bethlehem shipyard in Quincy since 1943, ca. 1945.
(Boston Public Library)

they had been in World War I, for by now the persuasive power of photographs
was continually being pressed into service. Yet only a handful of the photographs
of the attack on Pearl Harbor, which killed well over 2,000 people and effectively
destroyed the Pacific fleet, were published until a year later. For the first two
years of American involvement, no dead Americans could be shown, though pic-
tures of dead enemies, particularly the racially distinct Japanese, were published
throughout the war.

Ralph Morse's photograph of the screaming head that was all that was left
of a burned Japanese soldier was published in *Life* in 1943. Stills from an excruci-
ating film of a Japanese soldier running in flames to his death were published
two years later. (To maintain popular support for the war, active attempts were
made to demonize the enemy in word and image. Suspicion of the Japanese ran
so high that on the West Coast, American citizens of Japanese ancestry, some of
whose families had lived here for two or more generations and some of whom
had sons fighting on the American side, were interned in "relocation camps"
for the duration of the war. Photographers like Ansel Adams, Dorothea Lange,
and Clem Albers recorded the disrupted lives Americans imposed on some of
their own.)

Image controls were ever present. One of *Life*'s picture editors once tried
to get some pictures past the censor and was told they were "very interesting.
You may have them after the war."[6] Images of dead Americans were not shown
because the government and the military feared they would harm morale on the
home front. In the spring of 1943, with Americans complaining about rationing
and wage and manpower controls, Washington began to feel that its propaganda

1942 Clem Albers
*A young evacuee of Japanese ancestry waits
with the family baggage before leaving by bus
for an assembly center.* (National Archives)

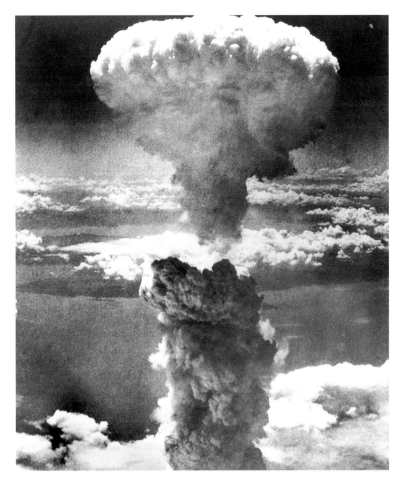

Photographer unknown
*Mushroom cloud resulting from atomic
bombing of Nagasaki*, 1945.
(Baldwin/Corbis-Bettmann)

had been too good and had convinced Americans that only the enemy was pay-
ing a price for war. Concluding that pictures could now be used to toughen up
the home front, President Roosevelt directed the military to release photographs
depicting American sacrifices and suffering.

In the summer, a few pictures of coffins or shrouded bodies were published,
but not till September were recognizably dead (but not identifiable) Americans
shown. The first example most people saw was George Strock's full-page photo-
graph of three dead marines on Buna Beach in the September 20, 1943, issue of
Life. A story about one of these men had appeared the previous February, but
permission to publish this picture had been denied. The magazine had com-
plained in print, saying, "If George had the guts to take it, we ought to have the
guts to look at it, face-to-face."

Many photographers used small cameras and got in close. (Robert Capa said, "If your pictures aren't good enough, you're not close enough.")

The photograph was calmly, almost classically composed, with the men
face down and their bodies apparently intact, but it not only displayed the death
of Americans who were sons, brothers, husbands, but also, in company with the
few horrific pictures of dead enemy forces, began to expand the limits of what
would be tolerated by the government, the military, the media, and the public.
When readers did look at this image, some were moved and some angered, yet

Harry Annas
Hispanic Father and Son, 1943.
(The Photography Collection, Carpenter Center
for the Visual Arts at Harvard University)

perhaps the government had been right and it was not entirely coincidence
that lagging war bond drives that used this picture soon met their quotas and
even exceeded them.[7] It wasn't long before a few pictures appeared of wounded
men who had been badly hurt and, unlike the happy patients of World War I
receiving visiting dignitaries, were clearly in pain and crisis and sometimes in
makeshift hospitals.

Photography changed the look of war. Not till the government permitted it,
of course. Like the rest of the country, the media were determinedly patriotic
and in fact followed the government line as if they were in its employ. Yet still
photographs exposed more of war's terror and violence and less of its glory than
before. An attitude was changing, and photography was hastening the change.

In the Second World War, action was omnipresent. Many photographers
used small cameras and got in close. (Robert Capa said, "If your pictures aren't
good enough, you're not close enough."[8]) Photographers were on the front lines,
on board ships, inside planes. They were also right next to the fighting men,
and the photographs now, on occasion, told more personal stories of individual
soldiers like Bill, who died on Buna Beach. Late in the war, in a very few instances,
the effects of exhaustion and loss on a particular man—the emotional corre-
lates of physical wounds—also came through.

War photography is an odd category that extends far beyond combat.
Civilians took up more space in this war's record than they had before, even on
the battlefield. W. Eugene Smith took harrowing pictures of Japanese women and
children being brought from their hiding places by U.S. Marines. Back in the
States, attention was paid to major changes brought on by the war, and Rosie the

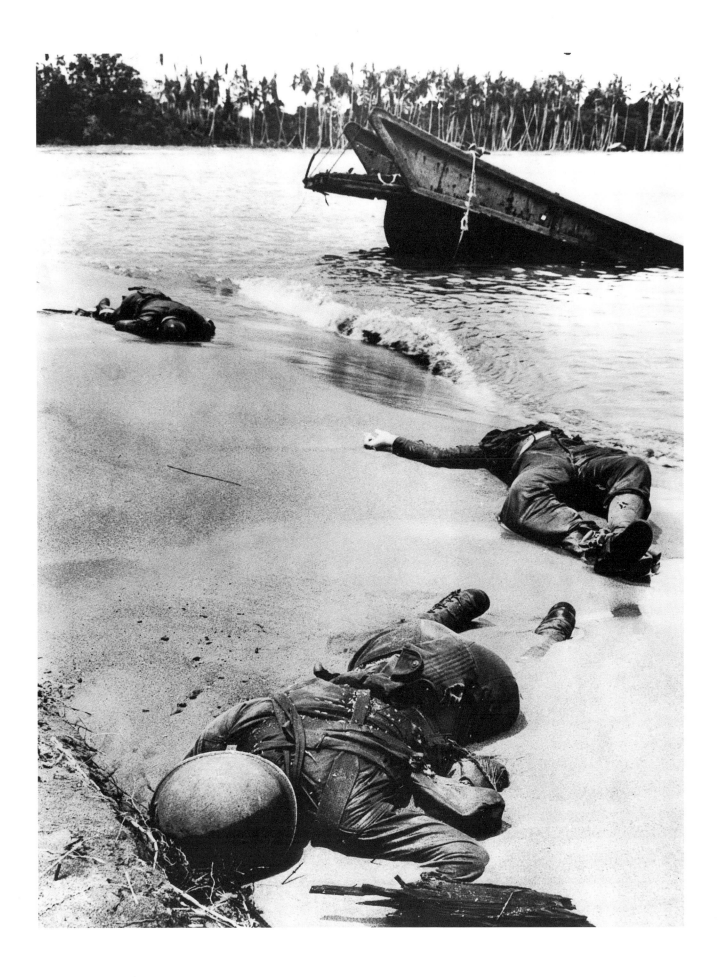

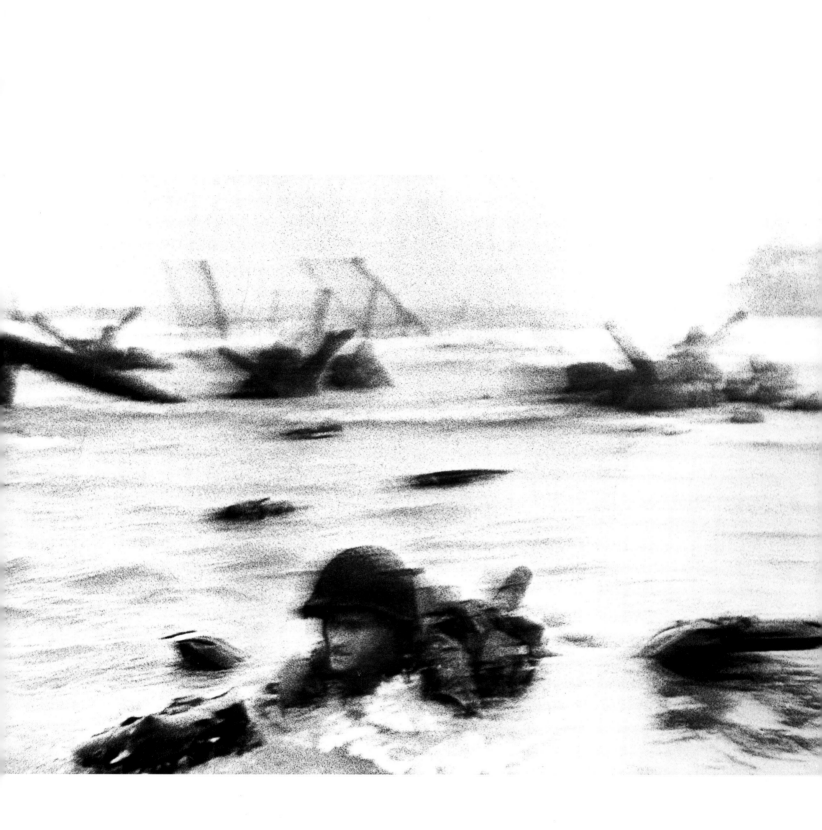

 Robert Capa
D-Day, Omaha Beach.
(© Robert Capa/Magnum Photos, Inc.)

Riveter was frequently shown competently performing the factory work that fighting men had previously done. (Photography also contributed late in the war and afterward to the campaign to get women out of the workforce and into the kitchen, making room in the workplace for returning soldiers.) Pictures of military men on living room walls or pictures of them home on leave are more poignant than ordinary portraits because the possibility of death lies more heavily on them.

World War II produced several emblematic photographs that outlived the war to become icons. Joe Rosenthal's photograph of the flag-raising on Iwo Jima was copied on a war bond poster, a postage stamp, even a bronze statue at Arlington National Cemetery. The photograph was such an instant and forceful symbol of victory that the Soviet photographer Yevgeny Khaldei consciously emulated it when Soviet soldiers raised the national flag over the Reichstag in Berlin, a photograph that in its turn became a Soviet icon.[9]

Carl Mydans's photograph of General Douglas MacArthur wading ashore in the Philippines also achieved iconic status; it is much more honored in memory than any bronze or stone statue of that memorable man. The photo-op, which was not yet called that, already existed in the 1940s, for photography's impact on

Capa's focus was correct and his camera steady enough. The darkroom assistant turned on too much heat, and the emulsion melted.

fame and opinion was a cultural commonplace. Some thought Rosenthal's Iwo Jima picture was posed, though it was not. MacArthur's picture was not exactly staged but might as well have been: According to Mydans, the general could have come ashore with dry feet on pontoons but, knowing what would make a dramatic image, directed his boat to let him off in knee-deep water.[10]

Robert Capa's photographs of the D-Day landings in Normandy constitute icons of an event, made by a photographer who was in as much danger as his subjects. Their authenticity is so indisputable and raw that they were echoed in the graphic D-Day sequence of Steven Spielberg's film *Saving Private Ryan*. The blurry quality of Capa's pictures added to their punch—a man being shot at in a swelling sea or on an open beach might well have trouble focusing. In fact, Capa's focus was correct and his camera steady enough. The darkroom assistant turned on too much heat, and the emulsion melted. The captions to the few pictures that were salvaged said Capa's hands were shaking.[11]

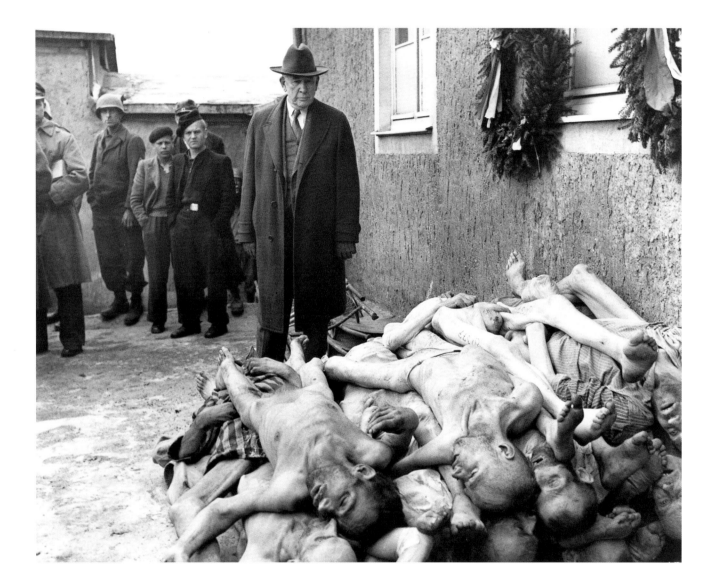

 1945 Photographer unknown
Senator Alban W. Barkley of Kentucky, Chairman
of the House Senate Committee on War Crimes,
Buchenwald, April, 1945. (National Archives)

The photographic witness could not be denied. The pictures had confirmed a degree of evil the world has yet to come to terms with.

A mistake in a darkroom made the pictures touch not only the fear (and the faint thrill for those who did not have to live it) of a dangerous maneuver but the extra emotional chord of sympathy and identification with the photographer himself. Capa was in the thick of it, the picture declared repeatedly, and the blur that supposedly signaled his understandable terror seemed to close the distance between the viewer and the war.

Then came the pictures from the concentration camps; they mark a divide in history and sensibility. The written accounts were incredible and in fact were often not believed. People remembered that the press exaggerated and were not prepared to believe that anything so unthinkable could occur as what happened at Auschwitz and Dachau. A few days after the written reports, the photographs came through and were published, usually on interior pages of the papers. Not long after that, the military released films that people went to see but could seldom bear to watch to the end. The photographic witness could not be denied. The pictures had confirmed a degree of evil the world has yet to come to terms with.

The war produced one last event that would indelibly mark history and consciousness: the explosion of the atom bomb. In this case, the news reports were more credible, but the magnitude of the destruction, plus uncertainties about what the new force would mean to humankind, made them bewildering. The photographs of the cloud over Hiroshima and later photographs of awesome and all-too-perfect mushroom clouds were easier to grasp. The image of the mushroom cloud, a visual shorthand for an unholy text, continues to burn in the mind.

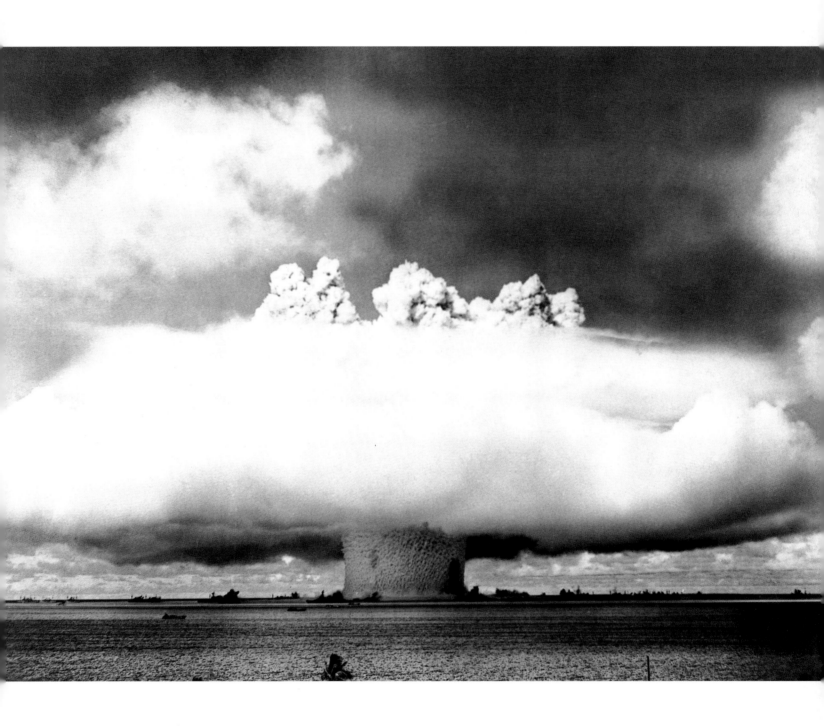

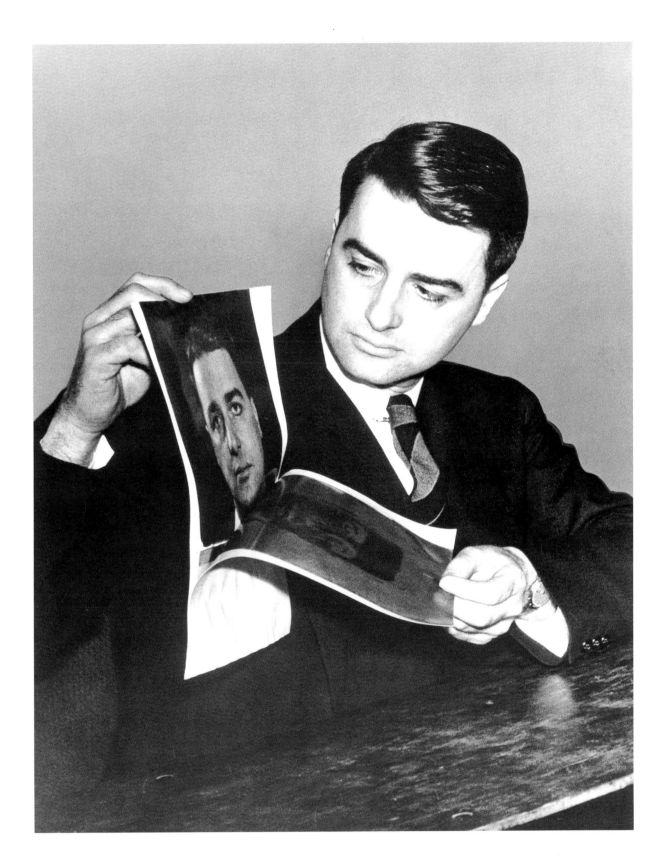

1947 Photographer unknown
*Edwin Land holding a positive print just
made with the new Polaroid process.*
(Polaroid Archives)

the photographic instant
and instant photography

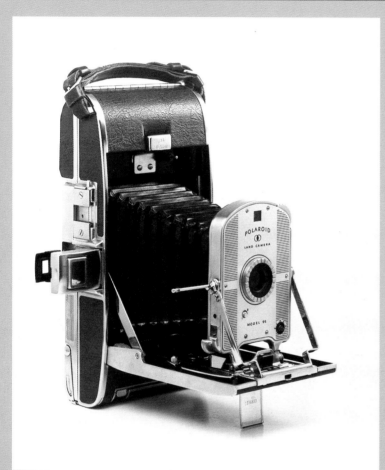

IN 1943, A THREE-YEAR-OLD GIRL ON A CHRISTMAS FAMILY vacation asked her father why she couldn't see the pictures they had just taken right away. She was no doubt asking what others had often thought: Why wait? Why does it take so long to get photographs back?[1]

For once, the impatience and ingenuousness of youth was rewarded. The question struck the girl's father, Edwin Land, as a challenge, and he set to work. A little more than three years later, on February 21, 1947, he presented the results to the public: the Polaroid instant photograph. The new product proved a huge success.

The Polaroid camera is a reminder that photography involves technology—optics, chemistry, mechanical know-how. Land was a scientist whose work had been devoted to the study of light. He had developed a polarizing material that reduced glare when used in sunglasses

and learned about photography and film while working to develop three-dimensional reconnaissance images during World War II. Through his own company, he was able to marshall the corporate resources necessary to meet the challenge posed by his daughter's question.

Land's famous invention, which sensitized and processed the film inside the camera with a separate chemical packet for each picture, radically shortened the time between taking an image and seeing it. Many inventions have dramatically changed other aspects of photography—color film and automatic focus, to name but two. Another major technological development has also affected the relationship between photography and time, but in a totally different fashion. When Dr. Harold Edgerton of the Massachusetts Institute of Technology developed the strobe flash, he made it possible to reduce exposure times and reveal sights far beyond the capabilities of the naked eye.[2]

Edgerton had a keen sense of drama evident in his choice of subjects: a bullet piercing an apple or exploding a balloon, a foot at the moment of impact with a football. His invention delighted ornithologists by revealing the wing movements and flight patterns of hummingbirds. It also had important practical applications for scientists conducting lab experiments, engineers studying manufacturing equipment, and military reconnaissance. An enormous strobe mounted on a plane was used to take nighttime pictures during World War II. The flash was so quick that the enemy hardly knew what had happened. The reconnaissance plane would be long gone and the scene once again dark before any real reaction was possible. Edgerton's company also developed the equipment that recorded the first atomic bomb tests: Photographs of the explosions were taken from a distance of seven miles using a ten-foot lens and an exposure time of 1/100,000,000 of a second.

The high-speed, reusable strobe flash soon became a basic piece of equipment for the professional photojournalist and the advertising photographer. Edgerton also developed specialized equipment to make photographs possible in outer space and in the depths of the ocean. The first pictures of the *Titanic* in 1985 relied on Edgerton's inventiveness. He was also partly responsible

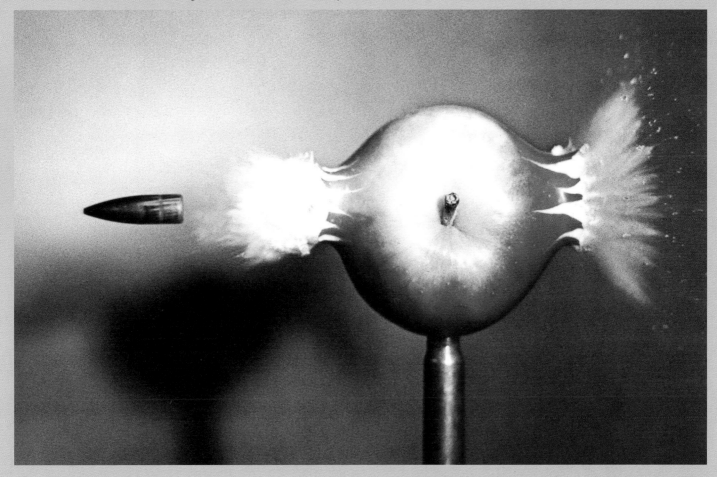

for the first photographs of blood circulating through the veins, images that, like X rays, extended human vision into the body.

Like Gilbreth's images of workers at their tasks, Edgerton's photographs have a formal appeal that goes well beyond their intended purpose. His bullet pictures and multi-flash photographs that broke motion down into discrete steps became fascinating, wildly popular novelties. Ralph Bartholomew used Edgerton's imagery as

The photographer Alvin Langdon Coburn said in 1918 that the camera is an instrument of "fast seeing."

the basis for a Playtex ad, showing the model's motion as a series of strobe-illuminated positions and providing yet another example of how advertising appropriates images from any and all sources.

The photographer Alvin Langdon Coburn said in 1918 that the camera is an instrument of "fast seeing."[3] He has been proven right. Time is fundamentally important in photography. The technology of time has resulted in serious commercial applications of the medium as well as in sheer, crowd-pleasing delight.

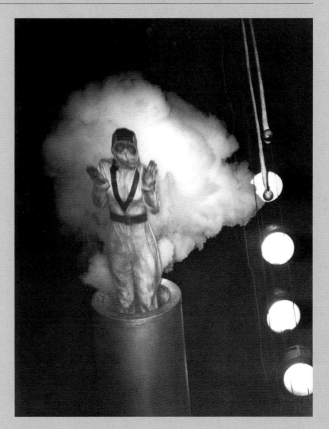

Weegee
The Cannon Act, 1952.
(Weegee/ICP/Liaison Agency)

123

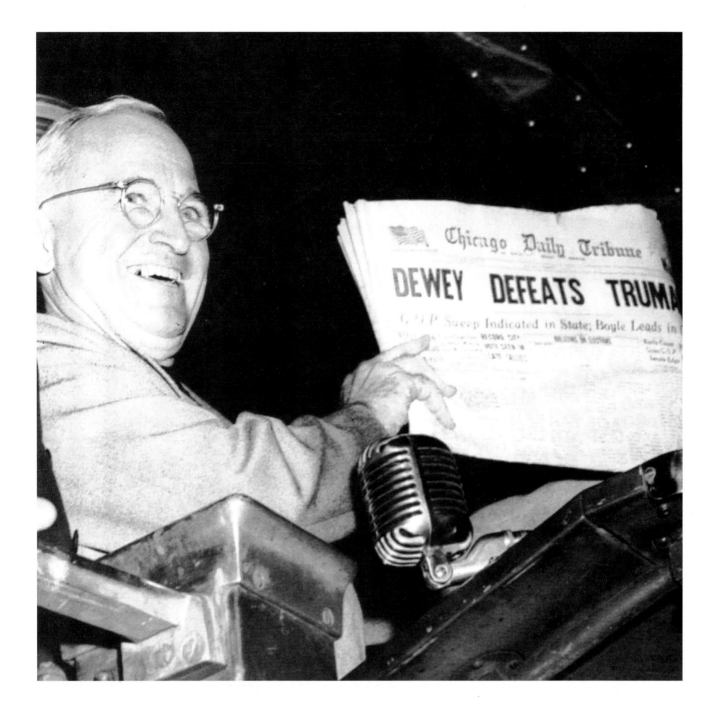

Byron Rollins
Dewey Defeats Truman.
(AP Wide World Photos)

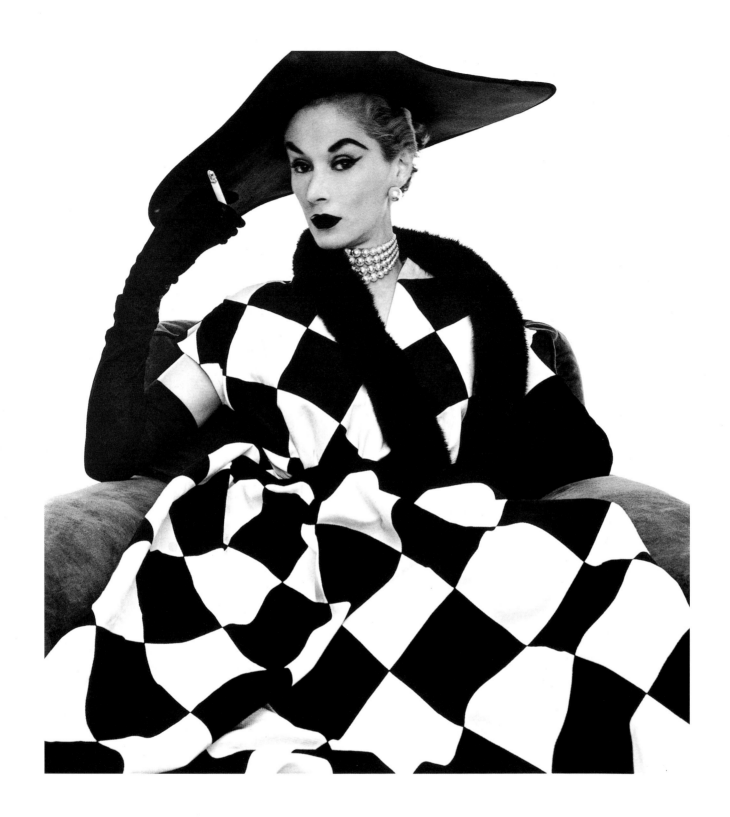

1950 Irving Penn
Harlequin Dress.
(© Irving Penn. Courtesy of *Vogue*)

fashion photography

Fashion consists
of shifting atti-
tudes, and fash-
ion photography
picks up on styles
in images as well
as clothes.

ALTHOUGH FASHION PHOTOGRAPHY CAN BE traced back to the middle of the nineteenth century, it only began to have any resemblance to a genre near the end of that century when clothing was manufactured for a larger middle class and photographs could be reproduced in magazines with broad circulations. Photographs were limited in number, and they were generally straightforward and descriptive until Baron Adolf de Meyer's moody, atmospheric, and romanti- cally lit Pictorialist images of the second decade.[1]

Then in 1924, just as photography was about to move in on fashion illustra- tion's territory, Edward Steichen injected modernism into the field, which would never be the same. Steichen's sharply focused photographs for *Vogue* had an up-to-the-minute look: He could turn society women and other models into images of the bracingly independent woman of the time, and he incorporated *art moderne* backgrounds and designs in a sleek, contemporary style.

In the 1930s, Steichen, who had an unerring sense of classical formality but couched it in modern terms, produced dramatic, high-contrast, boldly graphic compositions that resonated with an almost abstract elegance. Other photogra- phers of that decade, like Horst P. Horst and George Hoyningen-Huene, referred more explicitly to classicism. The decade's preferred tempo was stately, its ambi- ence ordered and harmonious.

Martin Munkacsi, a Hungarian-born photojournalist who arrived in the States in 1934, immediately introduced motion to fashion pages, and an element of not-quite-documentary realism and naturalism filtered into that refined and static realm. Fashion consists of shifting attitudes, and fashion photography picks up on styles in images as well as clothes. *Vogue* and *Harper's Bazaar* could not absorb social documentary or on-the-spot photojournalism, key though they were to the period, for they probably would have destroyed the fantasy and wish fulfillment at the core of the fashion world. Still, the door could be opened just a crack for the active woman who was waiting to come in. Toni Frissell, one of the many accomplished women who left their mark on this field, made fashion pho- tographs look like cleverly staged snapshots and took advantage of Munkacsi's breakthrough to show women in movement, whether languorous and dreamy or sudden and swift.

Fashion photography turned to color for obvious reasons even when color processes were truly painstaking, as they were before Kodachrome eased the way in 1935. One of the finest color photographers in the late 1930s, 1940s, and 1950s was Louise Dahl-Wolfe, whose sensibility was essentially conservative but who had a painter's eye for rich color and exquisitely balanced tones and was equally at home depicting opulent settings or women in what appeared to be relaxed

Avedon's adventurousness brought a bold inclusiveness into the realm of fashion photography.

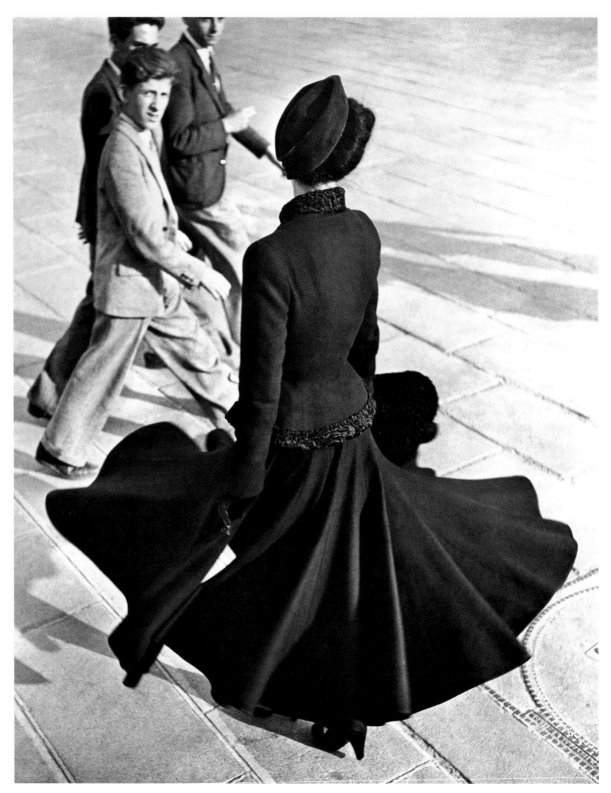

Opposite: Richard Avedon
Renée, The New Look of Dior, Place de la Concorde,
August 1947. (© Richard Avedon)

and casual moments. In later years, photographs by Hiro and others would make color rather than fashion the true subject of the picture.

In the 1940s, two art directors, Alexander Liberman at *Vogue* and Alexey Brodovitch at *Harper's Bazaar*, and two photographers they championed, Irving Penn and Richard Avedon, abruptly widened the range and attainments of fashion photography. Brodovitch and Liberman supported daring and individuality in photographers and with their innovative approaches to graphic design made their magazines into superb showcases. Fashion photography is destined for the page, and its effects depend on more than the photographer's talent. Like all editorial photography, it is a collaborative enterprise, but fashion involves an unusually large cast of editors, stylists, makeup people, hairdressers, models, and, not least, art directors.

Penn raised elegance (and photographic technique) to a rare level of perfection. Not overly concerned with the clothes, which were sometimes reduced to near-abstractions of tone and shape, he pared away everything he did not deem essential in order to concentrate on the model and a specific gesture—lips parting to receive a glass of wine, fingers touching a tongue to remove a speck of tobacco, eyes casting a sidelong glance. He believed that less is more and once said, "I always felt we were selling dreams, not clothes."[2]

His pictures were frequently taken in the studio against a plain if eloquently brushed backdrop. Penn erased the subject's context and made isolation itself a theme. With an absorption that was almost overwhelming, he directed the camera's loving gaze at the model, her beauty, and the way she wore and presented her essential femininity. His photographs are as cool as an engraved invitation

[Penn] created a kind of existentialist fashion photography in the postwar moment: perfection shimmering on the edge of entropy.

yet at the same time so fiercely concentrated that *Vogue*'s editors cut his space back in the 1950s, saying his pictures burned on the pages.[3]

Penn's goal was to bring order into the chaos of life, but he frequently undercut his own flawless image of a world preserved under glass, introducing a mouse into a sumptuous still life, adding flies to a window screen, revealing the raw edges of the backdrop behind a woman in an intricately constructed gown. In *Vogue*, he said, babies don't cry and fruit doesn't decay, but someone should say they do.[4] He created a kind of existentialist fashion photography in the postwar moment: perfection shimmering on the edge of entropy.

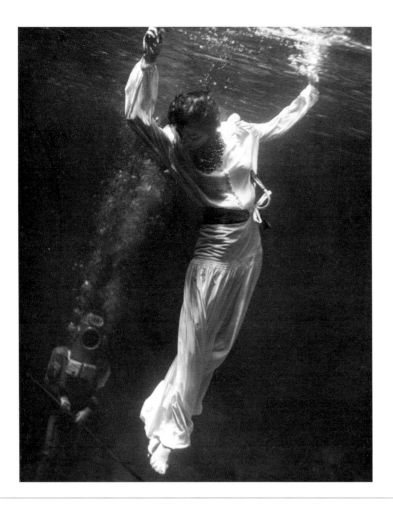

Toni Frissell
Woman in Fish Tank, *Vogue*, May 15, 1941.
(*Vogue*/Condé Nast Publications, Inc.)

Avedon, whom Penn has referred to as the greatest fashion photographer of the century, took off from Munkacsi's photojournalistic beginnings to show a world in motion on the streets in the 1940s and 1950s and then models leaping about a studio before a plain white backdrop in the 1960s and 1970s. His late 1940s photographs of the extravagant French postwar designs, which emphasized breasts, hips, cinched-in waists, and the luxury of excess fabric, depicted models fluidly descending steps or hugging a man or laughing, momentary images that were planned down to the last eyelash.

Avedon packed his images with narrative and incident—birds in flight, showgirls backstage at the *Folies*, disgruntled gamblers—and suggested emotions

Fashion photographers usually do advertising photography as well, as it pays better than editorial work . . .

ranging from joy to hesitation to despair, never for a minute covering up the artificial nature of his undertaking. A model in an *haute couture* suit watches acrobats on the street while posing with grand affectation among working-class Parisians. The picture unofficially winks; both photographer and model know that you know this isn't real.

Avedon's adventurousness brought a bold inclusiveness into the realm of fashion photography. Not a photojournalist, he parodied rapacious photojournalists in 1962 in an essay about a fictitious tryst between the model Suzy Parker and actor-director Mike Nichols. He put the first Eurasian and later the first black model onto the pages of *Harper's Bazaar*, threatening not to renew his

For two-thirds of the century, fashion photography flirted with realism without ever intending to commit itself.

contract in the former instance if the magazine did not cooperate.[5] A couple of decades later, he photographed an ad campaign for Dior as a serial story that kept people titillated week to week. Fashion photographers usually do advertising photography as well, as it pays better than editorial work, and for some years the ads and editorial pages have been hard to distinguish, heating up the competition for attention.

As the old hierarchies began to come apart in the 1960s and after, fashion magazines welcomed subversive elements that seemed to reflect contemporary culture. William Klein broke all the rules in the '60s, sometimes sending up fashion even as he praised it—posing a model in a waxwork museum display as if to ask which was the mannequin, arranging a surprise encounter between a well-dressed model and a painting of a nude. In the 1970s, Helmut Newton brought European levels of sex and violence to American fashion pages and Deborah Turbeville opened up poetic and sometimes disturbing vistas of melancholy and alienation.

By the 1980s, it was so chic to be contrarian, or impolite, or artistic, that a couple of designers published photographs by Cindy Sherman that turned their already far-out designs into bizarreries. At that point, both fashion and advertising photography, which had long paid deference to art, were picking up on contemporary art movements almost as quickly as artists could come up with them. This rapid adaptation of artistic experiment, so bold it occasionally resembled theft, was meant to signal "with-it" stylishness at first glance. Like advertising photography in the 1920s but now absorbing change at warp speed, fashion and advertising photography in the last quarter of the century spread what might have been elitist styles rapidly to a wide audience.

For two-thirds of the century, fashion photography flirted with realism without ever intending to commit itself. Neither dreams nor glamour can withstand too heavy a dose of realism, but since the camera is programmed to reproduce something real, fashion (and advertising) photography get a little boost in viewer response just by being photographs. There is very little that is more artificial, more pampered and corrected, than a picture of a model, who was more nearly perfect than the rest of the world to begin with and additionally has been tucked and cinched and uplifted and fitted, with every flaw painted out and new beauties painted in. She has been posed and lit to stupendous advantage and afterward printed, retouched, and cropped to the same, her waist whittled away and her bosom inflated by the retoucher's brush or the pixels of photoshop. The viewer, knowing no waist was ever that small, cannot help for an instant mourning her own girth and yearning to achieve a perfection possible only on paper.

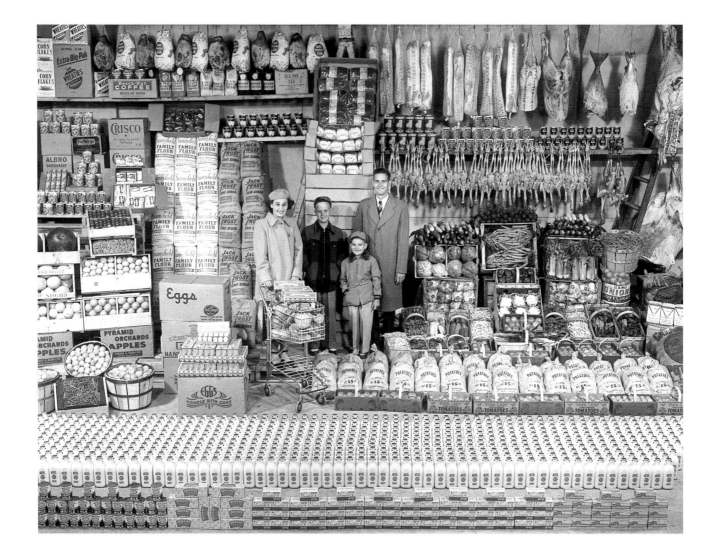

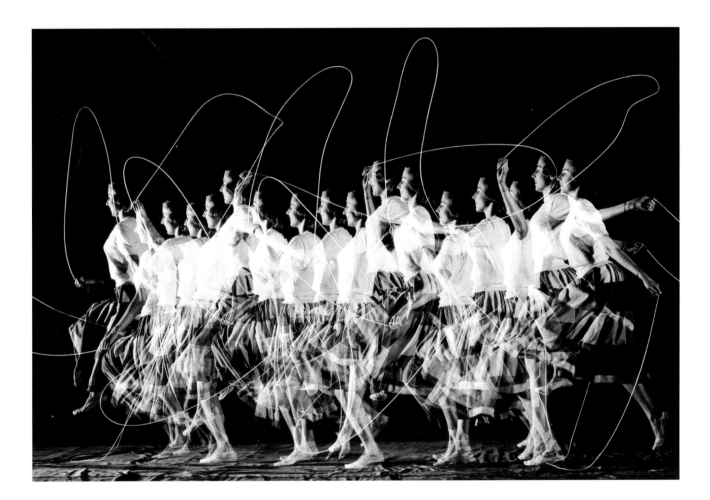

 Harold Edgerton
Moving Skip Rope.
(© Harold and Esther Edgerton Foundation, 1999.
Courtesy of Palm Press, Inc.)

sex and voyeurism

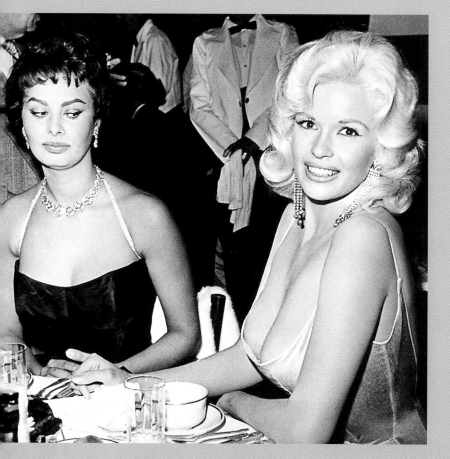

In Nathaniel Hawthorne's *The House of the Seven Gables*, the heroine was ill at ease with the photographer because he was such a cool observer. When hand cameras came along, people felt so spied on that a cartoonist drew a lady wearing an "Anti-Camera Shade" that covered her from the gaze of frustrated male photographers.

The discomfort of peering too closely at others persisted. When James Agee went south with Walker Evans in the 1930s, he wrote that it seemed to him curious, "not to say obscene and thoroughly terrifying," that an organ of journalism should "pry intimately into the lives of an undefended and appallingly damaged group of human beings,"[1] which he and Evans proceeded to do in word and photograph.

American Puritanism and law kept the sexual potential of photography in check for a long while. Titillation, however, was acceptable, and eventually advertisements, billboards, and television made it unavoidable. As early as the 1890s, cigarette manufacturers enticed men with photographic cards of women in scanty dress. Later, mattress ads showed women asleep, stocking ads showed them getting dressed, movies showed stars in their bedrooms—all visions of strangers not ordinarily available. Photographs of young women in tight or skimpy clothing bolstered the circulation of tabloid newspapers from the 1920s on. *Life* magazine, a mainstream journal, photographed women in bathing suits on any excuse whatever and in its first years ran a decorously suggestive photo essay on "How to Undress for Your Husband." Pinups like the wartime photographs of Betty Grable and Rita Hayworth were a PG-rated alternative to the undress of girlie photographs on calendars.

At the legal level, restrictions on sexual matter in literature were overturned long before restrictions on imagery, words being less threatening than pictures. The Supreme Court's acceptance of Joyce's *Ulysses* in 1933 and of Henry Miller's books in the 1950s preceded the public display of most comparable illustration. And photography's apparent realism remains a stumbling block. Controversial photographs by Robert Mapplethorpe might have been ignored had they been paintings instead. Photography feels too much like being there.

The story of photography's contribution to the expanding field of voyeurism is largely the story of polite

THE CAMERA IS AN INHERENTLY VOYEURISTIC INSTRUMENT, a peephole on the world, a little box that partially hides you and allows you to stare impudently at someone or something with or without permission. By coincidence, photography came along just as many Western nations were putting limits on public displays of death and sexual matters, while the modern city was simultaneously developing opportunities to peep at strangers on streets and trains and in department stores. Photography was on the side of the unrestricted, sometimes stolen view.

The camera's capacity for sexual seduction was immediately understood, and a sizable pornographic industry sprang up in short order. Less explicit pictures could also pack a disconcerting amount of sex; in England in 1861, a court case was brought against "provocative and too real" photographs on public display.

The photographer's advantage over the subject and the medium's resemblance to spying made some uneasy.

American Puritanism and law kept the sexual potential of photography in check for a long while. Titillation, however, was acceptable . . .

society co-opting the wider prerogatives generally granted to the less polite. This speeded up after World War II. Once Alfred Kinsey published *Sexual Behavior in the Human Male* in 1948, sexual taboos started to bend. In the early 1950s, when Marilyn Monroe was threatened with blackmail for having posed nude for a calendar, she turned the tables by confessing and saying she'd been so broke she took the job for fifty dollars. It worked. The public thought it so degrading to take off all your clothes for a measly fifty bucks that the response was sympathy. In 1953, when Hugh Hefner founded *Playboy*, dignifying his girl-next-door-takes-it-all-off centerfolds by surrounding them with literature, that calendar had the place of honor.

Advertisers grew bolder. The already established practice of adding a sexy woman to any sales pitch soon went into high gear. Photographs of women in bras and girdles were commonplace at the time, but Maidenform's "I dreamed I sailed down the Nile in my Maidenform bra" (and other adventures) ads supposedly appealed to women's exhibitionistic desires and certainly made the undress more risqué by making the dress so elaborate.

Fashion magazines, committed as they were to women's bodies and to turning out women dressed to attract male gazes, should have been proof enough that women as well as men liked to look at women's bodies. By the mid-1930s, these magazines and a few advertisers published an occasional nude from the back; more were on the way. Then in 1961, *Harper's Bazaar* published Avedon's photograph of Contessa Christina Paolozzi, who was not only frontally nude to the hip but also identified by name, and a countess to boot. The sexual revolution was beginning.

In 1965, Avedon photographed a strangely alienated *ménage à trois* and in 1974 updated it with a much more openly sexual group. By that time, European photographers were injecting broad hints of female sexual aggression, lesbianism, and violence into the fashion mix, mainly in *Vogue*. The subscribers, primarily upper-middle-class women in the suburbs, were offered a mixed menu of voyeuristic choices in magazines aimed at heightening their readers' attractions.

Art (and art photography) has been permitted to address the body in a way commerce was not (or at least for a long while was not), though display and publication can be problematic. Social and artistic changes affected this branch of photography too. The feminist movement prompted women to exhibit a different kind of interest in bodies: In the 1960s, Carolee Schneemann was photographed nude in the middle of a three-dimensional painting-construction in her studio, in the '70s Eleanor Antin photographed herself nude over a period of progressive weight loss, and in the '80s Nan Goldin photographed herself and her friends in bedroom and bath.

Calvin Klein's advertisements and Bruce Weber's photographs are largely responsible for turning men into openly acknowledged objects of voyeurism. In 1982, a billboard in Times Square displayed a muscular young man wearing nothing but briefs and lolling about like any old sex object for all to see. Weber's images in *GQ* spoke as openly of male sexuality as fashion magazines did of female. At last someone had acknowledged that the homosexual community had its desires, and that women did too. With the advent of AIDS in the 1980s, sexy male imagery proliferated, a poor substitute for the real thing with all its dangers. In the 1990s, Klein's ads showing sexually active adolescents created an uproar that made him withdraw them—giving him yards of extra publicity. Acceptable voyeurism stops at the age line.

Photographic technology wittingly or unwittingly continued to widen the possibilities for voyeurism in everyday life. The instant camera did its share of home sex scenes, the hand-held video camera has done more, and home videos that couples shoot of themselves making love have become big items in video shops.

Voyeurism is not only about sex but also about looking at anything prohibited. It hardly needs saying that as sexual permissiveness in the visual arena has increased, the amount and degree of violence permitted in widely published photographs has also risen, from the grisly instances in World War II to the hundreds of dead gangsters on Weegee's contact sheets to the horrors of Vietnam and Rwanda and beyond. It was nature rather than photography that made us voyeurs, but it was photography and modern media and the imperatives of the consumer society that brought so much material out of hiding and put it directly before our eyes.

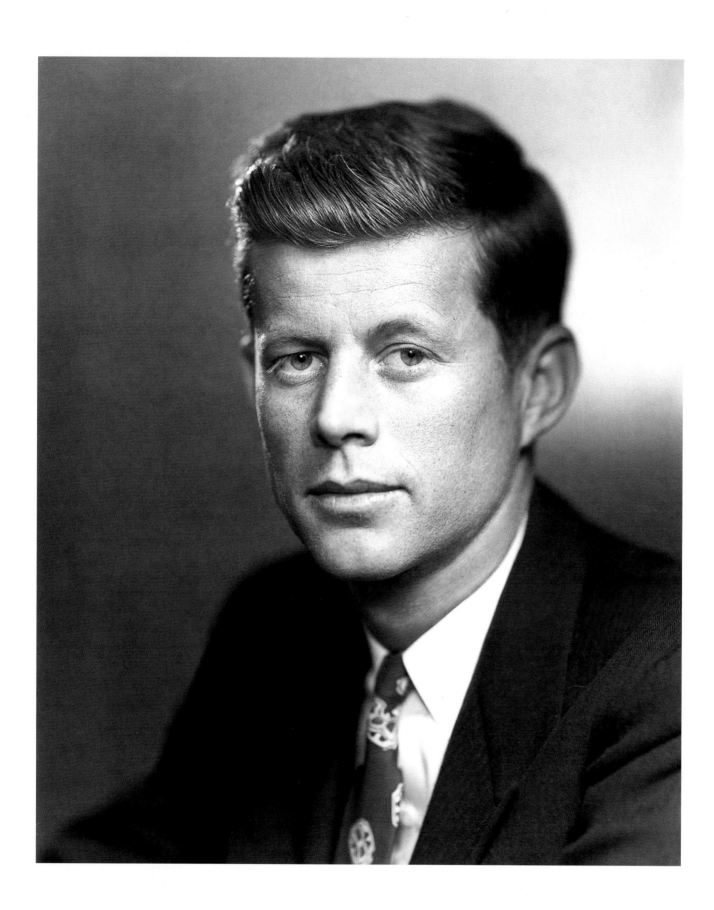

 1953 Bachrach Studio
John F. Kennedy.
(Bachrach Photography Studio)

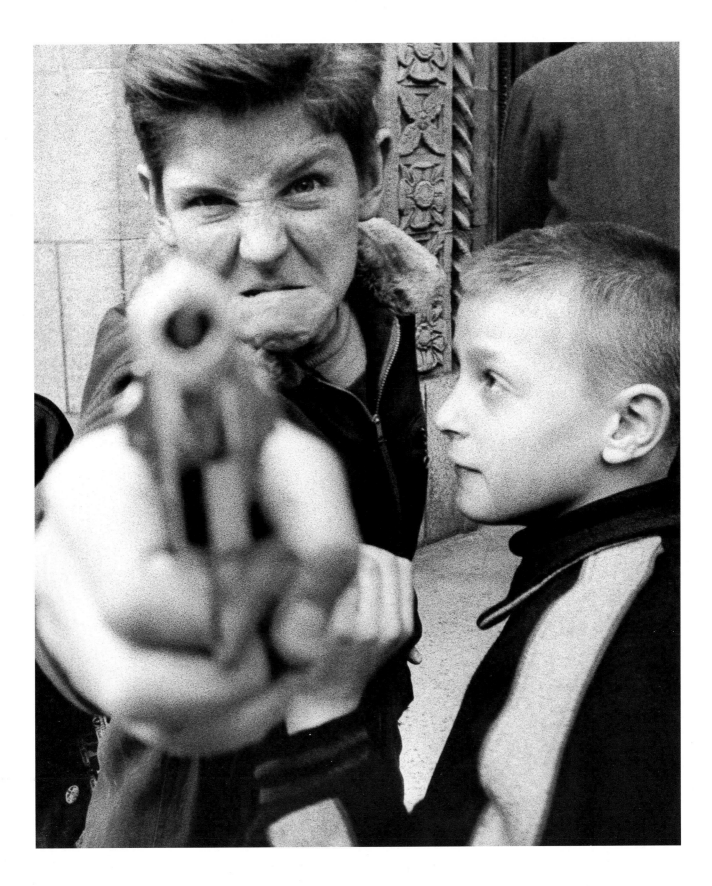

William Klein
Broadway and 103rd.
(© William Klein. Courtesy of the Howard
Greenberg Gallery, NYC)

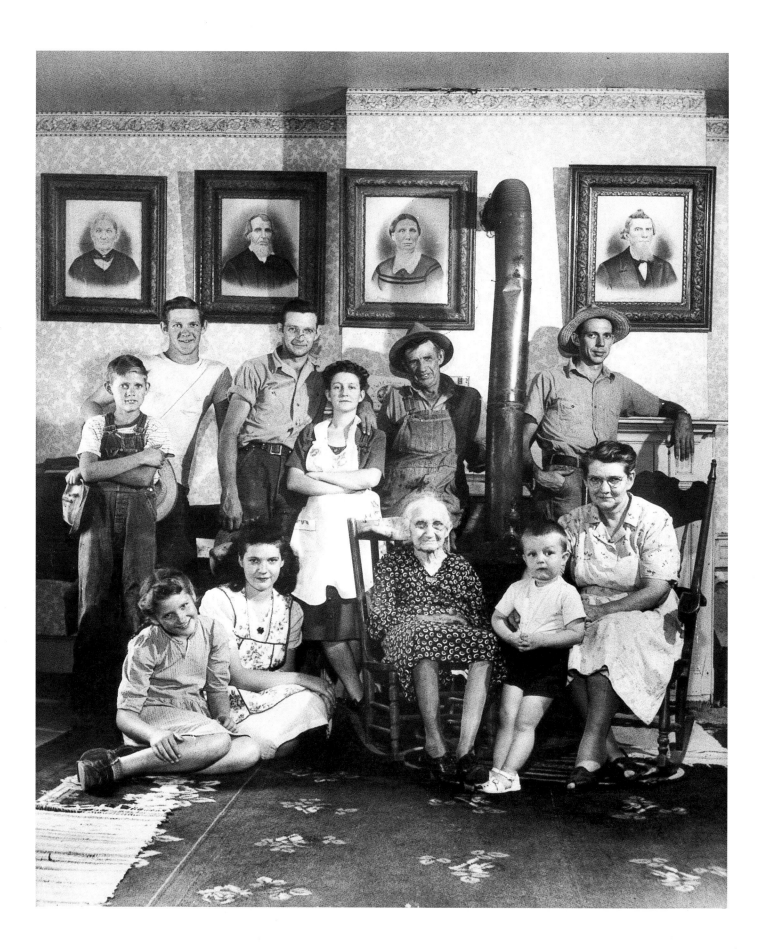

the family of man:
a heartwarming vision for
the cold war world

EDWARD STEICHEN'S NINETIETH BIRTHDAY was celebrated with a grand fête at New York's Plaza Hotel in 1969. The guest of honor's speech was pithy: "When I first became interested in photography, I thought it was the whole cheese. My idea was to have it recognized as one of the fine arts. Today I don't give a hoot in hell about that. The mission of photography is to explain man to man and each man to himself."[1]

For Steichen, the high point of his career, and the proof of his belief in photography's mission as he had come to view it, came in 1955 with *The Family of Man* exhibition at the Museum of Modern Art, New York. The exhibition traveled to thirty-eight countries over the next seven years and attracted more visitors than any other photography exhibit in history. The book based on the exhibition remains the best-selling photography book of all time.[2]

For Steichen, documentary-style photography was a universal language and the definitive modern form of visual communication. Paintings and fine art photographs would not do.

The idea for the show first came to Steichen in 1938 when he saw the International Photographic Exposition in New York City. He was overwhelmed by the Farm Security Administration (FSA) photographs on view and began to dream of an ambitious exhibition on "the spirit and face of America." During World War II, while head of a team of naval combat photographers, Steichen organized two photographic exhibitions at the Museum of Modern Art: *Road to Victory* in 1942 and *Power in the Pacific* in 1945. He mounted a similar exhibition during the Korean War in 1951. He described these presentations as "pageants," for like patriotic ceremonies—Fourth of July parades and speeches, bond rallies—they were designed to inspire and arouse the populace.

Steichen's wartime exhibitions used photo-enlargements and architectural installations to create pictorial environments altogether different from the traditional presentation of framed and matted fine art photographs arranged on walls in a row. Steichen followed this method in *The Family of Man*. Images that ranged in size from 8"x10" to 8'x10' were deployed in an installation by architect Paul Rudolph that featured a spare, hard-edged modernist style.

The exhibition was launched at a museum of fine art, but it was not, strictly speaking, an art exhibition. As his ninetieth-birthday speech so vividly suggests, Steichen had in the course of his career changed his mind about photography. Having given up on fine art photography—he had been a star of Pictorialism in the first years of the century—and turned to advertising and

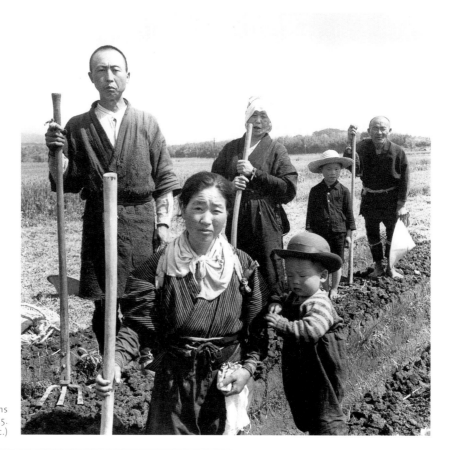

Carl Mydans
Kasakawa Family, 1955.
(Carl Mydans/*Life* Magazine © Time Inc.)

celebrity portraiture, he finally came to believe that photography was best used as an instrument of mass communication aimed toward a general public. For Steichen, documentary-style photography was a universal language and the definitive modern form of visual communication. Paintings and fine art photographs would not do.

The exhibition consisted of 503 photographs by 273 photographers from sixty-eight countries. It was a logistical triumph, since it entailed the examination of millions of images, though in the end the largest single source was *Life* magazine. Steichen felt that his wartime exhibitions had depicted war but failed to stop it, perhaps because they stressed the negative aspects of conflict. This new exhibition would take a more positive approach by showing the oneness of humanity and the value of peace, and so inspire people to act. *The Family of Man* was, in effect, a photo editorial, a pictorial sermon.

Steichen's efforts were criticized from two directions. Some members of the photo community were upset because the exhibition was not devoted solely to the art of photography. For his part, Ansel Adams, one of the great technical masters in the history of the medium, complained that Steichen had not supported the fine print aesthetic. Care had been taken, but not to Adams's standards; the photographers represented had not even made their own prints.

The exhibition included famous photographs, such as Dorothea Lange's *Migrant Mother*, but their significance was controlled by Steichen's message. Such images were removed from their original contexts and set within Steichen's carefully orchestrated narrative. This led to the other major criticism of the exhibition: The photographs were being used to illustrate a philosophical or political

What united the family of man—the phrase came from Steichen's brother-in-law, the poet and Lincoln biographer Carl Sandburg—were shared experiences arising from birth, death, war, love, and family.

position, and a questionable one at that. According to this view, the work on display had been gathered to express Steichen's beliefs. They were not his alone, to be sure, for Steichen represented a particular kind of postwar liberalism.

In addition to the FSA exhibit, Steichen may also have been influenced by a series of articles in *The Ladies' Home Journal* in 1948–49 that featured twelve families in twelve countries under the rubric, "People are people the world over." In *The Family of Man*, Steichen presented an image of an American family with images of families from different cultures, thereby suggesting that all families are in some way the same. What united the family of man—the phrase came from Steichen's brother-in-law, the poet and Lincoln biographer Carl Sandburg— were shared experiences arising from birth, death, war, love, and family. When it came to "explaining man to man," cultural or historical differences seemed irrelevant or at least surmountable to Steichen. And yet Richard Avedon was not alone in believing that the exhibition was based on "a dumb Sandburgian definition of man as a happy family. Hah!"[3]

The belief that the world is one, that at bottom all individuals and societies are alike and share fundamental experiences that define the human condition, may seem to many an admirable, if idealistic, point of view. Undoubtedly, many people have been deeply moved by *The Family of Man*. Whether or not others regard the exhibition as a product of "sentimental liberal humanism," a tag sometimes applied to Steichen's work, it seems clear that Steichen was unwilling to acknowledge cultural differences because he was so determined to stress human commonality.

Steichen deliberately removed from the exhibition a photograph of a racial lynching in the American South because it seemed too specific, too tied to a particular social and historical context. When the exhibition was in Moscow, an African student tore down several pictures in protest of the way in which he felt white Americans and other Europeans were presented as socially superior to Africans, Asiatics, and African-Americans, who were shown as impoverished and "physically maladjusted." There were also Soviet objections to a photograph of a Chinese child begging, and it was removed. In the realm of photography, selection is always an issue: Imagery used in the representation of nationality, ethnicity, gender, or class can never be neutral.

Steichen, like the early publishers of *National Geographic* magazine, may not have known better or perhaps chose not to acknowledge that his view of the world was not necessarily the only one. He also may not have realized how American his view might appear. In fact, with Nelson Rockefeller as its president, the Museum of Modern Art in that era backed a number of programs that served

For Steichen, the existence of nuclear weapons was the underlying reason for presenting the exhibition.

W. Eugene Smith
The Walk to Paradise Garden, 1946.
(© The Heirs of W. Eugene Smith; Center
for Creative Photography, University of
Arizona, Tucson)

as American public relations initiatives during the Cold War. The United States Information Agency, along with corporations such as Coca-Cola, sponsored the international tour of *The Family of Man* as a demonstration of America's good will and noble sentiments about humanity.

As the scholar Eric Sandeen has pointed out, however, some criticism of Steichen has been based on a limited knowledge of his actual point of view.[4] Later critics too often worked from the book rather than from the exhibition. The key image in the exhibition was a large transparency of a nuclear explosion. Dramatically lit in a dark room, it was the only image presented in color and, significantly, the only image not reproduced in the book. The reason was supposedly cost; the book originally sold for a dollar, and a color image would have driven up the price.

For Steichen, the existence of nuclear weapons was the underlying reason for presenting the exhibition. He believed that a reminder about the horrors of war and the nuclear threat, combined with a heightened awareness of the basic unity of humanity, would lead to a new political effort to overcome differences. Immediately following the image of the nuclear explosion, the viewer was faced with images of couples mounted on a wall-sized photograph of the United Nations General Assembly. These were accompanied by a text from Bertrand Russell stating that a war with hydrogen bombs would likely put an end to the human race. A room filled with photographs of children marked the path to the exit.

The final photograph in *The Family of Man* was W. Eugene Smith's *The Walk to Paradise Garden*, an image of his children walking hand in hand from darkness into light. The narrative embodied in the exhibition is therefore oddly similar to that of another extremely popular mass media work, Frank Capra's *It's a Wonderful Life*, made immediately after World War II. In each case, viewers pass through a dark, disturbing vision of existence into a hopeful, reassuring conclusion.

Steichen's pictorial and spatial orchestration made *The Family of Man*'s lesson clear. The United Nations was still a young organization at the time, and Steichen was among those who had high hopes for it. He was in his seventies when he organized the exhibition; his ideas about patriotism and humanity had been forged long before. *The Family of Man*'s emphasis on timelessness and universality may help to account for its continuing popularity in book form. Yet such an approach to "explaining man to man" marks the exhibition as the product of a very particular moment in the history of American culture.

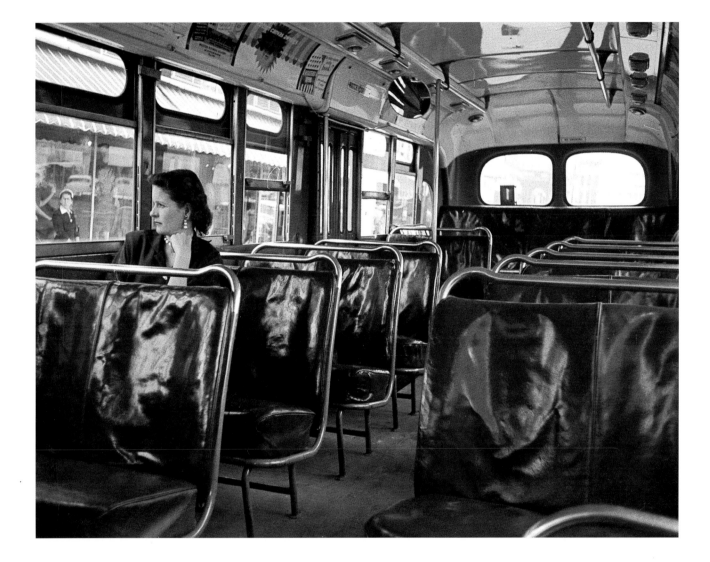

 Dan Weiner
Boycotted Bus, Montgomery.
(Courtesy of Sandra Weiner)

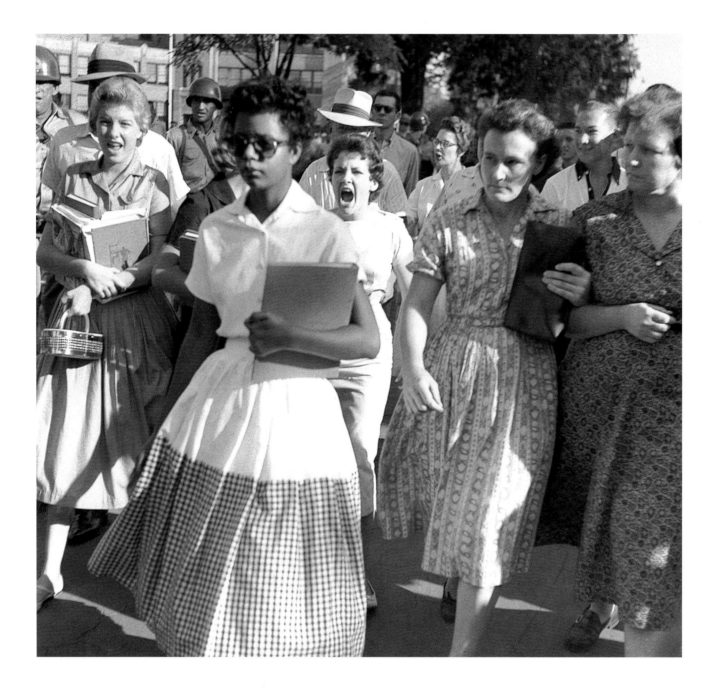

Pete Harris
Elizabeth Eckford pursued by mob, Little Rock, Arkansas.
(Corbis/Bettmann-UPI)

1957

Richard Avedon
Isak Dinesen, writer, Copenhagen, April 9.
(© Richard Avedon)

Carl Toth
Family in Water With Dog.
(Courtesy of Carl Toth Jr.)

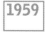

the americans and
the dark side of the 1950s

AMERICA IN THE 1950S IS NOW OFTEN RECALLED as an idyllic world of suburban homes, each with a station wagon parked in the driveway, steaks sizzling on the patio grill, and a brand-new television set in the living room. On that TV set—in a kind of closed loop—we see the *Ozzie and Harriet Show*, *Leave It to Beaver*, or some other version of white, middle-class family life. Obviously that picture never captured the whole truth. If it corresponds to an image of America offered in much of the popular photography and advertising of the time, there were others who provided an alternative view.

When *The Family of Man* exhibition opened in 1955 at the Museum of Modern Art, it included several photographs by a young Swiss-born photographer named Robert Frank. But in 1955, Frank himself was at work on a project supported by the Guggenheim Foundation that was to present a radically different vision of America and the world. *The Family of Man* was a great success with the general public. Frank's photographs—taken during travels across the United States in 1955 and 1956—would arguably become the most influential achievement of the entire postwar period in terms of their impact on photographers, artists, and writers.

America for Frank was a melancholy, even bleak or frightening place marred by racial and class divisions and enlivened only occasionally by a glimpse of lyrical sadness or joy.

Frank's book was called, simply, *The Americans*.[1] It was first published in France in 1958 and then in America in 1959 with a preface by Frank's friend, writer Jack Kerouac. Frank depicted America as a society with a deep-rooted sense of psychological isolation, what sociologist David Riesman called "the lonely crowd." America for Frank was a melancholy, even bleak or frightening place marred by racial and class divisions and enlivened only occasionally by a glimpse of lyrical sadness or joy. Frank's photographs, shot in black and white with a 35mm camera, seemed deliberately casual. The lighting and composition of the images were highly unconventional compared to most photojournalism or fine art photography at the time. Frank was after something more personal, more immediate and spontaneous.

Frank was a master of the quiet moment, the subtle sympathy that periodically appears within his often harsh or satiric vision. *The Americans* features eighty-three photographs in a complex sequence employing recurring motifs

Like film noir in the postwar period, they portrayed the criminal, the illicit, and the sensationalistic in a style full of deep blacks and brilliant flashlit whites . . .

such as the American flag, the car, jukeboxes, and the cross. Frank was also fascinated by drive-in movies and diners before they became nostalgic icons.

The book aroused strong responses, both favorable and unfavorable. Detractors called its photographic style "perverse" and its attitude toward America "communistic." Admirers paid tribute by making innumerable photographs that clearly imitated Frank's style.

Frank was not alone as a photographic dissenter. There were other photographers in New York who presented a less than sanguine view of American life, a view in which the organization man did not rule and prosperity had its perils. There was Weegee (Arthur Fellig), whose photographs were made primarily for the tabloid press. From the 1930s on, but especially after 1946, when his first book, *Naked City*, appeared, Weegee's images of murder and mayhem won him a following among artists and writers as the master of an approach akin to that displayed in hard-boiled detective fiction. Weegee's photographs offered raw, guilty pleasures to those tired of the prettiness of self-consciously "artistic" photography or the artificiality of advertising or standard news photography. Like film noir in the postwar period, they portrayed the criminal, the illicit, and the sensationalistic in a style full of deep blacks and brilliant flashlit whites, all contrast and no middle ground.

William Klein, a native New Yorker, lived in Paris after the war and studied art on the GI Bill. He then fell into a career as a fashion photographer before later, like Frank, turning to independent filmmaking. In 1954, he spent a relatively brief period back in New York, shooting photographs on the street in an effort to capture the intensity, the energy, the toughness of the modern metropolis. The

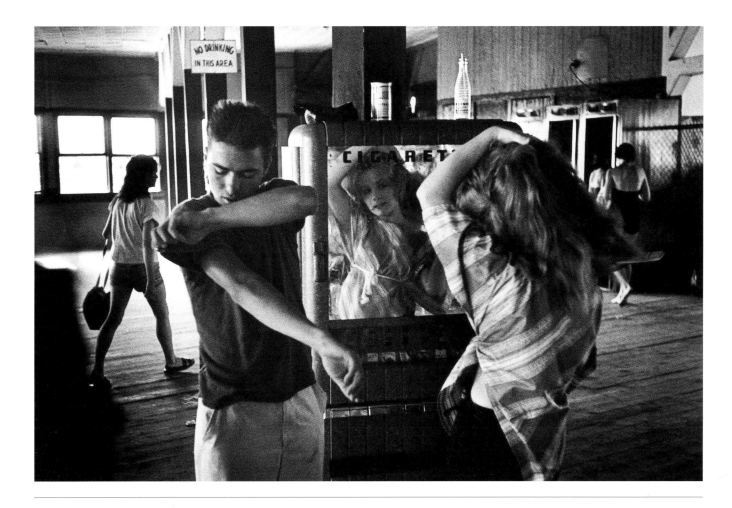

Bruce Davidson
Two Youths, Coney Island, 1959.
(© Bruce Davidson. Magnum Photos, Inc.)

photographs were published—only in Europe—in 1956 in a book titled *Life Is Good and Good for You in New York: Trance Witness Revels* (a play on the standard tabloid headline "Chance Witness Reveals"). The cover featured a mock Good Housekeeping seal. Klein said he regarded himself as "a walking photo booth for his subjects" and hoped he could be "as vulgar and brutal as the [*New York Daily*] *News*."[2] *Life is Good* relied on the graphic strength of its compositions and the direct, in-your-face quality of the encounters between photographer and subject. The result was a gritty, lively style that critic Max Kozloff has described as "slumming with jazzy abandon."[3]

By the end of the 1950s, other photographers had learned from Frank, Weegee, and Klein to search out this other America, to reveal the unorthodox vitality of an America that could be found only out on the streets or on the cross-country highway, in Times Square, or in some small town in the middle of nowhere.

photography transformed
1960–1999

III.

photography transformed
1960–1999

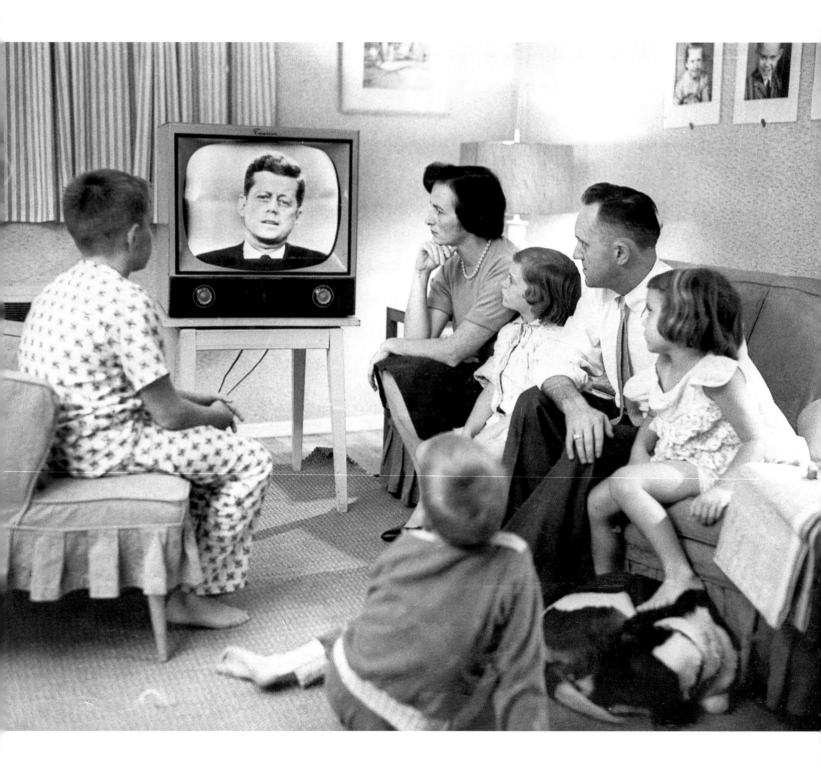

1960 Donald Phelan
First Ever Kennedy-Nixon Presidential TV Debate.
(© Donald Phelan. Courtesy of the photographer)

pop art, photography, and the mass media

AFTER WORLD WAR II, AMERICA ENJOYED the greatest economic boom in history. Between 1946 and 1956, national output doubled. Between 1940 and 1955, personal income almost tripled. Between 1950 and 1960, the national consumption of hot dogs rose from 750 million to two billion,[1] a statistic that surely has some relationship to the first two.

As the economy soared, the commercial and popular media soared with it. In 1955, the Audit Bureau of Circulation reported that more single-issue copies of magazines were being distributed in this country than there were citizens to read them.[2] Most cities of any size still had at least a morning and an evening paper; a few cities had five or six. A new medium was also making large demands on people's attention and bringing a steady stream of images into the home: From 1947 to 1957, the number of televisions in the United States increased from 10,000 to 40 million.[3]

As the distribution channels grew wider and more numerous, as the icons of popular culture like Marilyn Monroe and Elvis Presley were reproduced as prodigally and efficiently as comic strips or Campbell's soup, it dawned on some artists that what passed for culture had been relocated in Popular Culture. And what did Popular Culture ride in on? Photography, of course, and the photographically derived media of film and TV. There was no audit bureau to count the number of photographic images at loose in the land, but it surely outstripped hot dogs.

It dawned on some artists that what passed for culture had been relocated in Popular Culture.

Robert Rauschenberg, who is not, properly speaking, a Pop artist, began to incorporate photographs into his paintings and his "combine sculptures" by silkscreen and other transfer processes in the 1950s. Andy Warhol, who does qualify as Pop, painted copies of photo reproductions and in 1962 learned how to silkscreen photographs directly onto canvas. Rauschenberg also included distinctly inartistic objects, from mattresses to tires to stuffed goats, in his works; photography was merely one more banal and ordinarily overlooked artifact of daily life that could put subject matter back into art after Abstract Expressionism. Ordinary and overlooked as they may have been because of their ubiquity, photographs codified and transmitted the culture's myths and values, from Elvis to JFK to the conquest of space, the prevalence of violence, consumerism, and the dream of perpetually available sex.

It was not exactly a new idea to dragoon halftone reproductions into the ranks of art to expand the territory of painting and comment on society. Dada

Andy Warhol
Large Triple Elvis, 1963.
(The Andy Warhol Foundation for the
Visual Arts/ARS, NY)

artists had done something similar in the 1920s, but hierarchies in art had been reestablished since then, and photography was very low on the totem pole. Both painters and critics cried foul when Rauschenberg treated found objects and photographs as if they were on the same time-honored plateau as painting.

Rauschenberg went right on making use of anonymous, banal photographs, plus topical pictures of President Kennedy and the space program, his own photographs, X rays, and reproductions of works of art like Rubens's *Venus*. Yet he never quoted "art" photographs by the likes of Ansel Adams or Edward Weston. Warhol, who extended the photographic repertoire of his work to photo-booth portraits and newspaper photographs of car crashes and other disasters, was equally uninterested in art photography, which at the time, in the hands of people like Minor White and Paul Caponigro, was searching for means of expressing the deepest self.

Warhol, for his part, claimed he would like to be a machine. He celebrated mechanical reproduction, which by common agreement was at the farthest remove from the unique art object; he printed grids of nearly identical images of Marilyn, Jacqueline Kennedy, and electric chairs, as if saying that more was more and photography's power lay in its repetitiveness. It was precisely because photography was not art in their estimation that these two artists and the many who followed them were so eager to admit it into their new, rambunctious canon.

Warhol evidently regarded published photographs as found objects, there for the taking. He invited legal trouble more than once by using photographs he apparently had not even considered might be copyrighted, including Charles Moore's scathing pictures of the civil rights conflict in Birmingham in 1963.

What the new leaders of the art world considered the non-art of photography was used as a wake-up call for art itself, admonishing it to listen to contemporary life and detach itself from the bourgeois consumer culture.

(The question of photographic copyright goes back to court cases in the 1860s.) Perhaps Warhol was simply careless, or perhaps a disregard for the authorship of photographs was more widespread. Many newspapers did not bother to credit photographers, whose images, as infinitely reproducible as cereal boxes, appeared in papers and magazines that people looked at once and then threw out with the garbage.

Many artists and several art movements called on photography in the 1960s. Conceptual artists like John Baldessari and Bruce Nauman made photographs (or had them made) when it suited them, performance artists and Earth artists required photographic documents as records of their evanescent or inaccessible work. Earth, or Environmental, artists like Robert Smithson or Dennis Oppenheim, who altered landscapes at distant locations, were explicitly seeking a way out of the restrictive and highly commercialized confines of museums and galleries; ironically, their work returned to just these venues in the form of photographs.

Though some photographers, including Harry Callahan, tried out adventurous techniques like collage and montage from time to time, during the 1960s Callahan himself, Aaron Siskind, Minor White, and other inheritors of the art photography traditions of Stieglitz and company generally upheld the goals of straight photography and the fine print. Meanwhile, young street photographers and more experimentally inclined photographers were eagerly challenging the existing rules. The multimedia work of men like Rauschenberg and Warhol and their combination of photography and printmaking may have provided tacit encouragement to photographers like Naomi Savage and Wallace Berman to work in mixed techniques. The deliberate use of banal photographs in artworks may have encouraged photographers like Robert Adams and Lewis Baltz, who were already studying scenes that no one thought beautiful nor memorable before photographers framed them in their viewfinders.

What the new leaders of the art world considered the non-art of photography was used as a wake-up call for art itself, admonishing it to listen to contemporary life and detach itself from the bourgeois consumer culture. Even as photographers like Robert Frank and William Klein were recklessly breaking the sacred rules of sharp focus, careful framing, and flawless prints, artists from other disciplines were simply throwing all the rules overboard.

Inverting the arguments of the Pictorialists at the turn of the century, such artists stressed and indeed magnified the mechanical nature of photography, the absence of an artist's touch and even of an artist's eye, the anonymity and neutrality of the medium. Baldessari claimed that "the worst thing about a camera

In the early 1970s, a few art critics uneasily noted that art galleries were full of photographs . . .

is the viewfinder," because once a photographer looks through that he begins to organize what he sees. To escape the dread confines of aesthetics, Baldessari set a timer and threw the camera in the air, or placed the camera before a television and timed it to take a picture every few minutes.[4] Ed Ruscha, who published books of undistinguished photographs of undistinguished sights such as *Every Building on the Sunset Strip*, took some of the pictures himself and had other people take the rest. "It's not really important who takes the photographs," he said. "I don't even look at it as photography; they're just images to fill a book."[5]

It was easier to embrace these attitudes because most of the world shared them. Photography had a few institutions in its corner but was associated in most people's minds not with art but with the bathing beauty crossing her legs on the front page of the tabloids or the masses of antiwar demonstrators in the picture magazines. The George Eastman House in Rochester, New York, had been showing fine photography since 1949 but did not have a large audience outside the field. The Museum of Modern Art's *Family of Man* show had drawn attention to photography as an art largely by concentrating on photojournalistic images, which already had a following. MoMA remained the chief proponent of photography as art throughout the 1960s; by then it emphasized a formalist aesthetic. No full-time photography dealer succeeded in New York until 1969.

University courses in photography multiplied during that decade, spreading knowledge of contemporary accomplishments in the medium, while low-life photography in a high-art context hovered more and more often on the field of vision. And the Conceptualists and Environmental artists who put photographs on center stage in their work, however subversively, kept photography circulating through art galleries that would not have deigned to show Stieglitz or Strand. In the early 1970s, a few art critics uneasily noted that art galleries were full of photographs, and they wrote themselves into corners trying to redefine these unheralded objects as art or transcendental forms or anything but what they were.

The boom in photography was about to begin. No doubt it owes its existence primarily to the art market boom of the 1960s, which had driven prices so high that collectors were casting about for fine images that were not overpriced. Then, too, the audience had grown more educated in recent years. But it was no small part of the equation that by the 1970s art lovers were thoroughly accustomed to seeing photographs in art galleries and museums as components of cutting-edge art that had won the approbation of critics and curators. The artists who deliberately denigrated photography as art had done it the biggest favor of all.

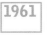 Eliot Porter
Dungeon Canyon, Glen Canyon, Utah.
(Courtesy of Scheinbaum & Russek, Ltd., Santa Fe, NM)

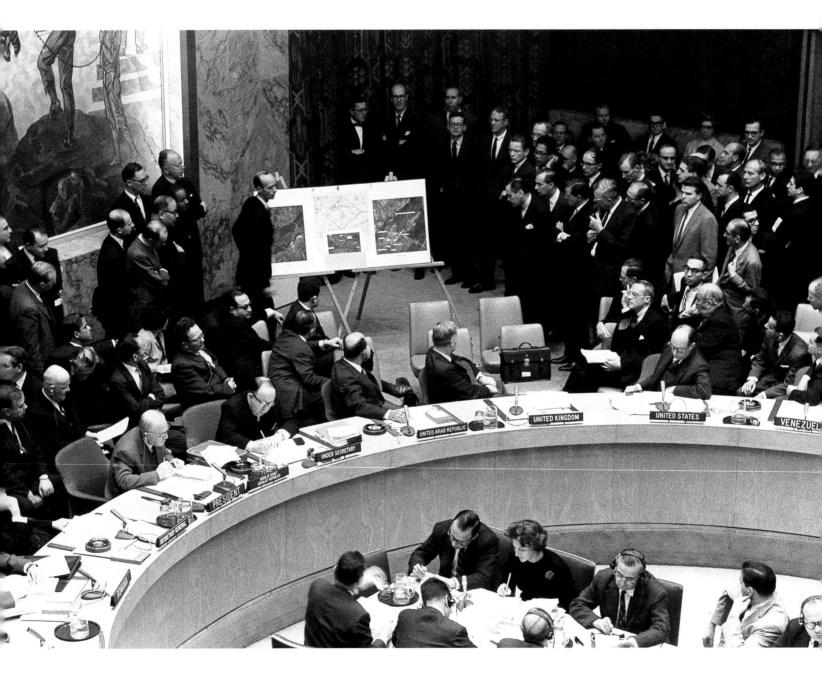

1962 Photographer unknown
*UN Council decides to await results of talks between
parties concerned during Cuban missile crisis.* (UN/DPI)

surveillance and
the photograph as evidence

IT WAS PREDICTED ALMOST FROM THE moment of photography's invention that it would have a miraculous ability to provide evidence and identification. In 1839, even before Louis Jacques Mandé Daguerre's invention of the medium was officially announced, an American wrote about the new discovery, "What will become of the poor thieves, when they shall see handed in as evidence against them their own portraits, taken by the room in which they stole, and in the very act of stealing!"[1]—a fairly accurate prediction of bank surveillance cameras. By the 1840s, the European police were taking mug shots of suspects in custody; the first in America were taken in 1854 in San Francisco.[2] The suspects understandably did not wish to be so easily identified, and many tried to contort their faces beyond recognition.

In the nineteenth century, aware that a certain truthfulness inheres in photography's very nature, few saw reason to doubt the camera's reports. There are many ways a photograph can mislead or be made to mislead, but what it does show has a direct tie to the reality of whatever was before the lens when the shutter opened, for the subject is the physical cause of the image and leaves a trace of itself on film. Such a transfer of reality is intuitively understood as evidence or proof and has been put to the test repeatedly.

There are many ways a photograph can mislead or be made to mislead, but what it does show has a direct tie to the reality of whatever was before the lens when the shutter opened . . .

Inevitably, the law has made extensive use of photography. The first court case in America that turned on photographic evidence was tried in California in 1859; photographs of original documents convinced the court that signatures had been forged.[3] An 1865 wanted poster for John Wilkes Booth and two of his co-conspirators in the plot to kill Lincoln displayed photographs of the three men. Around the same time, a few police departments decided that photographs of the scene of a crime could also be useful.

Portrait photographs have been invaluable not just for the police but for state and private authorities as well. In the 1860s, the Chicago and Milwaukee Railway Company added photographs to its passengers' season passes.[4] In 1914, photographs on passports, an idea that had been proposed years earlier, suddenly seemed urgent because of a world war. More recently, state automobile

Serial images sent with official notice of
a traffic violation recorded by a municipal
police department camera, 1999.

agencies put drivers' faces on licenses, and employees at nuclear facilities and in other occupations that require security clearance, as well as in many that do not, must wear photographic badges. Photographs of missing children serve the cause of identification just as wanted posters do. Beginning in the 1980s, when some children had been missing for years, their photographs were manipulated by computer programs designed to show likely changes in appearance as they grew up.

Photographic identification remains essential. Detectives, kidnappers, and blackmailers alike depend on photographs. Dental X rays are one of the few sure means of identifying a body. Not long ago, robbers who could not get into an ATM hauled off the entire machine, tore it apart, and then abandoned it—with their pictures still intact on the film in the camera.

And yet, photographic evidence must meet the same rigorous standards as other evidence. The night that O. J. Simpson's former wife was murdered, footprints made by Bruno Magli shoes were left behind. No such shoes were found in O. J.'s possession, but a photographer submitted as evidence an earlier photograph of him wearing just that model. The possibility that the photograph had been doctored cast doubt on it until the photographer produced his contact sheet with several pictures of O. J. wearing the very same shoes. No one suggested that an entire contact sheet had been altered.

A photograph's credibility is determined by many factors. One of these is context: A photograph in the *Journal of the American Medical Association* has more authority than one in a supermarket tabloid. Captions and explanations, which go beyond what is visible in the photograph itself, also make a difference. Patricia Hearst, kidnapped by the Symbionese Liberation Army in 1974, was videotaped not long afterward as a member of the group that abducted her, with a submachine gun in her hands. Had she been coerced, or brainwashed? The image did not, could not say. Photography has stringent limitations, and in some instances has been superseded. Early in this century, fingerprints proved more exact in certain criminal cases, and in the last few years DNA tests have made the latest bid for infallibility.

The photograph's adroit abilities of identification and bearing witness have made it a prime tool of surveillance, for good and ill, and since the nineteenth century it has been used by government and private authorities to amass documentation that reinforces their bases of power.[5] Today we see photography everywhere, and it sees us as well. In the 1960s, civil libertarians decried government photographic surveillance of antiwar demonstrations; in the 1990s, some protested automatic cameras placed by police in high-crime or drug-ridden

Not long ago, robbers who could not get into an ATM hauled off the entire machine, tore it apart, and then abandoned it—with their pictures still intact on the film in the camera.

neighborhoods. News photography, both for the press and for television, put enormous audiences into the position of surveillance teams. At the violent Democratic convention in Chicago in 1968, a television reporter who was menaced warned his attackers: "The whole world is watching"; students were soon chanting this in the face of police in the streets.

The hand-held videocam has partially reversed the balance of power, sometimes putting the burden of proof and surveillance into private hands, as when a passerby videotaped presidential candidate Gary Hart with a young woman on his lap who was not his wife, or when a private citizen recorded Rodney King's beating by the Los Angeles police.

Aerial reconnaissance, which had been so essential in World War II, improved during the Cold War with ever-more-sensitive films and lenses, and eventually with spy satellites. In 1960, a CIA pilot named Francis Gary Powers on reconnaissance above the U.S.S.R. was shot down. He survived and was tried and sentenced, an incident that brought American-Soviet relations to a new low.

Two years later, aerial photography over Cuba produced evidence that nearly provoked atomic war. The United States had reason to believe that the Soviets were deploying ballistic missiles in Cuba within range of U.S. cities, but the Soviets denied it and America could not prove it. In October of 1962, when the weather cleared sufficiently for reconnaissance photography, pictures were taken of offensive missile installations. President Kennedy proclaimed a quarantine of Cuba and raised the alert level of the Strategic Air Command to full readiness for war. At the United Nations, the Soviet delegate denied that offensive missiles were in Cuba; immediately afterward, Adlai Stevenson, the U. S. delegate, presented the photographs. The effect was stunning. America declared a blockade of Cuba even as Soviet ships were steaming toward the island.[6] At the last minute, Nikita Khrushchev agreed to remove the missiles from Cuba, keeping the world safe for a few more moments. Whether the world is safe or not, cameras keep on watching.

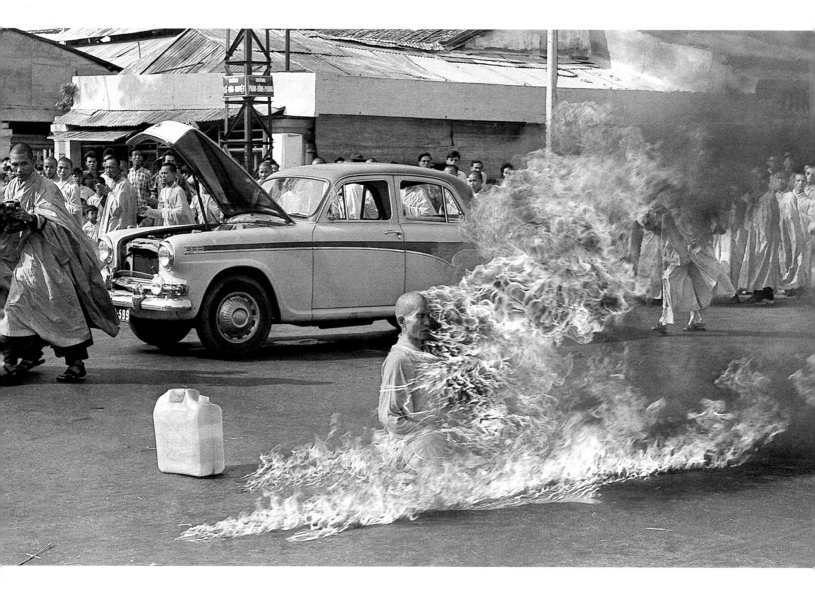

1963 Malcolm Browne
Quang Duo Immolating Himself, June 11.
(AP Wide World Photos)

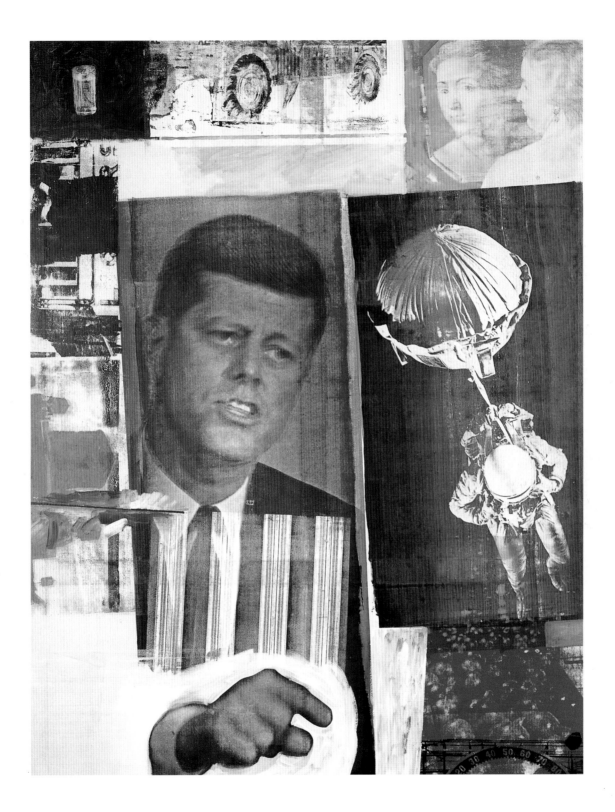

 Robert Rauschenberg
Retroactive II.
(Collection Museum of Contemporary Art, Chicago;
partial gift of Stephan T. Edlis and H. Gael Neeson)

civil rights:
photography and social awareness

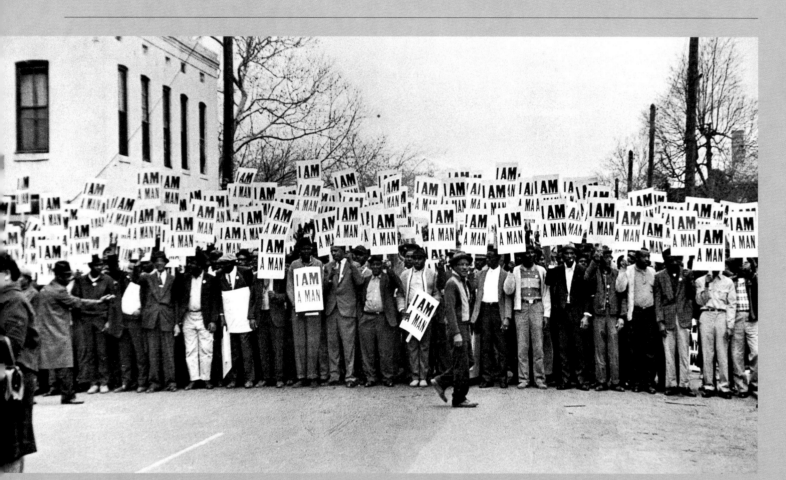

A PHOTOGRAPH THAT DRAMATIZED A HORRENDOUS CRIME helped to inspire the modern civil rights movement. In Mississippi in 1955, a fifteen-year-old African-American from Chicago, Emmett Till, was kidnapped, tortured, and murdered for an alleged flirtatious encounter with a white woman. A photograph was taken of his mutilated body after it was recovered from a river. The gruesome, shocking postmortem image was published in *Jet* magazine, then in other black publications, but not in the

The antilynching movement dates back to the early part of the century, and lynching photos were a regular part of the literature.

mainstream white media. When paired with a portrait of Till as a smiling, attractive young man, the image had a profound effect on the entire African-American community, including Julian Bond, John Lewis, and many others

who would become activists and leaders of the civil rights movement of the late 1950s and early 1960s.[1]

The antilynching movement dates back to the early part of the century, and lynching photos were a regular part of the literature. But the photograph of a slain Emmett Till, along with the 1954 U.S. Supreme Court case *Brown v. Board of Education*—both the changes it mandated and the social conflicts it produced—is a symbolic starting point for the civil rights movement. The Till murder took place only three months before Rosa Parks, refusing to move to the back of a bus in Montgomery, Alabama, set off a bus boycott and one of the first great confrontations in the movement.

The civil rights movement was marked by a series of well-known major events: the bus boycott in Montgomery in 1955–56, the lunch counter sit-ins, the school integration crises in Little Rock in 1957 and at Old Miss in 1962, the March on Washington, and the march

to Montgomery. These events were confrontational and each was heavily covered by photographers (as well as television news), who often made dramatic photographs of beatings and arrests that showed individuals and large rallies caught up in violent or dangerous situations. Every crisis provided famous images, though no single photograph of the immense crowd or of individual dignitaries at the March on Washington caught the public imagination as forcefully as film footage or sound recordings of Martin Luther King Jr.'s "I Have a Dream" speech.

After the photograph of Emmett Till's body, photographs of dogs attacking demonstrators, especially those made in Birmingham in 1963, probably rank as the most influential images of the era. They were published around the world and provoked widespread outrage. Americans were shocked by them. In the middle of the Cold War, when direct conflict had been supplanted by image warfare, such photographs tarnished the image of America. The leaders of the Soviet Union quickly saw an opportunity to "expose" American democracy and counter American charges of Soviet totalitarianism and oppression by publishing them. A Danny Lyon photograph of a demonstrator being forcibly arrested by a policeman was published on the front page of the official Soviet newspaper, *Pravda*, with the caption "U.S. Police Brutality."[2]

The civil rights groups also knew how to influence public opinion. Led by James Forman, the Student Nonviolent Coordinating Committee (SNCC) recruited staff photographers; the first to join was Danny Lyon,

Photographs made leaders on both sides—George Wallace as well as Martin Luther King Jr.—known across the country.

in 1962. Like Hine and the early child-labor reformers, civil rights groups used photographs on posters and pamphlets to win support and raise funds. The nonviolent practices of the early protesters made the nature of the confrontations clear: police, state troopers, politicians, and outraged white civilians on one side, calm demonstrators being brutalized on the other. Whether it was dogs or water hoses that were turned against the demonstrators or the spectacle of food being dumped onto lunch-counter protesters in a drugstore, each situa-

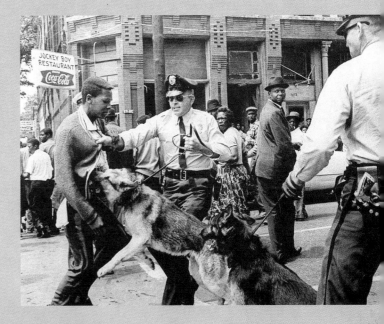

tion made for strong pictures, some not unlike combat images, at a time between the wars in Korea and Vietnam when America was ostensibly at peace.

Photographs made leaders on both sides—George Wallace as well as Martin Luther King Jr.—known across the country. Established celebrities also participated in a few major demonstrations such as the march from Selma to Montgomery, and sometimes in more everyday activities—writers like James Baldwin, performers and actors like Harry Belafonte and Marlon Brando, the singer-songwriter Bob Dylan. Their presence spiced up the visual record.

Most of the images, however, show less-renowned figures and unknown individuals caught up in historical events. Beyond the images of demonstrations and public rallies, there is a larger record of the movement, including photographs taken by a group called the Southern Documentary Project, that captures the day-in and day-out activities of the civil rights organizations. These photographs show the internal meetings, the freedom schools, the painstaking work of door-to-door voter registration.

The opponents of civil rights also attempted to use photographs to their advantage. State councils took pictures of their own and created files on "agitators"; sometimes local publications turned over photographs to help with this surveillance. At the same time, the mass

Danny Lyon
Cambridge, Maryland, Spring 1964. Fellow SNCC photographer Clifford Vaughns is arrested by the National Guard.
(Magnum Photos, Inc. © 1964 Danny Lyon)

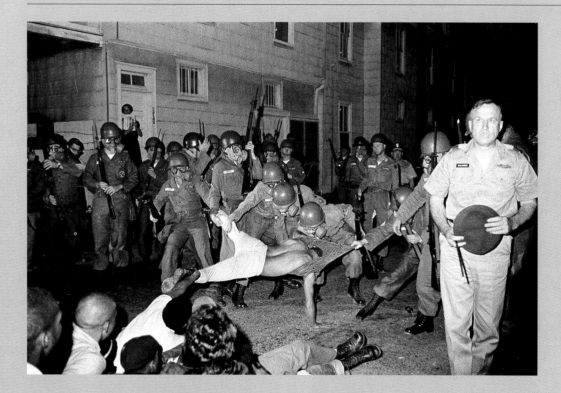

media as well as the civil rights organizations used photos of the authorities to show them in an unfavorable light, not only in the street demonstrations, but also in images such as a famous shot of a gleeful pair of officers in court, one reaching into a bag of Red Man chewing tobacco, the very picture of clichéd Southern redneck culture.

After the King assassination, photographs documented the riots that broke out across the country . . .

The central photographs are the images of struggle and resistance or repression, but in the end there were also images of assassination—of Medgar Evers, of King, of Viola Liuzzo (a volunteer from Detroit), of the three civil rights workers who were arrested and released, then followed, killed, and buried (the latter events were semi-fictionalized in the movie *Mississippi Burning*). These are not images of an event, but of its aftermath, including the photographs on the "missing" posters for the three young men.

The most famous images of the civil rights movement are from the South, but powerful images also came from New York, from Chicago, where King marched to protest segregated housing and where the Nation of Islam leadership had its headquarters, from Los Angeles, and elsewhere. After the King assassination, photographs documented the riots that broke out across the country, showing images of looters and mobilized National Guard troops and burning buildings that were in stark contrast to the heroic photographs of marchers on the road from Selma to Montgomery. The civil rights movement helped establish a new pattern for the coverage of social activism. So when other groups, such as the United Farm Workers in California or the American Indian Movement at Wounded Knee, South Dakota, emulated the tactics of the civil rights activists, the results were media events as well as political actions. From the 1960s on, the two would be increasingly difficult to separate.

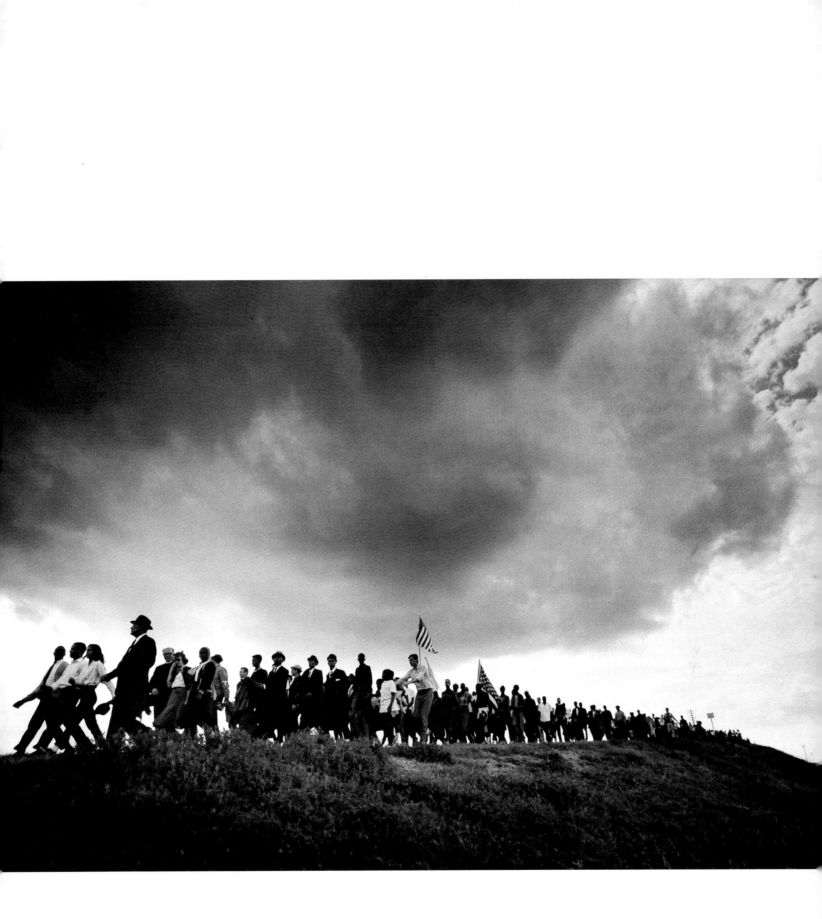

the counterculture: changing times, changing images

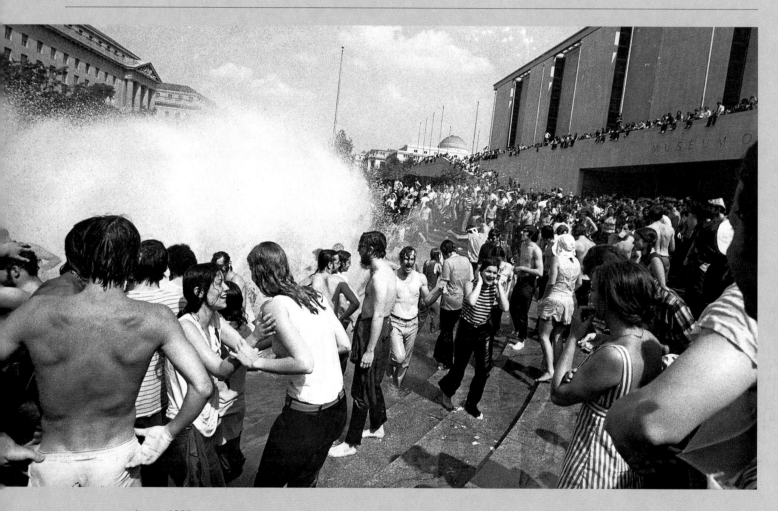

In the 1950s, photographers such as Robert Frank and William Klein were all but unknown outside of the photographic and art community. But photographers were learning from them that it was possible to make photographs in a different way, photographs that revealed a different vision of America. In the 1960s, through a kind of cultural inversion, what had been an underground movement in photography suddenly became the center of attention. And the figure who best represented that shift was Diane Arbus.[1]

Arbus had been gradually developing her approach to photography for some years, but in 1960 she received her first commercial magazine assignment. In 1967, along with Lee Friedlander and Garry Winogrand (both deeply influenced by Frank), she appeared in an exhibition at the Museum of Modern Art marked by an edgy, ironic, even subversive approach to American society. By the time of her death, by suicide, in 1971, Arbus had established a reputation among critics and a wide following through her pictures of sideshow performers, nudists, and transvestites, along with others who might well have seemed ordinary but never quite appeared that way in her photographs. A posthumous retrospective in 1972 had the highest attendance to date of any one-person photography exhibit at the Museum of Modern Art.

Arbus's photographs inspired a whole new photographic interest in unusual subcultures, in life at the margins not usually represented in mainstream publications—life beyond the margins of *Life*. For her, no subject matter was off-limits. "There are certain evasions, certain

nicenesses, that I think you have to get out of," she said,[2] and her photography represented an escape from evasion and niceness, including the niceness of the upper-middle-class world into which she was born. Arbus received two Guggenheim grants to study American rites, manners, and ceremonies, and her interest in America and Americana, like Frank's, testifies to a fascination with social differences and diversity that makes normalcy seem strange and strangeness seem normal.

The camera, Arbus said, gave her license to go anywhere and look at anything. In turn, her work gave other photographers a similar license to record any and all subjects.

The camera, Arbus said, gave her license to go any-where and look at anything.[3] In turn, her work gave other photographers a similar license to record any and all sub-jects. The tendency toward more adventurous photogra-phy that began in the 1960s cannot be attributed to Arbus alone. There was a general movement toward greater explicitness and a new fascination with all aspects of American life. At about the same time, for example, Tom Wolfe, the New Journalist par excellence, was exploring a variety of subcultures with a shrewd observation of manners and style that has marked his work ever since. He hung out with custom-car freaks and surfers before moving on to the archetypal 1960s group, Ken Kesey and the Merry Pranksters, which he famously described in *The Electric Kool-Aid Acid Test*. In much the same way, photographers began to document motorcycle gangs (Danny Lyon in *The Bike Riders*, 1968), a mix of sex, drugs, and guns in a circle of the photographer's friends (Larry Clark in *Tulsa*, 1971), and, later, intimate and abusive relationships from a woman's point of view (Nan Goldin, *The Ballad of Sexual Dependency*, 1986). Oddly enough, the epitome of this tendency to search out the extreme and the extraordinary was Bill Owens's *Suburbia* (1973), a deadpan, deadly portrait of the craziness that passed for normalcy in Middle America.

The 1960s introduced new photographic subject matter; they also popularized avant-garde photographic styles. The image of the sixties as a decade of sex, drugs,

and rock and roll, if only in the popular imagination, created photographic styles identified with the drugs and rock and roll—and with some sex appeal too. Rock album covers featured eye-catching images that showed the performers in a magical, colorful world that was some-times created through posterization, a process that removed detail and created large areas of color, or through solarization, achieved by exposing the image to light during the developing process in order to shift and heighten colors. These methods produced a photographic equivalent for the kind of psychedelic artwork often used on the posters and albums of San Francisco bands around the time of the so-called summer of love. For a group like Frank Zappa's The Mothers of Invention, the result was an appropriately unconventional style for *Freak Out* in 1966. Richard Avedon adopted a similar technique for a cover portrait of John Lennon for *Harper's Bazaar* in 1968, which showed Lennon in electric yellow, pink, and red, with op-art patterns for eyes.

The trendsetting Beatles produced one of the defini-tive covers of the era for their 1967 *Sgt. Pepper's Lonely Hearts Club Band*. Here Ringo, John, Paul, and George appeared next to their Madame Tussaud wax doubles, backed up by a montage of celebrity portraits. Following the breakup of the Beatles, John moved to New York with his wife, Yoko Ono. In a famous Annie Leibovitz photo-graph published in *Rolling Stone*, a major outlet for adventurous rock photography, he was shown naked, embracing the clothed Yoko, in another milestone in changing approaches to celebrity portraiture.

As a form of eye candy, rock album covers explored an assortment of experimental approaches, many involv-ing photography. The Doors used a shot of circus per-formers complete with midget and strong man—shades of Arbus—on the cover of their 1968 *Strange Days*. In a typical bit of goofing-off, the Mamas and the Papas were shown on the cover of the 1966 album *If You Can Believe Your Eyes and Ears* sitting (clothed) in a bathtub, while Jimi Hendrix's *Electric Ladyland* album featured a group of nude "foxy ladies"—no feminism there.[4]

Two album covers from the 1970s played off of famous photos from the past. In a Margaret Bourke-White photo from the 1930s, African-American flood

Harry Redl
Allen Ginsberg and "Moloch," 1958.
(Courtesy of the photographer)

victims are lined up beneath a billboard ad from the National Association of Manufacturers that celebrated a smiling white family in a car as testimony to "the American Way of Life." For a 1975 Curtis Mayfield album, the Bourke-White was turned into an entirely African-American image, with African-Americans not only below in the line but above in the car as well. The juxtaposition was pointedly ironic in the 1930s (the Farm Security Administration photographers had included that same billboard in several shots); the new version was appropri-

Suddenly the idea of a well-lit, centered subject seemed beside the point: What mattered was capturing a jazzy sense of the instant, with just a hint of mystery.

ately outrageous in the 1970s. In another bit of creative reuse, Led Zeppelin borrowed the photograph of the *Hindenburg* explosion for the cover of their 1969 album, an appropriate subject given their name and heavy-metal style.

Rock videos and album covers, rock world and Beat world portraits, and any number of ads aimed at a hip, youthful audience have borrowed from Frank, Arbus, and many other photographers of the social landscape. (The Rolling Stones used Frank photographs on *Exile on Main Street*.) There still are many photographers trying to fol-

low the personal social documentary approach in less commercial fashion. For a while in the seventies and eighties, "flash and slash" or "party" styles became popular under the influence of photographers such as Garry Winogrand and Larry Fink. Using flash and slow exposure times, blur and double images were introduced. Flash used in spaces it could not fill produced highly theatrical lighting, with figures that receded into the shadows or popped out in the glaring light. Suddenly the idea of a well-lit, centered subject seemed beside the point: What mattered was capturing a jazzy sense of the instant, with just a hint of mystery.

The photographic counterculture of the fifties and sixties lives on at the end of the century, though its position is uncertain given that the mainstream so quickly absorbs the most daringly explicit and experimental images. And the arrival of the computer at the party takes photographic Surrealism beyond what had been created by earlier generations that used staging, darkroom magic, and photomontage. We are now in a new photographic wonderland.

1966 Ray Leong
Mothers of Invention, Freak Out.
(Courtesy of the Zappa Family Trust)

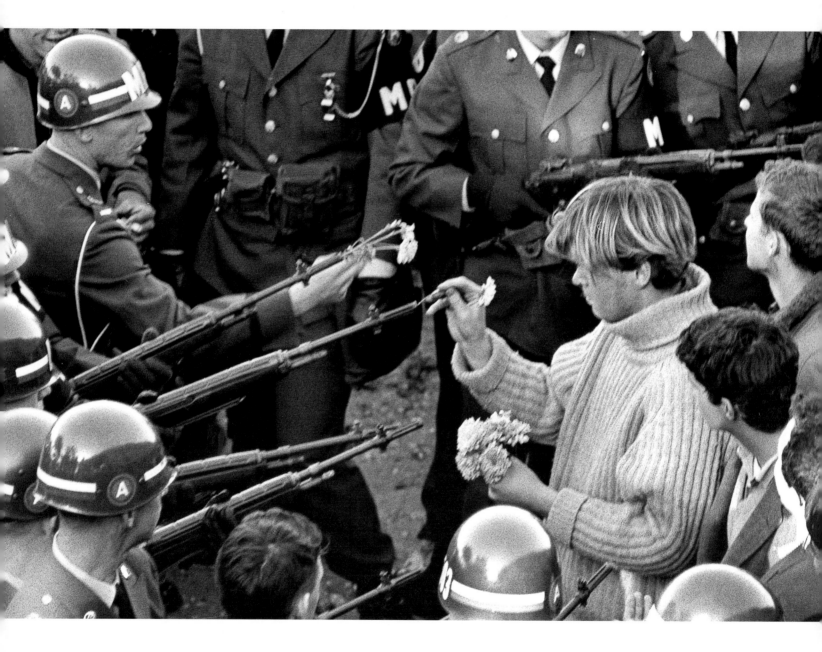

vietnam: shooting war

MICHAEL ARLEN CALLED THE WAR IN VIETNAM the "living-room war."[1] Day after day, night after night, amid the soap operas and the talk shows, the sitcoms and the sporting events, America's involvement in the conflict played out on television sets across the country. But he might also have called it "the front-page war." No matter what the headlines said and the TV showed, it was the photographs appearing in the nation's newspapers that often provided the first impressions and the most lasting images of the war.[2]

When a little girl ran down a rural Vietnamese road after being scorched by napalm and a Vietnamese police chief summarily executed a Vietcong suspect, millions of Americans saw the photos the next morning at breakfast or in the evening before dinner. Some photographs were deliberately withheld from publication because they were judged too disturbing. The *New York Times* refused to publish Malcolm Browne's image of a monk burning himself to death in protest against the South Vietnamese government's treatment of Buddhists; it was deemed "not fit fare for the breakfast table."[3] That image did appear in other outlets. Many of the most powerful photographs were published or republished in the weekly and biweekly magazines such as *Life*, *Look*, *Time*, and *Newsweek*. The American public was constantly bombarded by images of the war, many of them far more graphic than anything seen during previous wars. When Henry Cabot Lodge came to see John F. Kennedy regarding his appointment as ambassador to South Vietnam, the president had a copy of Browne's picture on his desk.

The still image crystallizes a moment in a way that the moving image cannot; it is the still image that in a fundamental manner remains fixed in the memory.

Many of the most indelible images, including the execution of a Vietcong suspect by the chief of the South Vietnamese national police, also appeared on television: Still photography and TV footage were in constant competition. Those who have yet to see such footage may wonder how a still image can match the drama of the movement of the girl running terrified down the road, the police chief's sudden action and the bloody collapse of the suspect, or, in later suicides by monks, the eerie sense of time passing as flames consumed a body. But the still image crystallizes a moment in a way that the moving image cannot; it is the still image that in a fundamental manner remains fixed in the memory.

The images appeared here, at home, because the photographers had access there, in the field. The war was fought all over Vietnam—in Saigon, in Hué, in Khe Sanh and the Highlands, in the Mekong Delta, in rice paddy after rice paddy,

173

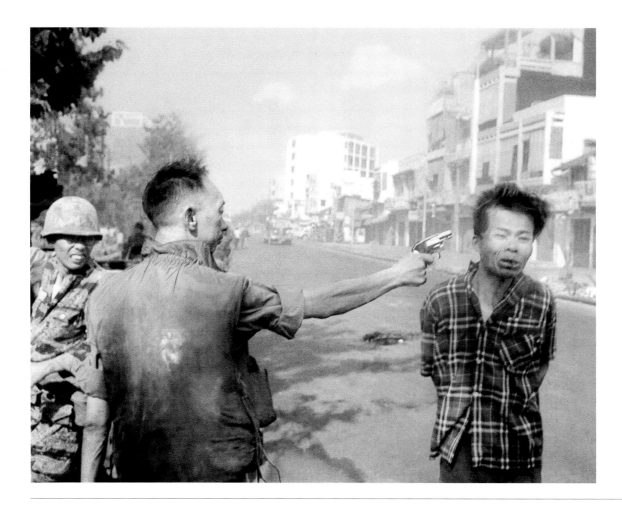

Eddie Adams
South Vietnamese National Police Chief Nguyen Ngoc Loan Executing Vietcong Suspect, 1969. (AP Wide World Photos)

village after village. The photographers were allowed to move with surprising freedom; there was ostensibly no official censorship, though a deliberate effort was made to control the reporting of the war through "news management."

It was an American war, but many of the finest photographs from Vietnam were produced by a trio of British photographers whose work often appeared in U.S. publications: Larry Burrows, who, though one of the first masters of color photojournalism, used black and white in a classic *Life* photo essay about a helicopter mission that ended with the crew chief in tears following the death of a copilot; Donald McCullin, who took a devastating series of images of the battle for Hué; and Philip Jones Griffiths, whose *Vietnam, Inc.* is perhaps the most powerful photo book to come out of the war and also the most controversial because of its indictment of the American war effort. (After the book was published in 1971, Griffiths was banned from Saigon by the South Vietnamese government.)

The politics of the photographers who worked in Vietnam are often difficult to pin down. David Douglas Duncan, the hardboiled former Marine known for his Korean war photographs, went to Khe Sanh during the siege and published a paperback called *I Protest* as a kind of broadside ("I protest the tactics. I protest the destruction. And I protest the war rhetoric in Vietnam."[4]). He then published a large hardcover book with other Vietnam images under the title *War Without Heroes*—a slightly misleading label, since for Duncan the war may not have been heroic but the Marines always were. He regarded combat photography in Vietnam as not unlike that in Korea or World War II and continued to photograph in a signature style at once gritty and melodramatic, with an emphasis on ordinary soldiers, not the brass.

The photographers were allowed to move with surprising freedom; there was ostensibly no official censorship, though a deliberate effort was made to control the reporting of the war through "news management."

Like the news of American casualties (and those of the enemy), the photographs just kept coming, one devastating image after another, along with standard-issue photographs of American politicians on fact-finding tours shaking hands with South Vietnamese officials, and pictures of soldiers relaxing at a USO show or a beach resort. And there were the photographs of body bags and flag-draped coffins. On June 27, 1969, *Life* published the straight-on identification photographs of the war dead from one week, showing all but twenty-five of the 242 casualties.

Vietnam War photography also included North Vietnam (correspondent Harrison Salisbury took photographs while there to report on the bombing), Laos, and Cambodia. During peace talks, there were photos from Paris, basic diplomatic photo-op shots, revealing nothing. More important was the so-called war at home, which generated a large store of images: photographs of rallies and other events, such as Garry Winogrand's photographs of an antiwar demonstration in Washington, D.C., and a prowar rally in New York, or the Diane Arbus portrait of a young man at a prowar parade who wears a "Bomb Hanoi" button and a skimmer straw hat and holds an American flag. Above all, there was John Filo's photograph of an anguished young woman kneeling beside the body of a student shot dead by the National Guard at Kent State. There were student deaths under similar circumstances at Jackson State, but no equally dramatic photo.

In Vietnam, the image of the combat photographer was once again glamorized according to what might be called the Robert Capa syndrome. Michael Herr's *Dispatches*, one of the best books about the war, includes portraits of Dana Stone and Sean Flynn (son of Errol), both of whom disappeared in Cambodia, and their friend, the madcap Brit Sean Page. Page, who was nearly killed by a mine, is described as hooting at a letter from a British publisher proposing a book that would once and for all "take the glamour out of war." Page's response: "I mean, you *know* that, it just *can't be done!* . . . Ohhh, what a laugh! Take the bloody *glamour* out of bloody *war!*"[5] The figure of the daring, dashing war photographer continued, though Burrows and others were killed. However, in *Apocalypse Now* (with a voice-over written by Herr), the image of the flamboyant war photographer took a beating in Dennis Hopper's portrayal of the burned-out, spaced-out photographer and acolyte to Marlon Brando's Kurtz.

Many shocks were administered by photographs during the war, but none was more devastating than Ron Haeberle's photographs of the massacre at My Lai on March 16, 1968, which spurred a war crimes investigation and led to the conviction of Lieutenant William Calley (who was later pardoned). Haeberle was a public information officer about to leave Vietnam. This was the first time he

Many shocks were administered by photographs during the war, but none was more devastating than Ron Haeberle's photographs of the massacre at My Lai . . .

had gone on a combat mission. He took photographs of civilians, many of them women and children, who were killed by American troops only moments later. He also photographed many of the dead bodies. Haeberle was uncertain about the situation; he had heard stories of children armed with grenades and other guerrilla tactics. He returned to base and delivered the rolls of black-and-white film he had shot with his Army camera, but kept a single roll of color he had shot with his own. Two weeks later, Haeberle went back to the States. There, a civilian again, he gave slide shows about his military experiences for friends and, eventually, for Rotary, Kiwanis, and high school groups. He included the massacre slides but it was not until August 28, 1969, after information about a possible massacre was brought to the attention of the government, that Haeberle was contacted by investigators. On November 20, the photographs were published in the *Cleveland Plain Dealer*, and later in *Life*.

One photograph, of many bodies lying on the road, was turned into a poster by an antiwar group with the caption "And babies? And babies," printed in red letters over the image (the question and response had come from a Mike Wallace television interview with one of the soldiers who was there). Photographs were also incorporated into antiwar works by other artists, including notable uses of photomontage combining war photographs and advertisements by Martha Rosler in her *Bringing the War Home: House Beautiful* series and by Robert Heinecken in images that combined beauty ads and a photograph of a war atrocity.

There is no way to gauge, finally, the full effect of still photographs—or, for that matter, television images—on policy makers and the American public. The famous images certainly attracted widespread attention and were discussed in major public speeches and innumerable private conversations. Many who lived through the period no doubt share the opinion that Eddie Adams's photograph of General Loan executing the Vietcong suspect marked a pivotal moment and could almost be credited with ending the war; at the height of the Tet Offensive, it was the single image that dramatized what America was engaged in. Peter Braestrup and others have argued that Tet was a military victory for America and South Vietnam but a media defeat, which in Braestrup's opinion unfortunately led to a turnaround in public opinion.[6] The North Vietnamese leadership was certainly aware that a psychological victory might conceivably be more valuable than a triumph on the battlefield when the opponent was a democratically elected government responsive to public opinion.

Later, there would be a backlash. During the Gulf War, photographers were systematically sealed off from the troops and the battlefield. The military had learned its lesson about media democracy. Grenada provided a kind of trial run:

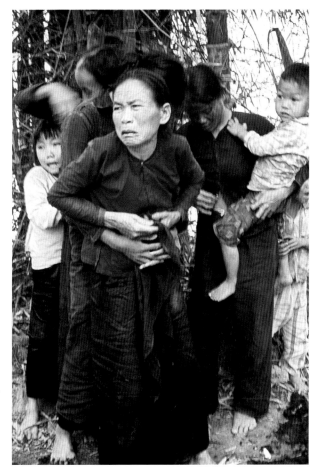

Ron Haeberle
My Lai Massacre, March 16, 1968.
(*Life* Magazine © Time Inc.)

Photographers were kept out for several days after American troops landed. In the Gulf War, the military behaved as if the only good combat picture was the one not taken and forced photographers to travel in "pools." As a result, apart from images carefully derived from videotape of aerial bombing, there were virtually no combat photographs in the U.S. press. The most powerful images were those taken in the aftermath of the battle—evidence of what had happened but not of how it occurred—such as photographs of the "highway of death" along which Iraqi soldiers were obliterated as they fled from Kuwait.

Near the end of *DelCorso's Gallery*, a 1983 novel about combat photographers by Vietnam veteran Philip Caputo (with characters apparently modeled on McCullin and Duncan), the title character, having followed the dogs of war from Vietnam to Beirut, laments the changes in war and combat photography. He asks, "What had happened and where had they gone, the decent, principled people who'd brought dignity to this calling, the Margaret Bourke-Whites, the Duncans, and Capas?" Then he adds, "We have lost something. None of us will ever photograph, with sincere pride and innocence, marines raising a flag on some future Surabachi."[7]

Arlen suggested that Vietnam was different, that it might not be quite as exciting or photogenic as the wars of the past that had produced iconic images by Capa, W. Eugene Smith, Margaret Bourke-White, and Duncan.[8] The images by Browne, Adams, Huynh Cong "Nick" Ut (who took the photograph of the napalmed girl), Haeberle, and many others belie that notion. It's just that flag-waving opportunities were limited. The best-remembered images from Vietnam are not the stuff that war monuments are made of.

1968

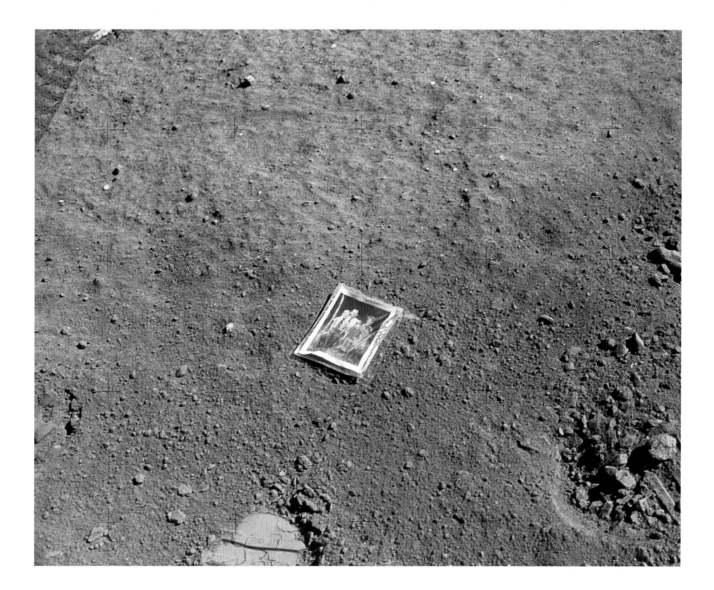

NASA
Family Picture on the Moon.
(Courtesy of NASA)

1969

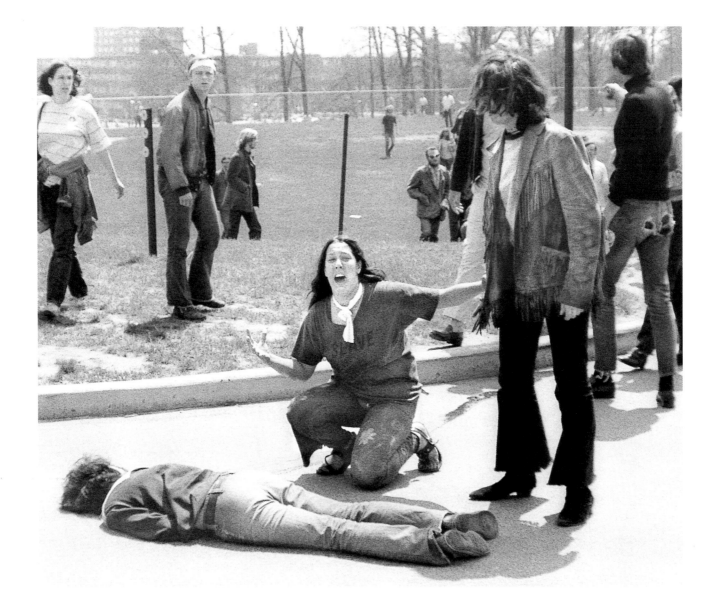

1971 *Photobooth portrait,*
Durham, North Carolina.

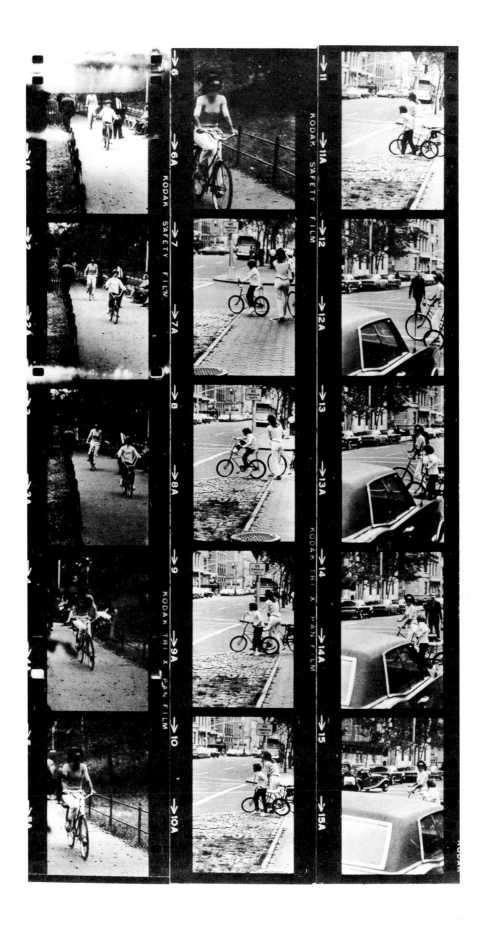

1972 Ron Galella
Jackie O Contact Sheet.
(Courtesy of the photographer)

1973 Photographer unknown
Kevin Costner high school senior yearbook photo.
(Seth Poppel Yearbook Archives)

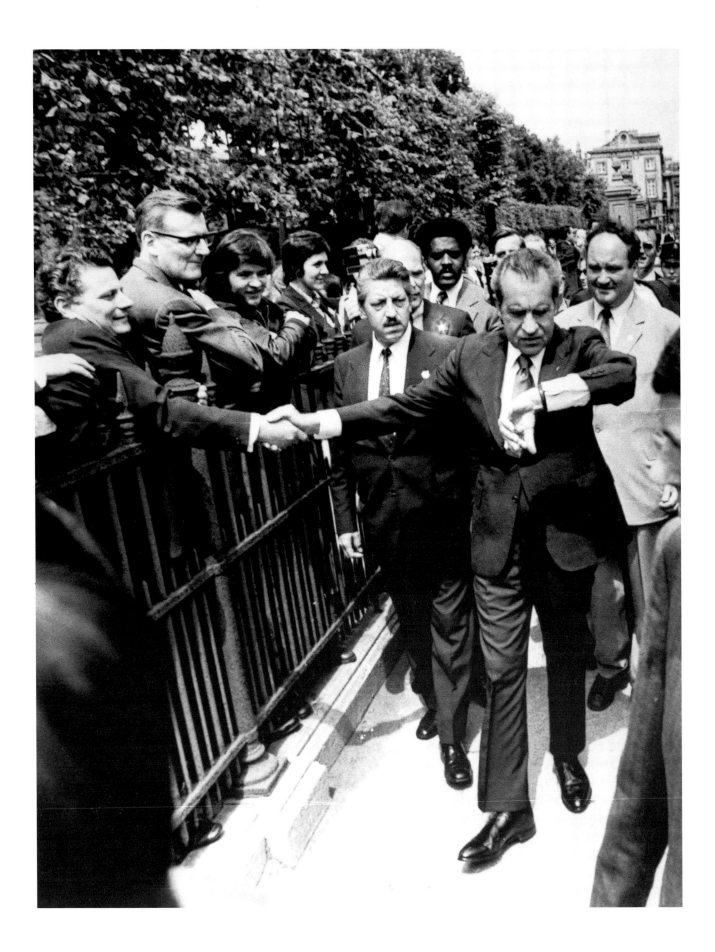

 Charles Tasnadi
Nixon checking his watch.
(AP Wide World Photos)

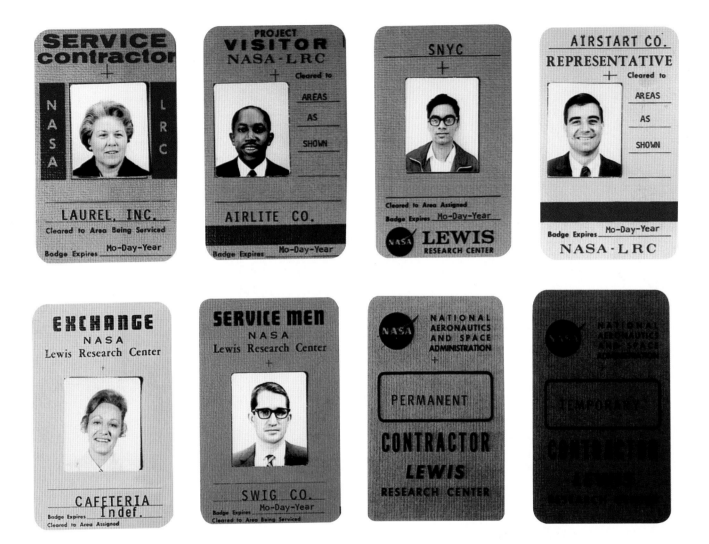

1975 *NASA employee badges.*
(Courtesy of NASA)

portraiture:
the ideal and the all-too-real

ONE OF THE GREAT DIVIDES IN PORTRAITURE (THOUGH THERE is some slippage) is between commercial photography made for the client, commercial photography made for the press, and portraits made for the artist who takes the picture. The first must please the subject, the second the editor, the third the photographer. A Bachrach portrait is expected to make the subject look a bit better than usual without seeming too fake. A newspaper picture does not necessarily flatter, nor does a magazine portrait. The "art" photograph aspires to being a good picture above all.

The other big divide is between a search for the inner life and a concentration on surfaces and roles, and this has changed over time. The idea that photography could uncover the soul held sway early in the century but had its nuances. In the first decade, Pictorialist photographers

like Edward Steichen and Gertrude Käsebier, both devoted to ideals of beauty, tended to locate the inner life in theatrical or symbolic imagery that spoke of "soul" and of profession as one of its signs. In 1918, when Alfred Stieglitz made his famous composite portrait of Georgia O'Keeffe, taking close-up, intimate pictures of her face and body over a period of years, he was trying to define not just a complete individual but the essence of Woman.

The suspicion that photography might steal a bit of the soul was expressed by a woman whom Edward Weston asked to sit for him. "I will not!" she said. "You would discover things inside of me to record which are none of your damn business!"[1] Weston's most fully realized portraits manage to compress a charged psychological narrative within a single frame. Beginning in the 1940s, Arnold Newman exchanged psychological intensity for boldly designed, shorthand symbols of accomplishment keyed to the props of the sitter's profession, like his portrait of Igor Stravinsky dwarfed by the lid of his grand piano.

Modernist American portraiture, beginning in the second decade with Paul Strand's stolen pictures of people on the street, generally stayed within the established tradition of direct, realistic representation, as opposed to European experiments with solarization, double exposure, shadow patterns, and the like.

Photographers who take pictures of the poor, who have been less defended against photographers and less practiced in the art of being photographic subjects, tend to dress them in the profession of poverty. The danger is that the images will become tourist souvenirs from the land of the downtrodden, the subjects mere symbols of their circumstances. (The rich and famous can far better afford to be symbols of their condition.) The Farm Security Administration photographers hoped to illuminate the troubles and sorrows of their subjects while preserving their human dignity. The best of their portraits, like Walker Evans's of the tenant families he lived with for a while, seem to be based on a sense of trust between photographer and sitter and give the subjects an opportunity to present a self they want the world to see.

If portraits of public figures reflect and possibly influence society's estimate of human capacity and acceptable display, it is no surprise that Steichen (who photographed for *Vogue* and *Vanity Fair* in the 1920s and 1930s), Irving

Arnold Newman
Igor Stravinsky (picture taken with crop in mind), 1946.
(© Arnold Newman. Courtesy of the photographer)

Penn, and Richard Avedon have been important portrait photographers, fashion and portraiture both being about appearance and how it is constructed.

The post–World War II world returned for a moment to interior psychology. Penn's early portraits thrust people into a narrow corner to see what happened to personality under such pressure or posed them with a fraying rug as if to say elegance be damned, we will all come to this too. Otherwise there were no props, only the sitters confronting the camera and making of themselves what they might. Many were not pleased with the results. Penn felt his obligation was never to his subjects but to the lady in Kansas who read *Vogue*.[2] Sitters had anticipated good will on the photographer's part, and Penn's adoption of a little-used prerogative anticipates later, more explicitly unflattering portraits like those of Diane Arbus.

Avedon, too, refused to flatter many of his sitters; indeed he often emphasized the stringy tendons of the neck, the sagging skin beneath the eyes, the skull beneath the skin. What interested him was the playacting that occurs before the camera's essentially public eye. Adam Gopnik suggests that Avedon's insight is that "in the last half of the twentieth century, at least in the higher reaches of the professional and artistic classes, both the private self and the public one came to be conceived dramatically."[3]

Glamour was no longer meaningful to stars, who wanted only to stand out from the welter of images.

Avedon sees the world as theater and is all too aware that romantic comedy does not play every night.

These photographers laid the groundwork, but social changes fueled the big shift toward a breakdown in privacy and decorum. Many rock stars in the 1960s and 1970s prided themselves on unkempt or outré clothes, hair, and makeup; young people followed suit. As Susan Sontag pointed out, Arbus's portraits of people on the fringes of society coincided with the acceptance of freaks as a subject of art.[4] Additionally, the media were multiplying, the tell-all syndrome was making its way into magazines and books and would soon infiltrate TV as well, and American culture was becoming increasingly fixated on celebrity and demanding the inside stories.

As the competition for celebrity pictures heated up, paparazzi raced to bare all in the lives of the famous—love affairs, drunken binges, nude sunbathing on private beaches. Big money was at stake, and photographers resorted to ingenious stratagems to get the picture, especially if the subject was off guard. Jacqueline Kennedy finally went to court in 1972 to stop Ron Galella from leaping out of bushes and frightening her children. The court ruled that he had to keep a certain distance.

Celebrity portraiture next combined Steichen's and the paparazzi's approach. Glamour was no longer meaningful to stars, who wanted only to stand out from the welter of images. Marlon Brando, for instance, was perfectly willing to share space with a beetle for Mary Ellen Mark's camera. The portraiture of Annie Leibovitz and some who came after consists of staged performances of an exaggerated, not necessarily flattering aspect of a star's reputation. The psyche is no longer in question; only the role is, and the surface appearance, appropriately enough for an era that values style over content. The stars are presented as brilliant logos of themselves.

Portraiture by and for the art world also veered into role playing and distinctly unflattering accounts. Between 1969 and 1971, Lucas Samaras took Polaroids of himself wearing wigs or making ridiculous faces and, a couple of years later, manipulated color Polaroid self-portraits until they turned into bad dreams. (Art world dignitaries happily shed their clothes for his lens, proving that it was truly chic to reveal all.) Joel-Peter Witkin has built a career on allegorical photographic tableaux that often center on portraits of amputees, hermaphrodites, and the obese.

A few shreds of wishful flattery are left for the rest of us, in wedding albums, yearbook photos, collections of family pictures, and images of memorable occasions. Self-portraits or pictures of the new baby or the best beloved are omnipresent, on T-shirts, watches, clocks, pins, mugs, and souvenir plates. People know not to expect much from essentially mechanical portraits for driver's licenses and passports, and are willing to camp it up for photo booths, digitized photo machines, or the old-fashioned fairground pictures in which you perch on a crescent moon or add your head to some famous vamp's body. Vanity is a serious business, but a better portrait is always a mere thirtieth of a second away.

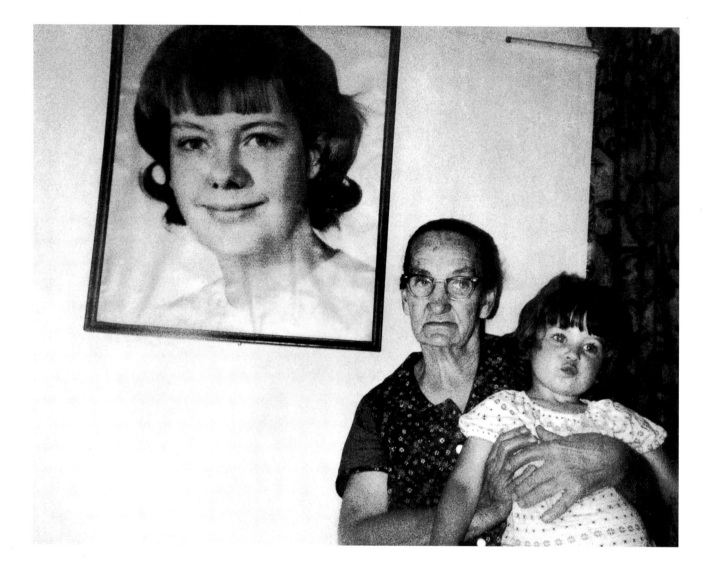

Mary Jo Cornett
Mamaw and my sister with the picture of my cousin that died.
Taken by a child in a class taught by Wendy Ewald.
(Courtesy of Wendy Ewald)

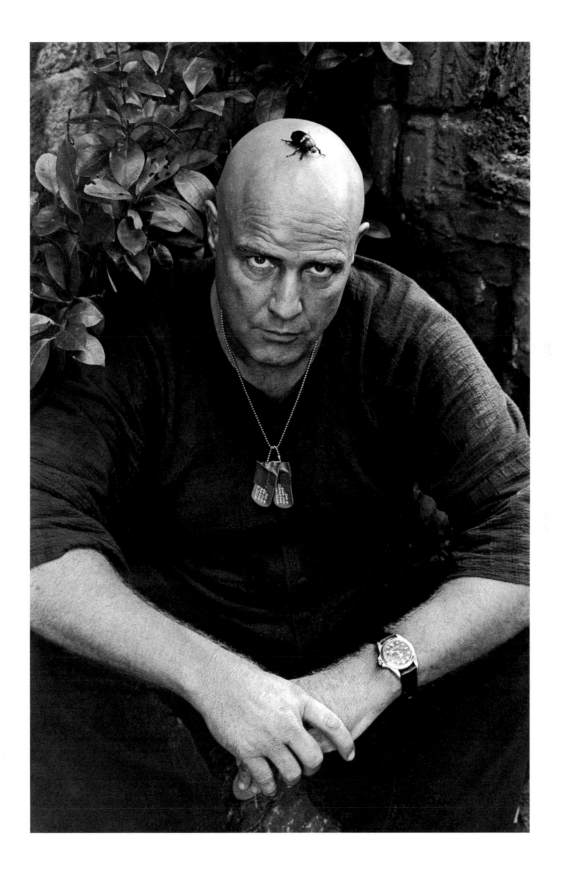

Mary Ellen Mark
Marlon Brando during the filming of
Apocalypse Now, *Philippines.* (© Mary Ellen
Mark. Courtesy of the photographer)

1977

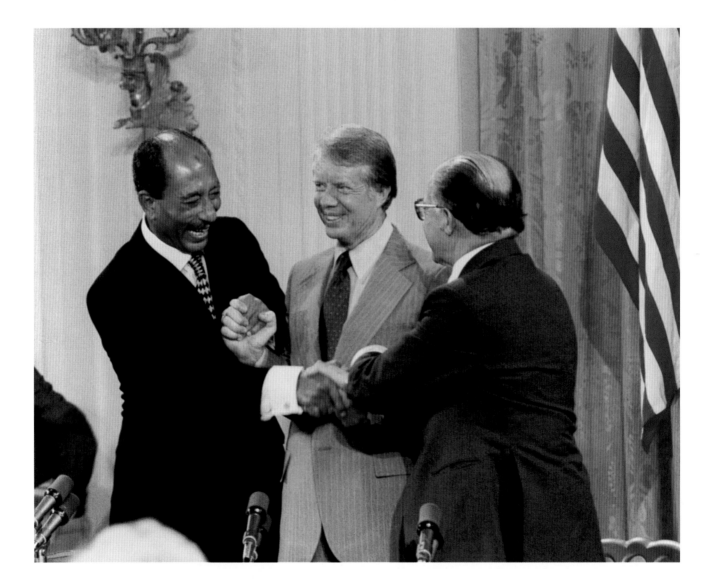

Cindy Sherman
Untitled Film Still #35.
1979
(Courtesy of the artist and Metro Pictures)

January 1981

SUNDAY	MONDAY	TUESDAY	WEDNESDAY	THURSDAY	FRIDAY	SATURDAY
				1 New Year's Day	2	3
4	5	6	7	8	9	10
11	12	13	14	15	16	17
18	19 Martin Luther King, Jr.	20	21	22	23	24
25	26	27	28	29	30	31

December 1980

S	M	T	W	T	F	S
	1	2	3	4	5	6
7	8	9	10	11	12	13
14	15	16	17	18	19	20
21	22	23	24	25	26	27
28	29	30	31			

February 1981

S	M	T	W	T	F	S
1	2	3	4	5	6	7
8	9	10	11	12	13	14
15	16	17	18	19	20	21
22	23	24	25	26	27	28

Photographer unknown
Landscape Calendar.

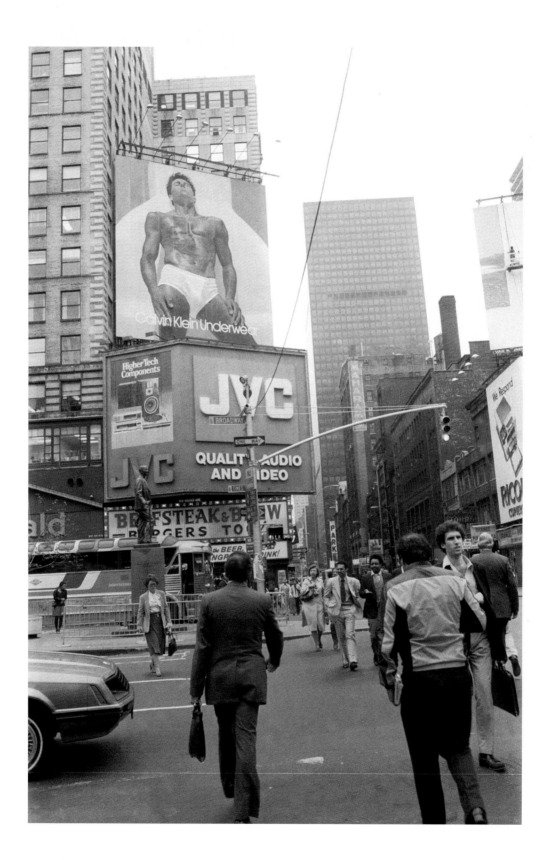

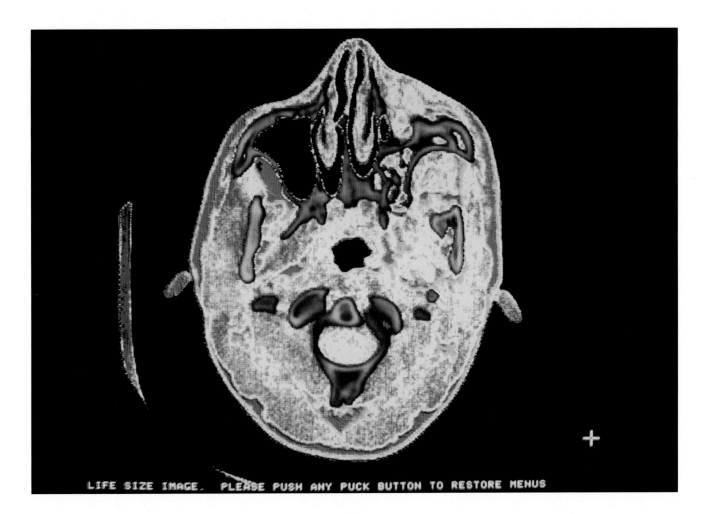

 1983 *CAT Scan (Computerized Axial Tomography).*
(Corbis/Charles O'Rear)

 1984 David Hanson
Waste Ponds and Evaporation Ponds.
(© David Hanson. Courtesy of the George Eastman House)

photography and the environment

In the United States, the grandeur of the landscape has always been identified with the greatness of the nation. Scenic wonders such as Niagara Falls, the Grand Canyon, and Yosemite have special status as national monuments. William Henry Jackson's photographs of Yellowstone, taken in 1871, have often been credited with more influence than they actually had, but they were unquestionably important in helping to pass the 1872 legislation that created Yellowstone Park, the first in the national park system.[1]

In America, land has traditionally been considered both as a special realm to be appreciated and preserved and as a resource to be exploited. The history of American landscape photography reflects the tension between these opposing views and provides a visual history of attitudes toward nature and land use, including the development of cities.[2] The nineteenth-century photographers of the West often took their photographs while accompanying geological survey expeditions. Their primary purpose was to record topographical features, and the pictures assisted in the search for minerals, the planning of transportation routes, and the mapping of the land for military purposes or, later, for use as real estate. Photography, in other words, was frequently an instrument of development. A dramatic photograph by Asahel Curtis (Edward's brother) of Seattle early in this century shows the leveling of the hills to make way for the city. The growth of the city, like the construction of railroads, dams, and bridges in other photographs, is presented as a triumph of civilization.

At least since the time of Emerson and Thoreau, Americans have been fond of regarding nature as a refuge, a source of spiritual renewal.

A positive view of nature transformed represents one major tradition in American landscape photography. A second major tradition presents a world seemingly untouched by human beings. In the work of Edward Weston, patterns found in nature—on sand or in wood, in a flower or a shell—move toward abstraction, as if to say that the most spiritual relationship to nature lies in an apprehension of its purest formal beauty. Minor White often photographed details of the landscape in a style the nineteenth century would not have recognized, as if the mysteries of the universe were not to be found in sweeping panoramas but sensed in the smallest elements of nature.

At least since the time of Emerson and Thoreau, Americans have been fond of regarding nature as a refuge, a source of spiritual renewal. American

Asahel Curtis
The Leveling of Hills to Make Seattle, 1910.
(Washington State Historical Society,
Tacoma)

landscape photographs often show what Estelle Jussim and Eva Lundquist-Cock call "the Landscape of God": visual hymns of praise to the glories of nature, whether heroic images of monumental subjects such as the Grand Tetons or intimate close-ups of glistening brooks and wildflowers in bloom.[3] The popularity of this view of nature and of the landscape photography that embodies it helps to explain the enormous appeal of Ansel Adams, probably the best-known and most beloved American photographer of the century and a man whose vision of nature and art was profoundly shaped by nineteenth-century attitudes.

At least since the time of W. H. Jackson, the history of the environmental movement in America has been bound up with the history of landscape photography, especially in the West. No figure has played a more prominent role in that history than Adams. A long-time member of the Sierra Club, he published numerous photographs in club publications and books devoted to wilderness areas. *The Sierra Nevada and the John Muir Trail*, published in 1938, included dramatic photographs of King's Canyon, California, that were used as part of an intense lobbying effort. Brought to the attention of Congress and President Franklin Delano Roosevelt by Secretary of the Interior Harold Ickes, the Adams images helped win approval—after a series of defeats—for legislation setting aside a half million acres as a national park. (Of course, where photography leads by showing pristine wilderness, tourism often follows, bringing people and change.)

When David Brower was executive director of the Sierra Club, he created a publishing program in support of the club's efforts to ward off the threatened destruction of significant natural areas. Adams and Nancy Newhall (wife of Beaumont and a major photo historian in her own right) created *This Is the*

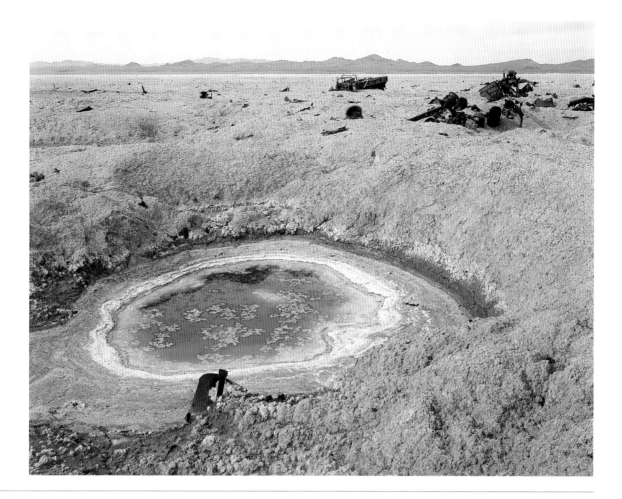

Richard Misrach
Crater and Destroyed Convoy,
Bravo 20, 1986.
(Courtesy of Jan Kesner Gallery,
Los Angeles)

American Earth, first as an exhibition that opened in 1955, then as a book that sold more than 200,000 copies between 1960 and the 1970s. (The book was reissued in 1992 to celebrate the 100th anniversary of the Sierra Club, and the exhibition was restaged.) The theme, Adams wrote in a memo, was "Conservation—both in its broad aspects as a background, and specifically in relation to the National Parks and Wilderness concepts."[4] It was a kind of environmental *Family of Man*, although in its activism it was perhaps closer to the use made of Hine photos by the Progressive-era reformers. Of the 102 photographs installed on large panels, 54 were by Adams, 48 by 39 other individuals and sources, including Margaret Bourke-White, Minor White, Edward Weston, and Eliot Porter. Newhall's poetic text accompanied photos designed to comment on the use of natural resources, the threat of overpopulation, and the effect of industrialization and urbanism. As David Featherstone has noted, the final section "suggests that the human spirit holds the ultimate answer as to how the earth can be saved, and that one may nurture that spirit by experiencing wilderness intensely."[5]

The Sierra Club "Exhibit Format" book series that followed *This Is the American Earth* featured fine color reproductions in relatively inexpensive volumes that showed special places of natural beauty. Perhaps the most notable was Eliot Porter's *The Place No One Knew*, photographs of Glen Canyon on the Colorado River taken in 1961 and 1962. The book was published in 1963, the year the Glen Canyon Dam permanently flooded the area and created Lake Powell. Only the photographs survive of a place that, as Marc Reisner has noted, took nature a hundred and fifty million years to create and humans ten years to erase.[6] (There are now proposals to remove the dam and restore the canyon.)

It has become commonplace to see images of oil-covered animals—marine birds, a sea otter, dead fish—that symbolize the devastation.

Porter was one of the first photographers to be known primarily for his work in color. In Glen Canyon he found a subject worthy of his talents. The rich colors of the rocks and vegetation and the reflections playing on the surface of the water helped make it a magical place, one that could not be presented as convincingly in black and white. At the time, color was often suspect among serious photographers, who considered it too pretty and commercial and appropriate only for advertising and fashion. Also, most photographers could not do their own color processing and printing, which was considered essential for guaranteeing personal artistic control.

Porter's images show an endangered, ultimately doomed area, but in a seeming state of grace, with no signs of humans or human activity. That describes one common kind of landscape image used by the environmental movement as a photographic plea. Another is the environmental nightmare picture that shows development or destruction as a warning of what might happen if nothing is done to stop it. A third approach combines the first two, in a pictorial strategy applied in endless variations: auto junkyard, pile of garbage, or other eyesore in the foreground, pristine vista in the background—the unspoiled and the despoiled in one neat pictorial package. Ansel Adams, in what was for him an atypical image shot both in black and white and in color, used a similar formula to contrast a cemetery statue of the Virgin Mary in the foreground with a derrick-strewn oil field in the background. (He claimed to have been interested only in the composition and light, not in the associations with death and destruction.)

The great example of environmental protest in photography is *Minimata*, the 1975 book by W. Eugene Smith with his wife, Aileen M. Smith, of a Japanese fishing village where chemical pollution caused birth defects.[7] The photographs are not primarily landscapes, though Gene Smith did take a photograph showing the toxic discharge pouring from a pipe into the bay. The most famous photograph from the series, *Tomoko in the Bath*, conveys the human cost of the environmental disaster by showing a crippled victim being bathed by her mother, the two of them posed like a Pietà with expressive Rembrandt lighting.

With the rise of supertankers and offshore drilling have come devastating oil spills, most notably that of the *Exxon Valdez* in Alaska on March 24, 1989. It has become commonplace to see images of oil-covered animals—marine birds, a sea otter, dead fish—that symbolize the devastation. These are the environmental equivalent of the photographs of starving children in famine situations around the globe.

The popular candidate for the title of greatest environmental photograph of all is an image of this planet, but it was not taken here. The earth, shown from

outer space, became the great icon of the environmental movement, appearing on the cover of that bible of the counterculture, *The Whole Earth Catalog*. Actually two such images have become ubiquitous. One was broadcast in 1967 from a satellite and turned into stills used on both covers of the first *Whole Earth Catalog* in 1968. Here was the world shown whole, a jewel suspended against the dark background of outer space. The other, *Earthrise*, was taken in 1968 by *Apollo 8* astronaut William Anders while on the moon, which appears in the foreground. That picture appeared on postage stamps, posters, and any number of other products and was used on the inside front cover of *The Last Whole Earth Catalog* in 1974, with the observation that it had "established our planetary facthood and beauty and rareness . . . and began to bend human consciousness."[8]

Not all environmentalist photographs are pure landscape photographs. Many different kinds of photographers have worked in support of environmental causes, which in recent decades have included a wide variety of issues, from water conservation and forestry to nuclear power. David Hanson has done a major project on the immense Western coal-mining and power-generating town of Colstrip, Montana. In Hanson's photographs, the effects of development on the landscape are immediately visible in garish colors. (The company might say the appearance is deceiving; advertising for corporations involved in environmentally sensitive industries such as mining, oil, and lumber tends to show emerald-green earth, crystal-clear water, and perfect blue skies.)

With varying degrees of political activism, any number of photo projects have been devoted to suburban development and highway strips, trailer camps, and the development of resort areas and golf courses. These contemporary

photographs rarely follow the Ansel Adams approach to nature, concentrating instead on the built environment rather than on preserves in which nature is "pure wilderness"—if such a thing ever existed. (As Rebecca Solnit has observed, the early photographs of Yosemite showed no signs of Native Americans.)[9] As early as the 1970s, Robert Adams (no relation to Ansel) was photographing the Denver area, showing the farmland on the periphery of the city being consumed by subdivisions; his 1977 book *Denver* now appears as a prescient early protest against suburban sprawl.[10]

These contemporary photographs rarely follow the Ansel Adams approach to nature, concentrating instead on the built environment . . .

Familiar calendar photographs of peaceful winter scenes in Vermont, autumn leaves changing color in Wisconsin, or desert wildflowers in bloom in Arizona are reminders that people like to comfort themselves with images of nature, especially when far away from it. Landscape photographs can provide a visual vacation, a brief imaginative trip out of the city or suburb until the next real journey into what we still call nature. Unfortunately, picturesque images from Jackson to the present have helped to make the national parks and other natural glories so popular that we must travel farther than ever to find the beauty in the calendar.

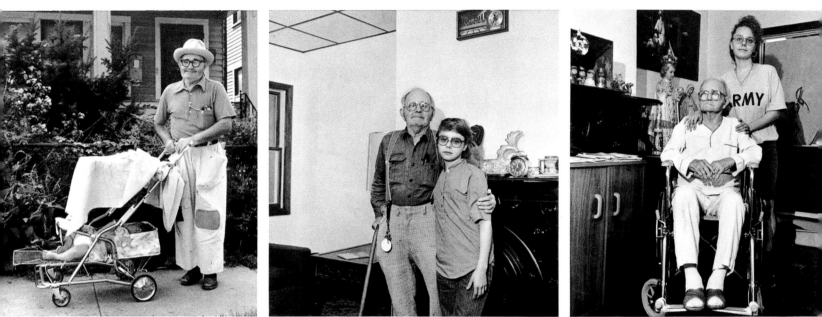

Eli Reed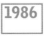
President Ronald Reagan cutout on a busy
Manhattan sidewalk, New York City, NY.
(Magnum Photos, Inc. © 1999 Eli Reed)

"Charlie" Squad ar Con Thien Feb, 1968

Fox Co 2nd Bat 1st Marines 2nd Platoon

"Doc" Allen Groshong, Newport News. Va.
Corpsman U.S. Navy
Killed April 8, 1968 Hill 504
Silver Star

Dear Allan,

It took me twenty years to contact your parents. I couldn't find a way to say "your son died saving my life." I know you understand. I finally did though. I talked to your father on the phone. It was difficult for both of us, but my load is so much lighter now. Johnny, Chip, Ted, Gerald, Bob and Sgt Jackson are here with you. I miss you all Love Brother

Lynn

48 E-52

Michael Samojeden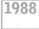
Test Ride (Michael Dukakis in tank).
(AP Wide World Photos)

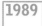

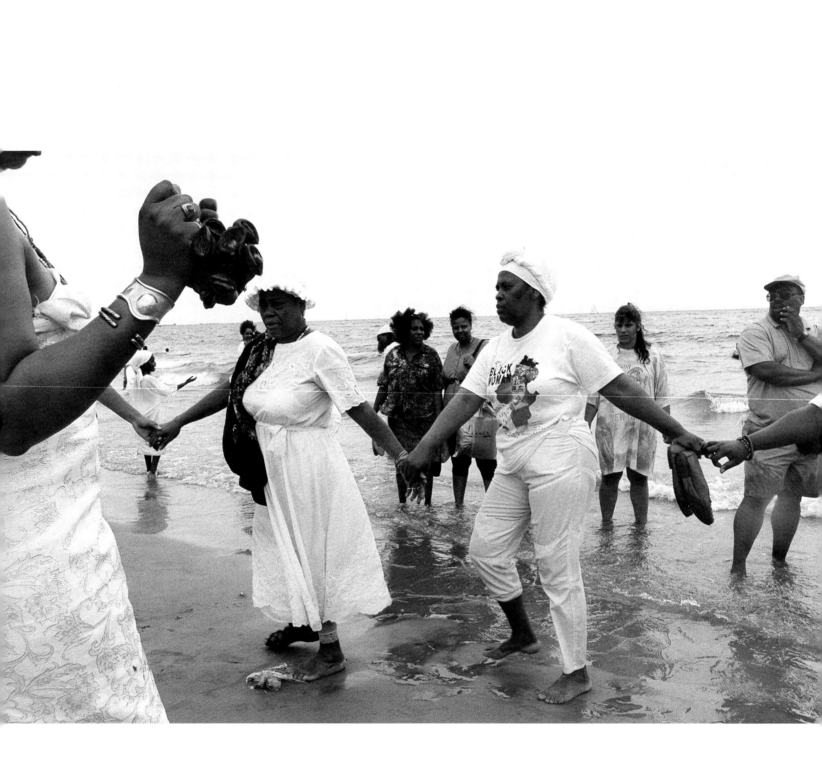

1990 Chester Higgins Jr.
Memorial to African ancestors who perished in Atlantic
Ocean during transfer from Africa to American enslavement.
(Courtesy of the photographer)

the new ethnic
(self-) representation

BASIC QUESTIONS TO BE ASKED OF ALL photographs of people: Who is taking pictures of whom? Where are they shown? And for what purpose?

In American photography, these questions take on special importance when the subjects of the photographs are members of racial and ethnic minorities. Given the treatment of members of these groups in the past (and present), the stakes are always high when it comes to photographic representation. Where stereotypes are at play, any picture may create a positive image or reinforce a negative one. The stakes are increased when the photographer is white, the subject a person of color, and the audience largely white—and more often than not, that has been the case.

An insider may have greater personal experience and knowledge of the subject and may elicit a more trusting, open response. Social proximity can lead to a physical and psychological closeness made evident in the photographs. But insider status is no guarantee of pictorial success. The results, as always, depend on the individual photographer and the elements of the specific situation.

When writer Eudora Welty traveled through the deep South in the 1930s, a young white woman working for the Works Progress Administration, she took snapshots, including many of African-Americans. She has said that in that particular time and place she was never questioned or avoided: "There was no self-consciousness on either side. There was no sense of violation of anything on either side. I don't think it existed; I know it didn't in my attitude, or in theirs. All of that unself-consciousness is gone now. There is no such relationship between a photographer and a subject possible any longer."[1]

Partly as a result of ethnic pride movements and a greater concern with image ethics and image politics, a new wave of photographic work is now being done by members of different ethnic and racial groups, with a full consciousness of what it means to participate in self-representation.

Today people are more aware of the significance of pictures than ever before. At some pueblos in the Southwest, there is a charge for tourists who wish to photograph—a minor source of funds, perhaps, but a major reminder that photography should not be regarded as a neutral, innocent activity, a right to which one is automatically entitled. For the Native American community, photography has always posed questions of power, authenticity, and use, as the case of Edward Curtis, the prolific photographer of Native American groups at the turn of the twentieth century, has shown. As Native photographer and curator Rick Hill has said, "Indians and photography just didn't get along for many years. The camera was an intrusion on Indian life. The photographs were taken for outside interests, by outside people."[2]

The stakes are increased when the photographer is white, the subject a person of color, and the audience largely white . . .

Whether traditional or cutting-edge, the new ethnic self-representation is based on the need to control one's own image.

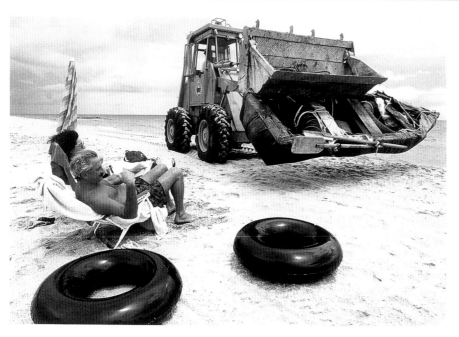

Eric Chu
Paradise, 1994.
(Courtesy of the photographer)

Of the photographs that document the civil rights movement, some were made by white photographers, some by African-Americans, some by journalists, some by photographers affiliated with the activist organizations, and others by those who worked for Southern government agencies opposing the activists. The African-American photographer Gordon Parks took photographs for the Farm Security Administration that addressed matters of race, and made photos for *Life* that included images specifically designed to interpret the African-American experience for a largely white, mainstream audience. But he has also been a fashion photographer and made abstract color images. Obviously not every photograph tells an explicitly political story, and not every photographer is defined by race and ethnicity all the time. Roland Freeman, Debbie Fleming Caffery, Chester Higgins Jr., Eli Reed, and many other African-Americans have photographed specifically African-American groups and activities, but they have also photographed elsewhere. (Higgins and Reed are across-the-board photojournalists, as is Joseph Rodriguez, a Latino who has done notable work photographing gangs in East Los Angeles.) Minority photographers can find themselves in photographic ghettos when they are asked to specialize in photographing their own group whether that is their primary interest or not. Yet they often think it important to make their ethnicity, which has always set them apart, an element in their work and a sign of pride.

Many of those using photography in the ethnic and racial communities are not photojournalists reporting on news or attempting extended documentation of aspects of social life. They are artists who use photography as their chosen medium, or one of their media. African-Americans like Carrie Mae Weems and Lorna Simpson are among those "artists who use photography" rather than "photographers who make art." Albert Chong makes works of art that reflect his African and Asian ancestry and Caribbean background, complex shrines using cowries, bird claws, feathers, and animal skulls. In his photographic work, the same elements often appear, sometimes bolstered by family photographs that suggest his reverence for the past and ID pictures on passports and licenses

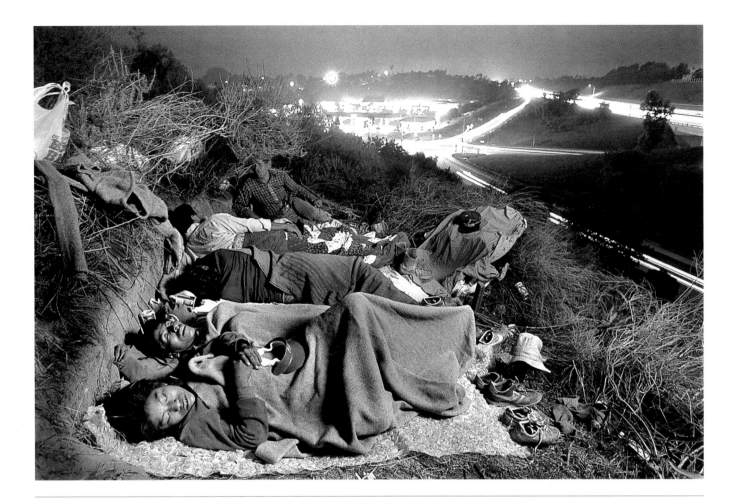

Don Barletti
Highway Camp, 1989.
(© Don Barletti. Courtesy of the
photographer)

that indicate shifting circumstances and various ways of defining identity. The
Vietnamese-American photographer Dinh Q. Le has created a series of works
exploring personal and cultural identity from a different angle. Using both a
computer and weaving, the artist combines his own self-portrait with significant
images from East and West, such as a sculpture of Buddha and an image of Jesus
taken from a fifteenth-century Western painting.

In the Native American community, artists such as Hulleah J. Tsinhnahjinnie
have used photography as an instrument of satire and political commentary, at
times adopting an approach to representing Native Americans that offers a self-
conscious alternative to Edward Curtis. (If there are Native American photogra-
phers who still create images in a Romantic style à la Curtis, at least it is their
own Romanticism.) And humor may be one quality that can divide insiders from
outsiders, since outsiders dare use it only at their own risk; being judged guilty
of laughing at, not with, leads to trouble.

Photographers from outside these various communities continue to make
important photographs within them, and to photograph those struggling to
enter, whether they arrive on rafts or dashing across highways. But in estab-
lished communities and in those of new immigrants, there are now concerted
efforts to support photographers who can work from the inside, with an insider's
vision. Representation is a controversial matter; there are sometimes sharp dif-
ferences within these communities. (Why should racial and ethnic groups have a
unified aesthetic when no other groups do?) Yet whether traditional or cutting-
edge, the new ethnic self-representation is based on the need to control one's
own image. The main question is, "Which side of the camera are you on?"

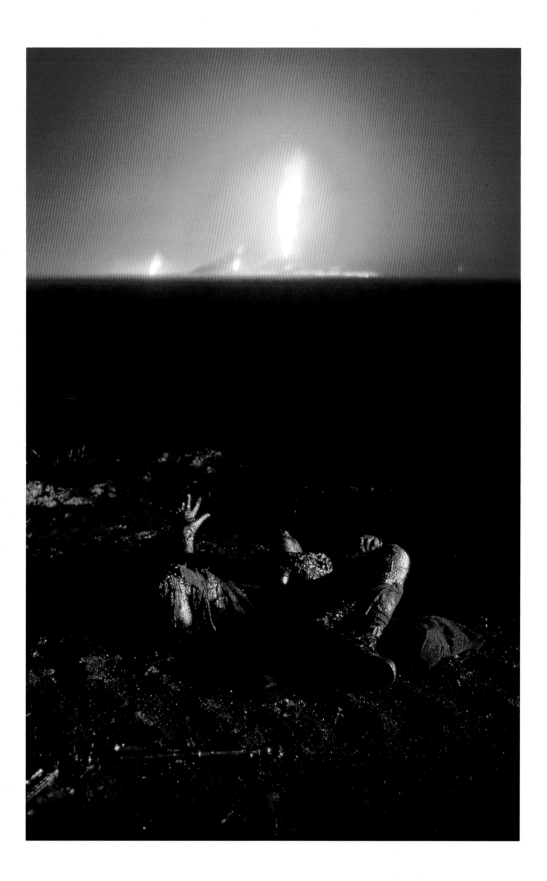

 1991 Steve McCurry
Victims of the war in the desert surrounding Kuwait City.
(© Steve McCurry/Magnum Photos, Inc.)

Family Abduction

Benjamin Heinrich

Age Progression by NCMEC

On: 3/28/91

Recovery Photo

Birth 7/8/82	Race: White	
Missing: 9/4/87	Ht: 3'09"	Wt: 35 lbs
Eyes: Brown	Hair: Brown	Sex: Male
Missing From:		Manistee, MI
Age Now 16 Yrs		United States

Benjamin's photo is shown aged to 9 1/2 years old. He was abducted by his non-custodial father.

WWW.MISSINGKIDS.COM

ANYONE HAVING INFORMATION SHOULD CONTACT
The National Center for Missing and Exploited Children
1-800-843-5678 (1-800-THE-LOST) OR
Manistee County Sheriff's Office (Michigan) - Missing Persons Unit
1-616-723-6941

Color courtesy of
Tektronix

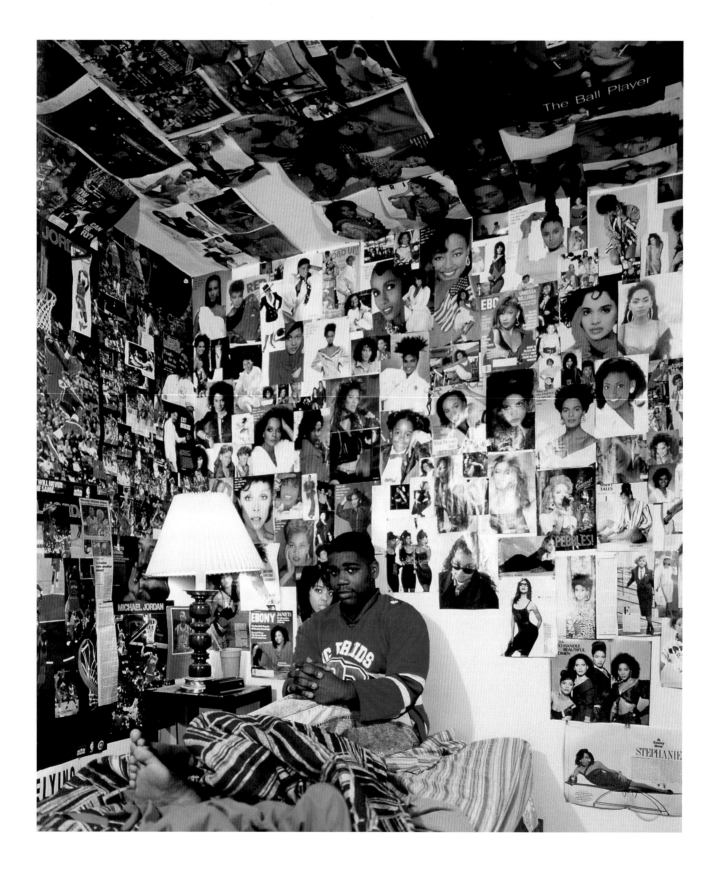

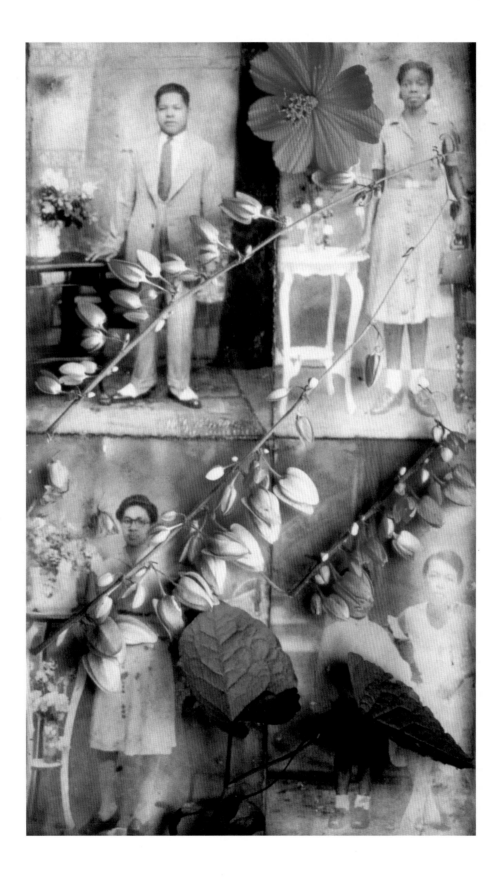

1994 Albert Chong
Story Bout My Father.
(Courtesy of Throckmorton Fine Art)

postmodern photography

Laurie Simmons
Woman/Purple Dress/Kitchen, 1976/1977.
(Courtesy of the artist and Metro Pictures)

PHOTOGRAPHY, LIKE ALL CULTURAL PRODUCTION, HOLDS A mirror up to its time and gives back a hot reflection, usually at an angle, skewed. But in the late twentieth century, it would almost be possible to say that the culture *is* photography, or photographically generated images. Personal behavior, politics, international affairs, even wars are partially determined by images. So photography, which has always brought back reports of the world and ourselves, began to bring back reports on photography.

Pop art had used photographs to comment on, perhaps to celebrate, the commercial culture of products like soup and Brillo and the prevalent visual media. By the late 1970s, society had become so conscious of immersion in the media that the press and TV themselves began to discuss media mechanics and influence, like the transformation of politics into photo-ops and the controversy over violence on TV. The notion was abroad that not only was the environment saturated with media and their images but that maybe there was nothing else, maybe all experience had become secondhand. Photography, once hailed as the great conveyor or truth and reality, was now said to have replaced reality itself.

The art world responded with postmodernism, a name indicating that the utopian aims of modernism and the high values it placed on individuality and originality had been discredited and were supposedly finished. There were said to be no more authors, no true creators, no single dominant ethos, only pastiches of the past and of many cultures, including the vernacular and commercial. The separation of culture into high and low was now regarded as just another instance of one class asserting its authority over another.

Rephotography was one artistic technique that reinforced the idea that originality was not the issue. Richard Prince rephotographed the commercial photography of Marlboro ads and removed the text, thereby making a copy of a stereotype—the myth of the American West that the cigarette company had hoped would shed its aura on their product. Prince was as clear about the death of the author in words as he was in images: "His own desires had very little to do with what came from himself because what he put out (at least in part) had already been out. His way to make it new was make it again, and making it again was enough for him and certainly, personally speaking, almost him."[1]

Barbara Kruger rephotographed portions of obscure ads or other commercial images, then added slogans with a feminist political slant, defying the established pattern of male authority over women. Enlarged to poster size and printed in black, white, and red, these earned her commissions for magazine covers as well as uncredited imitations in other periodicals. Kruger's work pointed up one of the paradoxes inherent in the postmodernist critique, particularly that branch of it known as appropriation for its wholesale use of pre-made imagery: The attempt to criticize the culture from within, employing its own artifacts and means, has built-in difficulties, and its edge can be blunted by sophisticated agents of the media cannily borrowing back from art the techniques of the critics themselves.

The clearest, if most limited, statement of the principles of appropriation was made by Sherrie Levine when she rephotographed well known images by textbook-sanctioned greats of photography like Walker Evans, Eliot Porter, and Edward Weston from reproductions of their work. In one stroke, she pointed out that almost everyone knew these photographs (and most art, for that matter) from books, rather than from the photographers' prints. This copy exercise further suggested that experience in

general was mediated through one sort of reproduction or another. Levine called into question the authorship and almighty authority of the male "masters" of photography, whose work could be reproduced and re-"authored" by commercial printers or by women. The masters did not agree. Some sued to prevent her from hanging "their" work in galleries again.

When it appeared in the 1970s and 1980s, postmodernism relied heavily on photography, women were its primary exponents, and most of them considered themselves artists and declined to call themselves photographers. Photography once more came up in the art world on the wings of certifiable art.

A few bona fide photographers had already been using certain techniques that would become central to postmodernism. At the beginning of the 1970s, Robert Heinecken protested the Vietnam War by appropriating a gruesome news photograph of a South Vietnamese soldier holding two severed Vietcong heads, printing the image over the pages of mainstream magazines, then secretly returning the magazines to the newsstands. Magazine buyers may have been uneasy, but the art world could not yet rouse itself for photography.

Some artists appropriated the look and messages but not the actual images of the commercial media. Cindy Sherman first came to public attention with black-and-white photographs of women playing familiar B-movie roles—housewife, lonely heart, librarian, sex kitten. All the characters were actually Sherman herself in wigs and costumes, suggesting that women had no central, immutable identity, only roles prescribed by films and photographs.

Laurie Simmons also portrayed women playing roles in photographs, but in her work the characters were small, anonymous plastic figurines, some of them color-coordinated with the decor, in miniature households where they cooked, cleaned the bathroom, or watched TV—plastic dolls leading plastic suburban lives. The postmodernists were fond of surrogate figures of many kinds, another way to say that all of us were leading surrogate lives derived from the media. They also invested heavily in scenes and sets that were staged and constructed in order to be photographed and then dismantled. This ploy goes back to the nineteenth century; it

was revisited by artists who, aware that politics and public events were largely photo-ops, believed playacting was the primary mode of being in the contemporary world.

Modernism has proved too stubborn to die just because its obituary had been written, but postmodernism remains alive as well. Curiously, in America the movement was influenced by French linguistic philosophers of the 1960s and 1970s—Jacques Derrida, Jean Baudrillard, Roland Barthes—who contended that the encompassing vision of essence and truth that modernists had spoken of was no longer operative; in its place stood fragmentation, ambiguity, and multiplicity. Barthes put the idea that all texts depended on previous texts most forcefully: "The text is a tissue of quotations drawn from the innumerable centres of culture."[2]

This was one opening into the emphasis on multiculturalism in art, literature, and university studies that has so marked the last quarter of the century. Postmodernist notions of pastiche, the end of originality, and the transfer of reality to the media, whatever their intellectual origins, have found expression in popular culture such as the music style called sampling and movies like *The Truman Show* and *Pleasantville*. More than merely an art movement, postmodernism is a stage in history.[3]

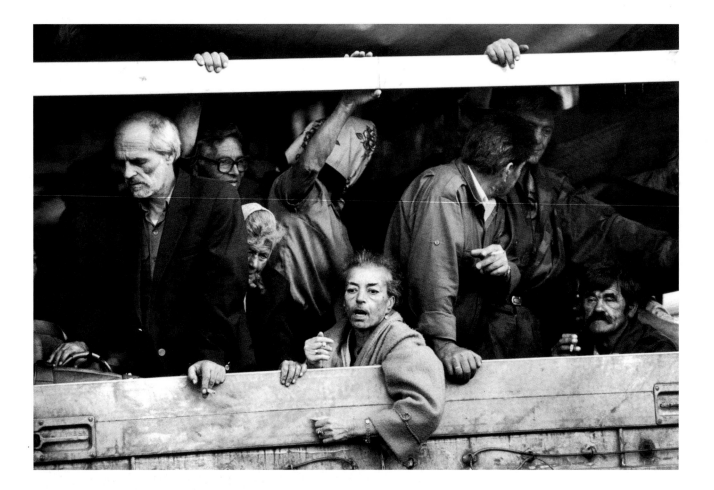

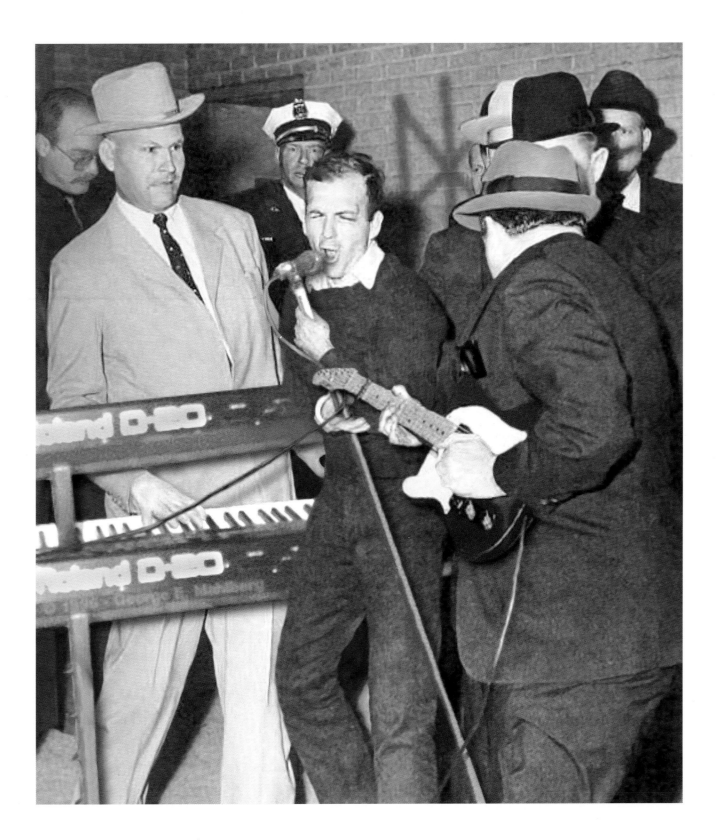

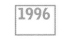 1996 George E. Mahlberg
Oswald/Ruby as Rock Band, 1996. Adaptation by
George E. Mahlberg of original photograph by
Bob Jackson, 1963. (Courtesy of the photographer)

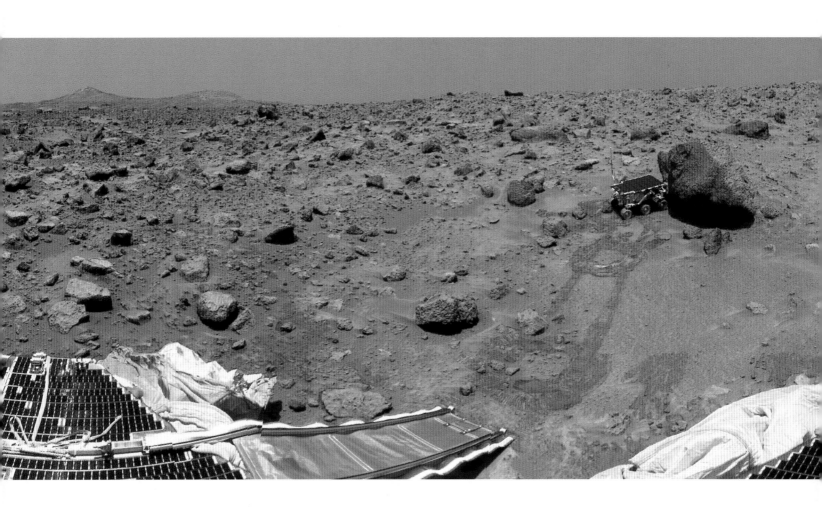

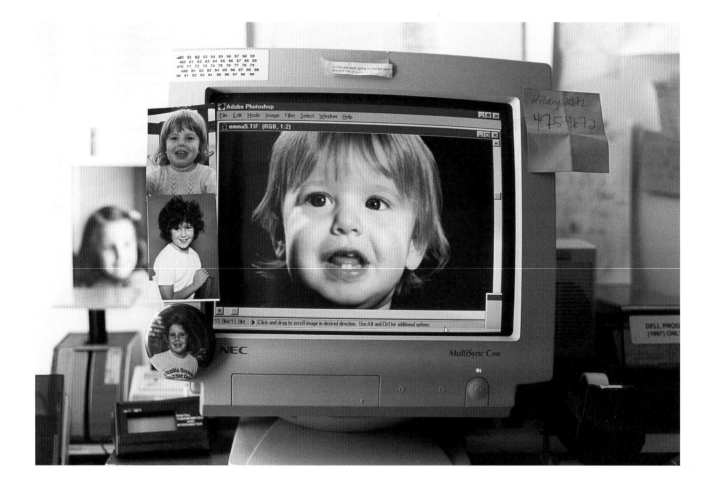

the digital revolution

WHAT THIS REVOLUTION LOOKS LIKE is the displacement of truth and the death of photography, which in some readings amount to the same thing. Even people who loudly proclaimed that photography lied knew photographs could produce something ordinarily called truth, but all of that evidently flew out the window when digitization came in the door.

The computer has certainly changed image making. From photography's inception, it was possible to alter photographs, if only by hand painting, and to alter the reality of what the camera saw by staging it, but digitization has made mutation and even fabrication amazingly simple, swift, and hard to detect. In a life immersed in images, the possibility that anyone with a little computer expertise could create fictions that looked entirely plausible and pass them off as fact necessarily affected ideas about sensory perception and raised philosophical and social issues.

Photography's reputation for veracity has been tenacious partly because human beings, like most animals, evolved in a world where believing what you see—food, danger, obstacles—has been essential to survival. Since photographs appear to replicate a recognizable reality, the eyes and mind react accordingly, though the brain is perfectly capable of overruling the first impression. Faked photographs, unless made as art or entertainment, seem especially duplicitous, even treacherous, as if George Washington had been caught in a lie.

Stalin's government made a habit of removing his enemies, first by killing them, then by expunging them from the photographic record, one obviously worse than the other but both indicative of vicious dictatorship. During the Army-McCarthy hearings in America in 1954, the Secretary of the Army was accused of offering preferential treatment to Private G. David Schine, Senator Joseph McCarthy's protégé, in order to keep McCarthy from investigating an Army department. A photograph was exhibited that appeared to show the Secretary of the Army smiling at Private Schine. The next day, the Army's counsel proved the photograph had been cropped by the McCarthy side; the Secretary had actually been smiling at a third man. McCarthy was discredited by these hearings. The cropped photograph hurt him; it was read as a clue to his character.

Neither Stalin nor McCarthy needed computers to reconfigure the historical record, but even as the photograph of Schine was being doctored, the first experimental digital images were in the works, and in the following decade they were used in space exploration.[1] In the 1960s and 1970s, the computer, not yet a household item, was hitched to new instruments to extend vision into territory far beyond the normal range, much as the camera had been in the previous

> Faked photographs, unless made as art or entertainment, seem especially duplicitous, even treacherous . . .

Martina Lopez
Revolutions in Time 1, 1994.
(© Martina Lopez. Courtesy of Schneider Gallery, Chicago)

century. The results were sometimes so extraordinary that even scientists doubted them at first: When the first scanning tunneling microscope images of atomic structure were published in the 1980s, some said they were nothing more than computer simulations, then changed their minds when the results were replicated, an essential for any scientific experiment.[2]

By the 1980s, expensive, high-end computers took over picture corrections that had formerly been done by hand at major publications. Printers used computers for color separations, TV engineers called on them to improve picture quality. By 1989, the *Wall Street Journal* estimated that 10 percent of all color photographs published in American were retouched or altered by digital means.[3]

People grew nervous when they were fooled by undetectable changes made to content. In February 1982, *National Geographic* moved two of the pyramids, those great immovables, closer together to create a better image for their vertical cover. It was a small move, a couple of inches on paper, but once it was revealed the immutable facts of the world no longer seemed so reliable. In August 1989, *TV Guide* merged Oprah Winfrey's head with Ann-Margret's body on one of its covers to show that Winfrey had slimmed down; Ann-Marget's husband discovered the deception when he recognized his wife's ring. The January 27, 1994, covers of *Time* and *Newsweek* had the exact same picture of O. J. Simpson, who had been accused of killing his former wife, but the *Time* cover darkened his

People fear being deceived about important events or what they take to be facts, yet there seems to be a natural delight in tricks and illusion.

skin and the shadows around his beard and brows and surrounded his head with a dramatic burst of light, making him look quite diabolical. What next?

People fear being deceived about important events or what they take to be facts, yet there seems to be a natural delight in tricks and illusion. Placement, honest labeling, and intent make a difference. No one cries foul when still photographs are flagrantly altered for entertainment purposes—Lee Harvey Oswald and Jack Ruby united in a rock band, an astronaut shaking hands with a Martian.

Commercials and movies, which have the money to exploit the new computer capabilities, have transformed expectations and made special effects a staple of existence. In the early 1990s, television cleverly brought the dead back to life, inserting film clips from old films into a contemporary setting, so that Humphrey Bogart, James Cagney, and Louis Armstrong visited a bar where Elton John was singing the praises of Diet Coke, and Gene Kelly danced with Paula Abdul in one of her music videos. No one "believed" these, but some voiced regret that the sacred texts of movie history were being suborned for commercial enterprises.

Films like *Star Wars* and *Jurassic Park* create new worlds impossible ever to enter yet visible and delightfully credible for the two hours that belief is willingly suspended. It is as if you could send your eyes to outer space while your physical body ate popcorn on Main Street. Movies have been handing out passes to worlds and lives you could not otherwise enter since the beginning of the century; the process has merely become more capable, extravagant, and convincing.

Graphic programs on home computers are making it possible for anyone with a little expertise to bring Daddy home for the birthday party or remove an old girlfriend from a favorite picture; even snapshots are no longer stable. The ease with which elements can be cut and pasted on a computer suits an era so devoted to pastiche and initially produced a rash of collage artists who had discovered a faster pair of scissors. The Internet has put myriad images within reach of millions, raising copyright issues that have yet to be resolved. A new distribution system, the Internet crosses borders without even applying for a passport and has escorted pornographic and seditious photographs into island fortresses and authoritarian dictatorships that once controlled the traffic.

Virtual reality systems, first developed in flight simulators for pilot training, use head mounts to restrict the perceptive faculties to a fictive universe, promising immersion in illusion, which some commentators fear could lead to a complete withdrawal from the world. ("Living? We'll leave that to the servants."[4]) When the virtual environments consist of sky, mountains, a golf course, or other plausible surroundings, they depend on what is still regarded as photographic reality,

american photography

Darryl Curran
Savoy Cabbage, Baby's Breath, Blade, 1995. Scanogram; digital
ink print from an ephemeral assemblage constructed on a flat-
bed scanner. (Courtesy of Nash Editions and the photographer)

something that looks like a pictured replica of the "real" thing, but in VR it may be neither photographic nor real.

The retreat into fantasy is still largely a theoretical problem, as virtual reality is not yet widely available, consistently persuasive, or sufficiently comfortable. (The comfort level is rising at a handful of CAVE's—computer assisted virtual environments—in academic settings around the world. Here the participant may need nothing more than polarized glasses and may be truly immersed in the experience, which can even extend underfoot.) The unsettled issues concern evidence: Can news photographs be believed, and are electronic photographs reliable proof? The courts, always a step behind technology, are gradually considering the new photographic paradigm, but then, photographs have always been subject to the same degree of inquiry as any other piece of evidence.

As to news, electronic cameras enlarge the potential for tampering. The camera can transmit images directly into the computer system of a newspaper, where computer technicians and picture editors can alter them at will. In 1989, the *St. Louis Post-Dispatch* removed a Diet Coke can from a front-page picture, improving the image but not exactly improving its trustworthiness.[5] Alarms went off. Had there been a machine gun on the table, would the paper have removed that as well without notifying its readers? Newspaper editors drew up new codes of ethics, generally insisting that no picture was to have its content changed, however slightly, without a printed acknowledgment. Most pledged not to change news pictures in any way. If pictures that are not news and do not need to be straight information have been altered, by now they are usually labeled "photo illustration," "computer composite," or something similar. The question of trust persists but so far seems not to have been breached in ways any more major than it was before the arrival of the computer.

The means of gathering images, however, has begun to change. Now it is less a question of capturing a single moment than of recording a string of moments and editing one out. (The motor-driven camera had already introduced this option.) Newspapers have printed single images from television transmis-

Jenny Okun
Exeter Cathedral, England, 1996.
(Courtesy of Nash Editions
and the photographer)

sions on their front pages, and newer digital video cameras are making it simpler for a photojournalist to take video footage and grab a single frame from the flow.

Computers can construct credible images almost entirely within the computer, as architects do when making computer models of a project that has not yet broken ground. Computers also take strings of fragmentary images and construct a model of the whole, as happens in CAT (computerized axial tomography) scans when low-dose X rays pass through the body from different angles and a cross-sectional, three-dimensional model is constructed by a computer program. (It is even possible to view the results from different angles, something obviously impossible with a two-dimensional image.) This is one aspect of a revolution in imaging that has been gathering force in this century with such advances as radar and sonar images, in which non-optical data have been converted into some form of visual display. Photography works by a combination of light and chemicals, but CAT scans, sonograms, MRI (magnetic resonance imaging) scans, and PET (positron emission tomography) scans do not register light waves nor operate in the visual wave length at all, and the images they produce are constructed from digital data by the computer.

We now have new kinds of nonoptical photographs, and vision has gained new access to the invisible. Images from deep space are electronically converted from records of wavelengths as short as gamma rays and as long as radio signals, most of which are outside the visible range. The picture is printed on photographic paper, but its formation defies the history of photography. No longer does light provoke chemical reactions; now energy stimulates photoelectric elements called charge-coupled devices (CCD's). The computer then composes an image that looks more like a standard photograph. When we look at images close to the edge of the universe, we see what human eyes have never seen and in all probability never will.

And yet they are believable. At the end of a century that has journeyed from utter faith in the truth of photographs to cynical disbelief, we find we still believe in photographs after all, even in photographs that are developed from an array of numbers by a machine that can see what we cannot. We believe in photo finishes of horse races, X rays that reveal tumors, scanning probe microscope photographs of chromosomes, and infrared photographs of stars in formation. We believe in license and passport photographs that are checked against the evidence of our faces when we travel. We believe so firmly in baby pictures that we carry them with us to show to other willing believers.

Digitization has prompted much talk about the death of photography. We should all be assured of so glorious an afterlife.

notes

I. THE DEVELOPING IMAGE, 1900–1934

The Snapshot Revolution
1 On family photographs, see Julia Hirsh, *Family Photographs: Content, Meaning, and Effect* (New York: Oxford University Press, 1981); Marianne Hirsch, *Family Frames: Photography, Narrative and Postmemory* (Cambridge: Harvard University Press, 1997); Deborah Willis, ed., *Picturing Us: African American Identity in Photography* (New York: The New Press, 1994); and Elizabeth Anne McCauley, *A. A. E. Disdéri and the Carte de Visite Portrait Photograph* (New Haven, Conn.: Yale University Press, 1985). On snapshots, see Douglas R. Nickel, *Snapshots: The Photography of Everyday Life, 1888 to the Present* (catalogue accompanying a show of that name, San Francisco Museum of Modern Art, May 22–September 8, 1998).

Photography as Fine Art
1 Alfred Stieglitz, "The Photo-Secession," reprinted in *Photography: Essays & Images*, ed. Beaumont Newhall (New York: Museum of Modern Art, 1980), p. 167.
2 Quoted in Richard Whelan, *Alfred Stieglitz: A Biography* (Boston: Little, Brown, 1995), p. 365.
3 Whelan, op. cit., p. 365.
4 "Photography," reprinted in *Classic Essays in Photography*, ed. Alan Trachtenberg (New Haven: Leete's Island Books, 1980), pp. 141-142.
5 Trachtenberg, op. cit., p. 141.
6 Quoted in Penelope Niven, *Steichen: A Biography* (New York: Clarkson Potter, 1997), p. 506.

Foreign Peoples, Foreign Places
1 The speaker was Alexander Graham Bell, inventor of the telephone and second president of the National Geographic Society. Quoted in C. D. B. Bryan, *The National Geographic Society: 100 Years of Adventure and Discovery* (New York: Harry N. Abrams, 1987), p. 43. On *National Geographic*, see also Catherine A. Lutz and Jane L. Collins, *Reading National Geographic* (Chicago: University of Chicago Press, 1993). For the general issues, see James Clifford, *The Predicament of Culture: Twentieth-Century Ethnography, Literature, and Art* (Cambridge: Harvard University Press, 1988).
2 See Arnold Genthe, *Genthe's Photographs of San Francisco's Old Chinatown*, selection and text by John Kuo Wei Tchen (New York: Dover, 1984).
3 See Christopher Lyman, *The Vanishing Race and Other Illusions: Photographs of Indians by Edward S. Curtis* (New York: Pantheon, 1982).

Extending Vision: Science and Photography
1 Jon Darius, *Beyond Vision* (Oxford: Oxford University Press, 1984), p. 12.
2 Ann Thomas, "Capturing Light: Photographing the Universe," in Ann Thomas et al., *Beauty of Another Order: Photography in Science* (New Haven: Yale University Press, 1998), p. 196.
3 On the archive, see Alan Sekula, "Photography Between Labor and Capital," in *Mining Photographs and Other Pictures 1948–1968: Photographs by Leslie Shedden*, ed. Benjamin H. D. Buchloh and Robert Wilkie (The Press of the Nova Scotia College of Art and Design and The University College of Cape Breton Press, 1983), pp. 193-202.
4 Darius, op. cit., pp. 36, 42, 44, 14.
5 For the story of X rays, see Vicki Goldberg, *The Power of Photography: How Photographs Changed Our Lives* (New York: Abbeville Press, 1991), pp. 48-50.
6 Clark A. Elliott, *History of Science in the United States: A Chronology and Research Guide* (New York: Garland Publishing, 1996), p. 151.
7 Darius, op. cit., p. 58.
8 *McGraw-Hill Encyclopedia of Science and Technology*, 18th edition, 1997, v. 13, "Photography."
9 Darius, op. cit., pp. 15, 13, 14.
10 For the story of Anderson's discovery, see Goldberg, op. cit., pp. 50-52.

Social Reform: The Camera as Weapon
1 Quoted in Maren Stange, *Symbols of Ideal Life: Social Documentary Photography 1890–1950* (New York and Cambridge: Cambridge University Press, 1989), p. 6.
2 In his essay, "Ever-the Human Document," in Alan Trachtenberg, Walter Rosenblum, and Naomi Rosenblum, *America and Lewis Hine: Photographs 1904–1940* (Millerton, N.Y.: Aperture, 1977), p. 131.
3 Trachtenberg, Rosenblum, and Rosenblum, op cit., p. 112.
4 See *Walter Rosenblum*, essays by Shelley Rice and Naomi Rosenblum (Dresden: Verlag der Kunst, 1990), and *Jerome Liebling: The Minnesota Photographs*, essay by Alan Trachtenberg (St. Paul: Minnesota Historical Society Press, 1997), and Jerome Liebling, *The People, Yes* (New York: Aperture, 1995).
5 See Susan D. Moeller, *Compassion Fatigue: How the Media Sell Disease, Famine, War, and Death* (New York and London: Routledge, 1999).
6 Stange, op. cit., p. 28.
7 Lewis Hine, "Social Photography, How the Camera May

Help in the Social Uplift," reprinted in *Classic Essays in Photography*, ed. Allan Trachtenberg (New Haven, Conn.: Leete's Island Books, 1980), p. 112.

Capturing Time: Motion Study and Social Control
1 On Taylor and Gilbreth, see Vicki Goldberg, *The Power of Photography: How Photographs Changed Our Lives* (New York: Abbeville Press, 1991), pp. 67-70, and Marta Braun, *Picturing Time: The Work of Etienne-Jules Marey (1830–1904)*, pp. 333-348.
2 See Mike Mandel, *Making Good Time, Scientific Management, The Gilbreths, Photography and Motion Futurism* (Riverside, Calif.: California Museum of Photography, 1989).

Photographing the News
1 Gail Buckland, *First Photographs: People, Places, and Phenomena as Captured for the First Time by the Camera* (New York: Macmillan, 1980), p. 165. The process was called "granulated photography." Buckland notes, "Practically every source states mistakenly that the first halftone in a newspaper was a picture of 'Shantytown,' New York, published in the *Daily Graphic*, March 4, 1880. In any case, it was not until the turn of the century that newspapers started using photographs regularly." For a history of photojournalism in America from the turn of the century through the 1930s, see also Michael L. Carlebach, *American Photojournalism Comes of Age* (Washington, D.C.: The Smithsonian Institution, 1997).
2 See Estelle Jussim's " 'The Tyranny of the Pictorial': American Photojournalism from 1880 to 1920," in *Eyes of Time: Photojournalism in America* by Marianne Fulton, with contributions by Estelle Jussim et al. (Boston: New York Graphic Society, 1988) p.58.

World War I: The Camera Goes to War
1 Susan D. Moeller, *Shooting War: Photography and the American Experience of Combat* (New York: Basic Books, 1989), pp. 111 and 115.
2 See January and February, 1915.
3 "Aero Photography," *Abel's Photographic Weekly*, December 21, 1918, pp. 533-537. Quoted in Vicki Goldberg, *The Power of Photography: How Photographs Changed Our Lives* (New York: Abbeville Press, 1991), p. 71.
4 See Paul Virilio, *War and Cinema: The Logistics of Perception*, trans. Patrick Camiller (London: Verso, 1989), p. 1 and passim. Radar does not work by optics but becomes more useful when converted to visual data.
5 Quoted by Kevin Brownlow, *The War, the West, and the Wilderness* (New York: Knopf, 1979), p. 85.

Advertising Photography
1 Robert Sobieszek, *The Art of Persuasion: A History of Advertising Photography* (New York: Harry N. Abrams, 1988), p. 165.
2 James D. Norris, *Advertising and the Transformation of American Society, 1865–1920* (New York: Greenwood Press, 1990), p. 41.
3 John Hamilton Phinney, "A 'Cut' Argument," *Printer's Ink* 23 (15 June 1898); quoted by Jackson Lears, *Fables of Abundance: A Cultural History of Advertising in America* (New York: Basic Books, 1994), p. 286.
4 Sobieszek, op. cit., p. 19.
5 Juliann Sivulka, *Soap, Sex, and Cigarettes: A Cultural History of American Advertising* (Belmont, Calif.: Wadsworth Publishing Company, 1998), p. 232.
6 Roland Marchand, *Advertising and the American Dream: Making Way for Modernity, 1920–1940* (Berkeley: University of California Press, 1985), p. 149.
7 George Gallup poll in *Advertising Age*, January 20, 1932, p. 5, cited in Marchand, ibid., p. 149.
8 Patricia Johnston, *Real Fantasies: Edward Steichen's Advertising Photography* (Berkeley: University of California Press), 1997, p. 36.
9 Egbert G. Jacobson, foreword to *Annual of Advertising Art in the United States* (1921): ix, quoted in Johnston, op. cit., p. 33.
10 Johnston, op. cit., p. 32.
11 Herbert Molderings, "Urbanism and Technological Utopianism: Thoughts on the Photography of the Neue Sachlichkeit and Bauhaus," in *Germany: The New Photography, 1927–1933*, selected and edited by David Mellor (London: Arts Council of Great Britain, 1978), p. 93.

The Cult of Celebrity
1 Daniel J. Boorstin, *The Image: A Guide to Pseudo-Events in America* (New York: Atheneum, 1987, first published 1962), p. 567. For a discussion of the photograph's contribution to celebrity in the nineteenth century, see Vicki Goldberg, *The Power of Photography: How Photographs Changed Our Lives* (New York: Abbeville Press, 1991, pp. 103-112).
2 Vicki Goldberg, "The Pictures that Serve a President's Image," *New York Times*, October 12, 1997, p. 37, Section C.
3 Clive James, *Fame in the Twentieth Century* (New York: Random House, 1993), p. 50.
4 Boorstin, op. cit., pp. 67-68.

II. THE PHOTOGRAPHIC AGE, 1935–1959

LIFE and the Rise of the Picture Magazines
1 Robert T. Elson, *Time Inc., The Intimate History of a Publishing Enterprise*, vol. 1: 1923–1941 (New York: Atheneum, 1968, pp. 197-300). For an account of *Life's* beginnings, see Elson; Loudon Wainwright, "*Life* Begins: The Birth of the Late, Great Picture Magazine," *Atlantic Monthly*, May 1978; and Vicki Goldberg, *Margaret Bourke-White: A Biography* (New York: Harper & Row, 1986), pp. 172-183. For a good selection of pictures from the early years, see *LIFE: The First Decade*, published to accompany a show of that name in 1979.
2 Bernard DeVoto, *Saturday Review*, January 29, 1938, quoted by W. A. Swanberg in *Luce and His Empire* (New York: Charles Scribner's Sons, 1972), p. 145.

The Wire Services
1 Susan Kismaric, *American Politicians: Photographs from 1843 to 1993* (New York: Museum of Modern Art, 1994), p. 203.
2 For a good summary of wire service development, see Marianne Fulton, *Eyes of Time: Photojournalism in America* (Boston: New York Graphic Society, 1988), pp. 109-113.
3 See the obituary for William Githens, *New York Times*, November 2, 1998, p. 54.
4 For a fuller account of the crash, see Vicki Goldberg, *The Power of Photography: How Photographs Changed Our Lives* (New York: Abbeville Press, 1991), pp. 192-195.

The Farm Security Administration (FSA): Documenting the Depression
1 From the first shooting script, reprinted in F. Jack Hurley, *Portrait of a Decade: Roy Stryker and the Development of Documentary Photography in the Thirties* (New York: Da Capo, 1977), p. 187. In addition to the works listed below, see also William Stott, *Documentary Expression and Thirties America* (New York: Oxford, 1973) and Hank O'Neal, *A Vision Shared: A Classic Portrait of America and Its People, 1935–1943* (New York: St. Martin's Press, 1976).
2 Quoted in Lawrence W. Levine, "The Historian and the Icon," in *Documenting America 1935–1943*, ed. Carl Fleischhauer and Beverly W. Brannan (Berkeley and Los Angeles: University of California Press, 1988), p. 40.
3 Quoted in F. Jack Hurley, *Russell Lee, Photographer* (Dobbs Ferry, N.Y.: Morgan and Morgan, 1978), p. 18; Stryker quoted in "The FSA Collection of Photographs," in Roy Emerson Stryker and Nancy Wood, *In This Proud Land: America 1935–1943 As Seen in the FSA Photographs* (Greenwich, Conn.: New York Graphic Society, 1973), p. 14.
4 Quoted in Stryker and Wood, p. 19.
5 See James Curtis, *Mind's Eye, Mind's Truth: FSA Photography Reconsidered* (Philadelphia: Temple University Press, 1989), pp. 78-87.
6 Quoted in James Guimond, *American Photography and the American Dream* (Chapel Hill: University of North Carolina Press, 1991), p. 117.
7 Levine, op. cit., p. 39.
8 Stryker and Wood, op. cit., p. 7.
9 Hurley, op. cit., p. 66.
10 *Walker Evans at Work*, ed. Jerry L. Thompson (New York: Harper & Row, 1982), p. 112.
11 Guimond, op. cit., p. 100.
12 In a memo reprinted in Stryker and Wood, p. 188.

MoMA, 1937: The History of Photography Comes to the Museum
1 For Newhall's account of Barr's surprising offer and its consequences, see his *Focus: Memoirs of a Life in Photography* (Boston: Bulfinch Press, 1993), pp. 43-53.
2 *Photography: 1839–1937* (New York: Museum of Modern Art, 1937). The catalogue was published as a book in the following year as *Photography: A Short Critical History*; revised editions later appeared under the title *The History of Photography* (New York: Museum of Modern Art, 1982).
3 Christopher Phillips, "The Judgement Seat of Photography," reprinted in *The Contest of Meaning: Critical Histories of Photography*, ed. Richard Bolton (Cambridge: MIT Press, 1989), p. 21.
4 John Szarkowski, *Photography Until Now* (New York: Museum of Modern Art, 1989). Three other major works by Szarkowski are *The Photographer's Eye* (New York: The Museum of Modern Art, 1966); *Looking at Photographs: 100 Pictures from the Collection of The Museum of Modern Art* (New York: The Museum of Modern Art, 1973); and *Mirrors and Windows: American Photography Since 1960* (New York: The Museum of Modern Art, 1978).

World War II: Censorship and Revelation
1 Said by Dan Longwell. Quoted in Loudon Wainwright, "*Life* Begins: The Birth of the Late, Great Picture Magazine," *Atlantic Monthly*, May 1978, p. 61.
2 Wilson Hicks, *The News Photographer*, 1/14/48, Time Inc. Archives, quoted in Vicki Goldberg, *Margaret Bourke-White: A Biography* (New York: Harper & Row, 1986), p. 269. On Steichen, see Christopher Phillips, *Steichen at War* (New York: Harry N. Abrams, 1981), p. 9.
3 On still pictures activated by guns, see *Life: World War II*,

ed. Philip B. Kunhardt Jr. (Boston: Little, Brown, 1990), p. 5. This is an update of a 1950 publication and contains many photographs by Signal Corps, wirephoto agency, even enemy photographers, as well as *Life* staffers. On the color film, see Christopher Phillips, op. cit., p. 47.
4 Moeller, p. 192.
5 Paul Virilio, *War and Cinema: The Logistics of Perception*, trans. Patrick Camiller (London: Verso, 1989), pp. 76-77.
6 John Morris, "This We Remember," *Harper's Magazine*, September 1972, p. 73.
7 For details about this photograph, see Vicki Goldberg, *The Power of Photography: How Photographs Changed Our Lives* (New York: Abbeville Press, 1991), pp. 196-199.
8 See Richard Whelan, *Robert Capa: A Biography* (New York: Alfred A. Knopf, 1985), p. 211.
9 On Khaldei, see Vicki Goldberg, "Beyond Battle: A Soviet Portrait," *New York Times*, January 31, 1997, p. 1, Section C. On Rosenthal, see Goldberg, *The Power of Photography*, pp. 142-147.
10 Carl Mydans, *Carl Mydans, Photojournalist* (New York: Harry N. Abrams, 1985), p. 13.
11 Robert Capa, *Slightly Out of Focus* (New York: Henry Holt, 1947), p. 151.

The Photographic Instant and Instant Photography
1 The story is recounted in Peter C. Wensberg, *Land's Polaroid: A Company and the Man Who Invented It* (Boston: Houghton Mifflin, 1987), pp. 82-83, and in Victor K. McElheny, *Insisting on the Impossible: The Life of Edwin Land* (Reading, Mass.: Perseus Books, 1998), p. 163.
2 For Edgerton, see *Stopping Time: the Photographs of Harold Edgerton*, ed. Gus Kayafas, text by Estelle Jussim (New York: Harry N. Abrams, 1987).
3 Quoted by Susan Sontag in *On Photography* (New York: Farrar, Straus and Giroux, 1977), p. 124.

Fashion Photography
1 See Nancy Hall-Duncan, *The History of Fashion Photography* (New York: Alpine Book Co., 1979), p. 12.
2 Quoted by Martin Harrison in *Appearances: Fashion Photography Since 1945* (New York: Rizzoli, 1991), p. 18. There are many books by and about Penn, including John Szarkowski, *Irving Penn* (New York: Museum of Modern Art, 1984); Irving Penn, *Passage: A Work Record* (New York: Alfred A. Knopf/Callaway, 1991), which has the most copious reproductions; and *Irving Penn: A Career in Photography*, edited by Colin Westerbeck (Boston: The Art Institute of Chicago in association with Bulfinch Press, published in conjunction with an exhibition at The Art Institute of Chicago, November 22, 1997–February 1, 1998).
3 Interview with Vicki Goldberg for the *New York Times*, 1991.
4 1991 interview.
5 Harrison, op. cit., p. 115. Numerous books by and about Avedon include *Avedon: Photographs 1947–1977* (New York: Farrar, Straus & Giroux, 1978); *Richard Avedon: An Autobiography* (New York: Random House, and Rochester, N.Y.: Eastman House, 1993), with the most numerous reproductions; and *Evidence 1944–1994: Richard Avedon*, ed. Mary Shanahan (New York: Random House, and Rochester, N.Y.: Eastman House, 1994).

Sex and Voyeurism
1 James Agee and Walker Evans, *Let Us Now Praise Famous Men* (Boston: Houghton Mifflin, 1960), p. 7.

The Family of Man: A Heartwarming Vision for the Cold War World
1 Quoted in Penelope Niven, *Steichen: A Biography* (New York: Clarkson Potter, 1997), p. 688.
2 Edward Steichen, *The Family of Man*. Prologue by Carl Sandburg. (New York: Museum of Modern Art, 1955).
3 Quoted in Jane Livingston, *The New York School: Photographs 1936–1963* (New York: Stewart, Tabori & Chang, 1992), p. 265, n106.
4 Eric J. Sandeen, *Picturing an Exhibition: The Family of Man and 1950s America* (Albuquerque: University of New Mexico Press, 1995), pp. 48, 67 and passim. Sandeen's book is the only book-length study of the exhibition, which has also occasioned important commentary by writers such as Roland Barthes ("The Great Family of Man," in *Mythologies*, trans. Annette Lavers [New York: Hill and Wang, 1972], pp. 100-103), and Allan Sekula ("The Traffic in Photographs," in *Photography Against the Grain: Essays and Photo Works 1973–1983* [Halifax, Nova Scotia: The Press of the Nova Scotia College of Art and Design, 1984], pp. 76-101). A recent contribution to the debate over the exhibition is Marianne Hirsch's chapter on "Reframing the Human Family Romance" in her *Family Frames: Photography, Narrative and Postmemory* (Cambridge: Harvard University Press, 1997), pp. 41-77.

The Americans and the Dark Side of the 1950s
1 On Frank and *The Americans*, see the catalogues from two major retrospective exhibitions, *Robert Frank: New York to Nova Scotia*, ed. Ann W. Tucker, assoc. ed. Philip Brookman (Houston: Museum of Fine Arts, 1986), and *Robert Frank: Moving Out*, Sarah Greenough and Philip Brookman

(Washington, D.C.: National Gallery of Art ,1994).
2 Quoted in Colin Westerbeck and Joel Meyerowitz, *Bystander: A History of Street Photography* (Boston: Bulfinch Press, 1994) pp. 346, 347.
3 In "William Klein and the Radioactive Fifties," in *The Privileged Eye: Essays on Photography* (Albuquerque: University of New Mexico Press, 1987), p. 45. See also James Guimond's chapter on Frank, Klein, and Arbus, "The Great American Wasteland," in his *American Photography and the American Dream* (Chapel Hill: University of North Carolina Press, 1991), pp. 205-244. Weegee is discussed in both essays.

III. PHOTOGRAPHY TRANSFORMED, 1960–1999

Pop Art, Photography, and the Mass Media
1 Harold Evans, *The American Century* (New York: Alfred A. Knopf, 1998), p. 435.
2 John Tebbel and Mary Ellen Zuckerman, *The Magazine in America, 1741–1990* (New York: Oxford University Press, 1991), p. 244.
3 William L. O'Neill, *Coming Apart: An Informal History of America in the 1960s* (Chicago: Quadrangle Books, 1977), p. 3; cited in Jonathan Fineberg, *Art Since 1940: Strategies of Being* (New York: Harry N. Abrams, 1995), p. 244.
4 From a speech at the School of Visual Arts, New York, 1996.
5 Quoted by A. D. Coleman in "Ed Ruscha (!): 'My Books End Up in the Trash,'" *New York Times*, August 27, 1972; reprinted in A. D. Coleman, *Light Readings: A Photography Critic's Writings 1968–1978* (New York: Oxford University Press, 1979), p. 115.

Surveillance and the Photograph as Evidence
1 *The Corsair*, April 13, 1839, quoted in William Welling, *Photography in America: The Formative Years, 1839–1900* (New York: Thomas Crowell, 1978), p. 8.
2 Gail Buckland, *First Photographs: People, Places and Phenomena As Captured for the First Time by the Camera* (New York: Macmillan, 1980), p. 160.
3 Andra A. Moenssens, "The Origin of Legal Photography," *Fingerprint and Identification Magazine*, vol. 43, no. 7, January 1962, p. 6.
4 *The Photographic News*, 1861, p. 180; cited in Helmut Gernsheim, *The Rise of Photography 1850–1880: The Age of Collodion* (New York: Thames and Hudson, 1988), p. 201.
5 See John Tagg, "The Burden of Representation: Photography and the Growth of the Surveillance State," *Ten 8*, no. 14, 1984, pp. 10-12.
6 For a brief account of the photographs and the crisis, see Vicki Goldberg, *The Power of Photography: How Photographs Changed Our Lives* (New York: Abbeville Press, 1991), pp. 71-72. For a fuller account of the incident, see James G. Blight and David A. Welch, *On the Brink: Americans and Soviets Reexamine the Cuban Missile Crisis* (New York: Hill & Wang, 1989).

Civil Rights: Photography and Social Awareness
1 See Steven Kasher, *The Civil Rights Movement: A Photographic History, 1954–68* (New York: Abbeville Press, 1996).
2 Danny Lyon, *Memories of the Southern Civil Rights Movement* (Chapel Hill, N.C.: Center for Documentary Studies, Duke University and University of North Carolina Press), p. 128.

The Counterculture: Changing Times, Changing Images
1 For Arbus, see *Diane Arbus* (Millerton, N.Y.: Aperture, 1972) and *Diane Arbus: Magazine Work*, ed. Doon Arbus and Marvin Israel, essay by Tom Southall (Millerton, N.Y.: Aperture, 1984). Susan Sontag is withering toward Arbus in *On Photography* (New York: Farrar, Straus and Giroux, 1977), pp. 32-48.
2 Diane Arbus, p. 2.
3 Diane Arbus, p. 1. She also said, "I'm never afraid when I'm looking in the ground glass" (i.e., through the lens), p. 12.
4 For a selection of the sixties album covers, not all photographic, see Storm Thorgerson, *Classic Album Covers of the '60s* (New York: Gallery, 1989).

Vietnam: Shooting War
1 Michael J. Arlen, *Living-Room War* (New York: Penguin, 1982). There is also a more straightforward reason for the title: Arlen was the *New Yorker* television critic, and the book gathered his pieces, which were largely defined by his response to the news coverage of the war.
2 The best discussion of Vietnam War photography remains Susan D. Moeller's discussion in *Shooting War: Photography and the American Experience of Combat* (New York: Basic Books, 1989), pp. 323-413.
3 Moeller, op. cit., p. 404.
4 David Douglas Duncan, *I Protest!* (New York: Signet, 1968), n.p. [9].
5 Michael Herr, *Dispatches* (New York: Avon, 1978), p. 266.
6 Peter Braestrup, *The Big Story*, 2 vols. (Boulder: Westview Press, 1977).
7 Philip Caputo, *DelCorso's Gallery* (New York: Dell, 1983), p. 334.
8 Arlen, op cit., p. 82.

Portraiture: The Ideal and the All-too-Real
1 Quoted by Susan Morgan in *Edward Weston: Portraits* (New York: Aperture, 1995), p. 5. For a good selection of photographic portraits, see Ben Maddow, *Faces: A Narrative History of the Portrait in Photography*, photographs compiled and edited by Constance Sullivan (Boston: New York Graphic Society, 1977). For a discussion of the aesthetics of portraiture, see the essays on this subject in Max Kozloff, *Lone Visions, Crowded Frames: Essays on Photography* (Albuquerque: University of New Mexico Press, 1994).
2 Interview with V.G., 1991.
3 "The Light Writer," in *Evidence 1944–1994 / Richard Avedon*, ed. Mary Shanahan (New York: Random House, and Rochester, N.Y.: Eastman Kodak Co., catalogue of an exhibition at the Whitney Museum of American Art, March 24–June 26, 1994), p. 106.
4 Susan Sontag, "America, Seen Through Photographs, Darkly," from *On Photography* (New York: Farrar, Straus & Giroux, 1977), reprinted in Vicki Goldberg, *Photography in Print* (New York: Simon and Schuster, 1981), pp. 506–520.

Photography and the Environment
1 On Jackson, see Peter B. Hales, *William Henry Jackson and the Transformation of the American Landscape* (Philadelphia: Temple University Press, 1988).
2 See, for example, Sandra S. Phillips et al., *Crossing the Frontier: Photographs of the Developing West, 1849 to the Present* (San Francisco: San Francisco Museum of Art, 1996).
3 Chapter 5 in *Landscape as Photography* (New Haven, Conn.: Yale University Press, 1985), pp. 21-36.
4 David Featherstone, "This Is the American Earth: A Collaboration by Ansel Adams and Nancy Newhall," in *Ansel Adams: New Light* (San Francisco: The Friends of Photography, 1993), p. 64.
5 Featherstone, op cit., p. 70.
6 Marc Reisner, "The Place No One Knew," in *Perpetual Mirage: Photographic Narratives of the Desert West*, ed. May Castleberry (New York: Whitney Museum of American Art, 1996), p. 153.
7 W. Eugene Smith and Aileen M. Smith, *Minimata* (New York: Holt, Rinehart and Winston, 1975). After Gene Smith was severely beaten by company thugs, Aileen Smith continued to photograph. Approximately one quarter of the photographs in the book are by her.
8 Quoted by Vicki Goldberg in *The Power of Images: How Photographs Changed Our Lives* (New York: Abbeville Press, 1991), p. 57.
9 Rebecca Solnit, *Savage Dreams: A Journey into the Landscape Wars of the American West* (New York: Vintage, 1994), pp. 236, 299.
10 Robert Adams, *Denver* (n.p.: Colorado Associated University Press, 1977).

The New Ethnic (Self-) Representation
1 "Introduction: Eudora Welty and Photography: An Interview" [conducted by Hunter Cole and Seetha Srinivasan] in Eudora Welty, *Eudora Welty: Photographs* (Jackson: University Press of Mississippi, 1989), p. xiv.
2 "In Our Own Image: Stereotyped Images of Indians Lead to New Native Art Forms," *Exposure*, vol. 29, no. 1 (Fall 1993), p. 9. See also Lucy Lippard, ed., *Partial Recall: Photographs of Native North Americans* (New York: The New Press, 1992), and Alfred L. Bush and Lee Clark Mitchell, *The Photograph and the American Indian* (Princeton: Princeton University Press, 1994). Lippard, in her Introduction (pp. 23-25), presents a balanced view of Curtis—something badly needed after the revisionist criticism spurred by Lyman [see above, fn.] had gone too far.

Postmodern Photography
1 Richard Prince, *Why I Go to the Movies Alone* (New York: Tantam Press, 1983), p. 63.
2 Roland Barthes, "The Death of the Author," 1968, reprinted in Barthes, *Image Music Text*. Essays selected and translated by Stephen Heath (New York: Hill & Wang, 1977), p. 146.
3 See Fredric Jameson, *Postmodernism, or The Cultural Logic of Late Capitalism* (Durham, N.C.: Duke University Press, 1991).

The Digital Revolution
1 See William J. Mitchell, *The Reconfigured Eye: Visual Truth in the Post-Photographic Era* (Cambridge: The MIT Press, 1992), p. 3. Much has been written about digitization and photography. Early entries included Fred Ritchin, *In Our Own Image: The Coming Revolution in Photography* (New York: Aperture, 1990), and *Ten.8*, vol. 2, no. 2, Autumn 1991, "Digital Dialogues."
2 Mitchell, op. cit., p. 66.
3 Clare Ansberry, "Alterations of Photos Raise Host of Legal, Ethical Issues," I, January 26, 1989, p. B1; cited by Mitchell, op. cit., p. 16.
4 Philippe Auguste Villiers de L'Isle-Adam, Axel, 1890.
5 On the *Post-Dispatch*, see Elizabeth Rogers, "Now You See It, Now You Don't," *News Photographer 44* (August 1989), 16-18; cited by Vicki Goldberg, *The Power of Photography: How Photographs Changed Our Lives* (New York: Abbeville Press, 1991), pp. 99-100.

bibliography

Agee, James, and Walker Evans. *Let Us Now Praise Famous Men*. New York: Houghton Mifflin, 1989.

Berger, John. *Ways of Seeing*. Harmondsworth, England: Penguin, 1972.

Bolton, Richard, ed. *The Contest of Meaning: Critical Histories of Photography*. Cambridge: MIT Press, 1989.

Boorstin, Daniel J. *The Image: A Guide to Pseudo-Events in America*. New York: Random House, 1992.

Bryan, C. D. B. *The National Geographic Society: 100 Years of Adventure and Discovery*. New York: Harry N. Abrams, 1987.

Carlebach, Michael J. *American Photojournalism Comes of Age*. Washington, D.C.: Smithsonian Institution Press, 1997.

Castleberry, May, ed. *Perpetual Mirage: Photographic Narratives of the Desert West*. New York: Whitney Museum of American Art, 1996.

Darius, John. *Beyond Vision*. Oxford: Oxford University Press, 1984.

Davis, Keith F. *An American Century of Photography: From Dry-Plate to Digital*, 2nd ed., rev. and enlarged. Kansas City, Mo.: Hallmark Cards, 1999.

Faas, Horst. *Requiem*. New York: Random House, 1997.

Frank, Robert. *The Americans*. Introduction by Jack Kerouac. New York: Scalo, 1993 [1959].

Fulton, Marianne. *Eyes of Time: Photojournalism in America*. Boston: New York Graphic Society and the International Museum of Photography at George Eastman House, 1988.

Ganzel, Bill. *Dust Bowl Descent*. Lincoln: University of Nebraska Press, 1984.

Gee, Helen. *Photography of the Fifties: An American Perspective*. Tucson: University of Arizona, Center for Creative Photography, 1980.

Goldberg, Vicki. *The Power of Photography: How Photographs Changed Our Lives*. New York: Abbeville Press, 1991.

Goldberg, Vicki, ed. *Photography in Print: Writings from 1816 to the Present*. New York: Simon and Schuster, 1981.

Green, Jonathan. *American Photography: A Critical History, 1945 to the Present*. New York: Abrams, 1984.

Grundberg, Andy, and Kathleen McCarthy Gauss. *Photography and Art: Interactions since 1946*. New York: Abbeville, 1987.

Guimond, James. *American Photography and the American Dream*. Chapel Hill: University of North Carolina Press, 1991.

Hirsh, Julia. *Family Photographs: Content, Meaning and Effect*. New York: Oxford University Press, 1981.

Johnston, Patricia. *Real Fantasies: Edward Steichen's Advertising Photography*. Berkeley: University of California Press, 1997.

Jussim, Estelle, and Gus Kayafas. *Stopping Time: The Photographs of Harold Edgerton*. New York: Harry N. Abrams, 1987.

Jussim, Estelle, and Elizabeth Lindquist-Cock. *Landscape as Photograph*. New Haven, Conn.: Yale University Press, 1985.

Kasher, Steven. *The Civil Rights Movement: A Photographic History, 1954–68*. New York: Abbeville Press, 1996.

Kismaric, Susan. *American Politicians: Photographs from 1843 to 1993*. New York: Museum of Modern Art, 1994.

Kozol, Wendy. *Life's America: Family and Nation in Postwar Photojournalism*. Philadelphia: Temple University Press, 1994.

Kunhardt Jr., Philip B., ed. *Life: World War II*. Boston: Little, Brown, 1990.

Lippard, Lucy, ed. *Partial Recall: Photographs of Native North Americans*. New York: The New Press, 1992.

Lyons, Nathan, ed. *Photographers on Photography*. Englewood Cliffs, N.J.: Prentice-Hall, 1966.

Maddow, Ben. *Faces: A Narrative History of the Portrait in Photography*. Photographs compiled and edited by Constance Sullivan. Boston: New York Graphic Society, 1977.

Mitchell, William J. *The Reconfigured Eye: Visual Truth in the Post-Photographic Era*. Cambridge: MIT Press, 1992.

Moeller, Susan D. *Compassion Fatigue: How the Media Sell Disease, Famine, War, and Death*. New York and London: Routledge, 1999.

Newhall, Beaumont. *The History of Photography*, rev. ed. New York: Museum of Modern Art, 1982.

O'Neal, Hank. *A Vision Shared: A Classic Portrait of America and Its People, 1935–1943*. New York: St. Martin's Press, 1976.

Phillips, Sandra S., et al. *Crossing the Frontier: Photographs of the Developing West, 1849 to the Present*. San Francisco: San Francisco Museum of Art, 1996.

Phillips, Sandra S. *Police Pictures: Photographs as Evidence*. San Francisco: Chronicle Books, 1997.

Rosenblum, Naomi. *A History of Women Photographers*. New York: Abbeville Press, 1994.

Rosenblum, Naomi. *A World History of Photography*, 3rd rev. ed. New York: Abbeville Press, 1997.

Sandeen, Eric J. *Picturing an Exhibition: The Family of Man and 1950s America*. Albuquerque: University of New Mexico Press, 1995.

Sobieszek, Robert. *The Art of Persuasion: A History of Advertising Photography*. New York: Harry N. Abrams, 1988.

Sontag, Susan. *On Photography*. New York: Farrar, Straus and Giroux, 1977.

Steichen, Edward. *The Family of Man*. Prologue by Carl Sandburg. New York: Museum of Modern Art, 1955.

Stieglitz, Alfred. *Camera Work: The Complete Illustrations 1903–1917*. Cologne: Taschen, 1997.

Stott, William. *Documentary Expression and Thirties America*. Chicago: University of Chicago Press, 1986.

Szarkowski, John. *Looking at Photographs: 100 Pictures from the Collection of the Museum of Modern Art*. New York: The Museum of Modern Art, 1973.

Szarkowski, John. *The Photographer's Eye*. New York: The Museum of Modern Art, 1966.

Trachtenberg, Alan. *American Image: Photographs from the National Archives, 1860–1960*. New York: Pantheon, 1979.

Trachtenberg, Alan. *Reading American Photographs: Images as History, Matthew Brady to Walker Evans*. New York: Noonday, 1989.

Trachtenberg, Alan, Walter Rosenblum, and Naomi Rosenblum. *America and Lewis Hine: Photographs, 1904–1940*. Millerton, N.Y.: Aperture, 1977.

Travis, David. *Photography Rediscovered: American Photographs, 1900–1930*. New York: Whitney Museum of American Art, 1979.

Willis, Deborah, ed. *Picturing Us: African American Identity in Photography*. New York: The New Press, 1994.

acknowledgments

O. Winston Link, *Link and Thom with Night Flash Equipment, March 16, 1956*. (Courtesy of the photographer and the Fraenkel Gallery, San Francisco)

The text of *American Photography: A Century of Images* is a collaboration. "The Snapshot Revolution," "Science and Photography," "World War I," "Advertising Photography," "The Cult of Celebrity," "LIFE," "The Wire Services," "World War II," "Fashion Photography," "Sex and Voyeurism," "Pop Art," "Surveillance and the Photograph as Evidence," "Portraiture," "Postmodern Photography," and "The Digital Revolution" were principally written by Vicki Goldberg.

"Photography as Fine Art," "Foreign Peoples, Foreign Places," "Social Reform," "Capturing Time," "Photographing the News," "The Farm Security Administration," "MoMA, 1937," "Instant Photography," "The Family of Man," "The Americans and the Dark Side of the 1950s," "Civil Rights," "The Counterculture," "Vietnam," "Photography and the Environment," and "The New Ethnic (Self-) Representation" were principally written by Robert Silberman.

We wish to express our gratitude and appreciation to John Schott and KTCA; Ellen Hovde, Muffie Meyer, Ronald Blumer, Holly Gill, Jennifer Boehm, Amy Ulrich, Julie Faral, Avra Scher, and many others at Middlemarch; Garrett White and Karen Hansgen; Suzanne Greenberg and Barbara Norfleet and the Carpenter Center at Harvard; Andy Hempe and the Houston Public Library; Joe Struble, Becky Simmons, and the International Museum of Photography at George Eastman House; Mark Hayward and the Museum of Science and Industry in Chicago; and Aaron Schmidt and the Boston Public Library. And, of course, the photographers.

Vicki Goldberg
Robert Silberman

For their assistance in the completion of this project, the editors wish to thank: Richard Avedon; Robert D. Bachrach; Barbara Gladstone Gallery, NY; Boston Public Library; Don Bowden, Associated Press; Timothy Bullard; David Burgevin, Smithsonian Institution; the Center for Creative Photography, Tucson, AZ; Darryl Curran; Richard Dreiser, Yerkes Observatory, Williams Bay, WI; Jeff Drosik, Ellis Island Immigration Museum; Joel Druat, Houston Public Library; Joanna Fiori; Pat Fundom, Hallmark Photographic Collection, Hallmark Cards, Inc., Kansas City, MO; Alison Gallup, VAGA; Thomas Garver; Stacey Gengo, Museum of Contemporary Art, Chicago; Mike Gentry, NASA; Laura Giammarco, Time Life Inc.; Wendy Glassmire, National Geographic Society; G. Ray Hawkins and Katrina Doerner, G. Ray Hawkins Gallery, Santa Monica; Robert Heinecken, Howard Greenberg Gallery, NY; Jan Kesner, Jan Kesner Gallery, Los Angeles; Craig Krull, Craig Krull Gallery, Santa Monica; Martina Lopez; John McIntyre, International Center for Photography, NY; George E. Mahlberg; Metro Pictures, NY; Therese Mulligan and Amelia Hugill-Fontanel, George Eastman House, Rochester, NY; Graham Nash, R. Mac Holbert, and Chris Pan, Nash Editions; Ken O'Brien; Jenny Okun; Palm Press, Concord, MA; Panopticon Gallery, Boston;

Elizabeth Partridge, Imogen Cunningham Trust, Berkeley, CA; Karen Quinn, Museum of Fine Arts, Boston; Andrea Rapp, Magnum Photos; Harry Redl; David Scheinbaum; Karen Sinsheimer; Kevin Smith; Robert Sobieszek, Peter Brenner, and Cheryle Robertson, Los Angeles County Museum of Art; the Paul Strand Archive, Millerton, NY; Throckmorton Fine Art, NY; Carl Toth Jr.; Dawn Troy, Fraenkel Gallery, San Francisco; Sandra Weiner; Linda Wolcott-Moore; Victor Zamudio Taylor; Gail Zappa; Donna Van Der Zee; and all others who helped to provide images for these pages.

Special thanks are due to Simon Johnston, praxis: design; Alan Rapp, Sara Schneider, and the staff at Chronicle Books; Ellen Hovde, Muffie Meyer, and Middlemarch Films, New York; Gerald Richman, Erika Herrmann, and the staff at KTCA/Twin Cities Public Television, St. Paul; John Schott; Robert Weinberg; and O. Winston Link.

Note: Representatives of Robert Frank and the estate of Diane Arbus were contacted regarding inclusion of photographs by Frank and Arbus in this book. It was not possible to include the work of either.

index